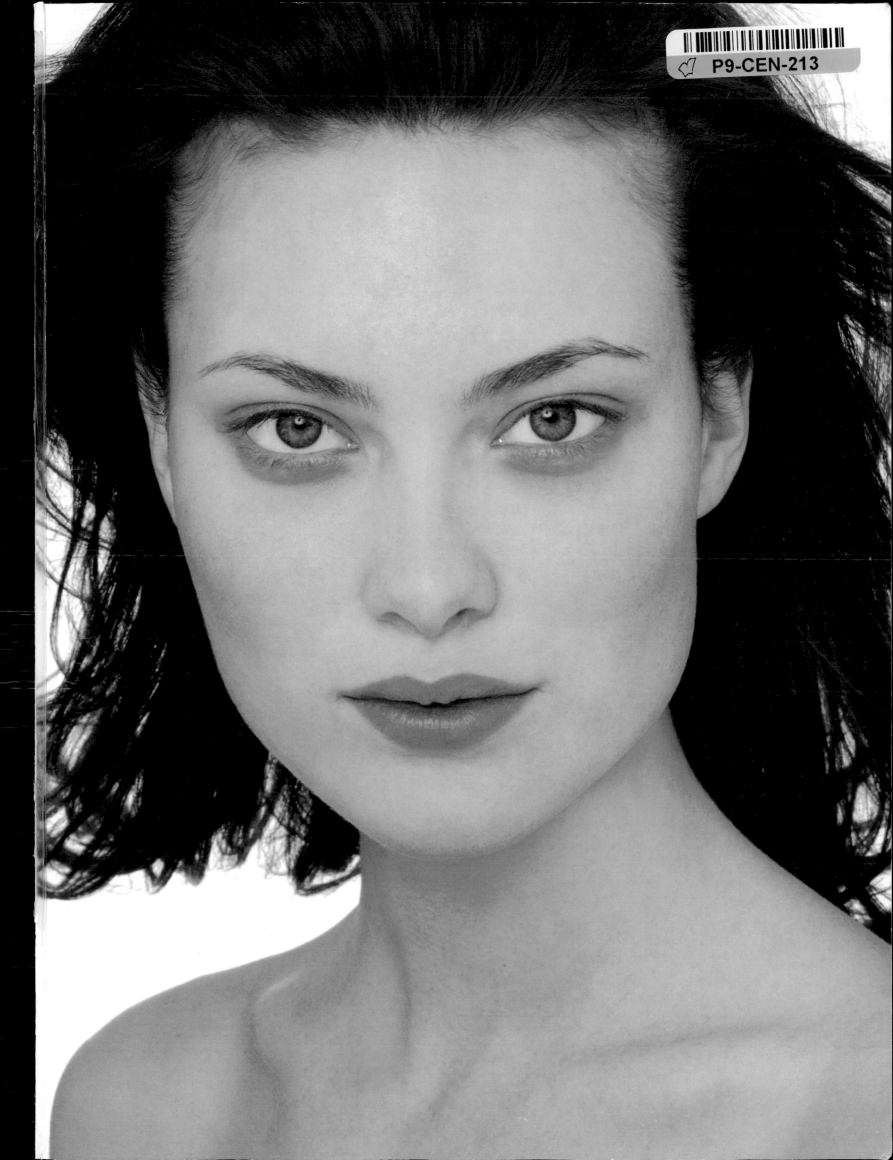

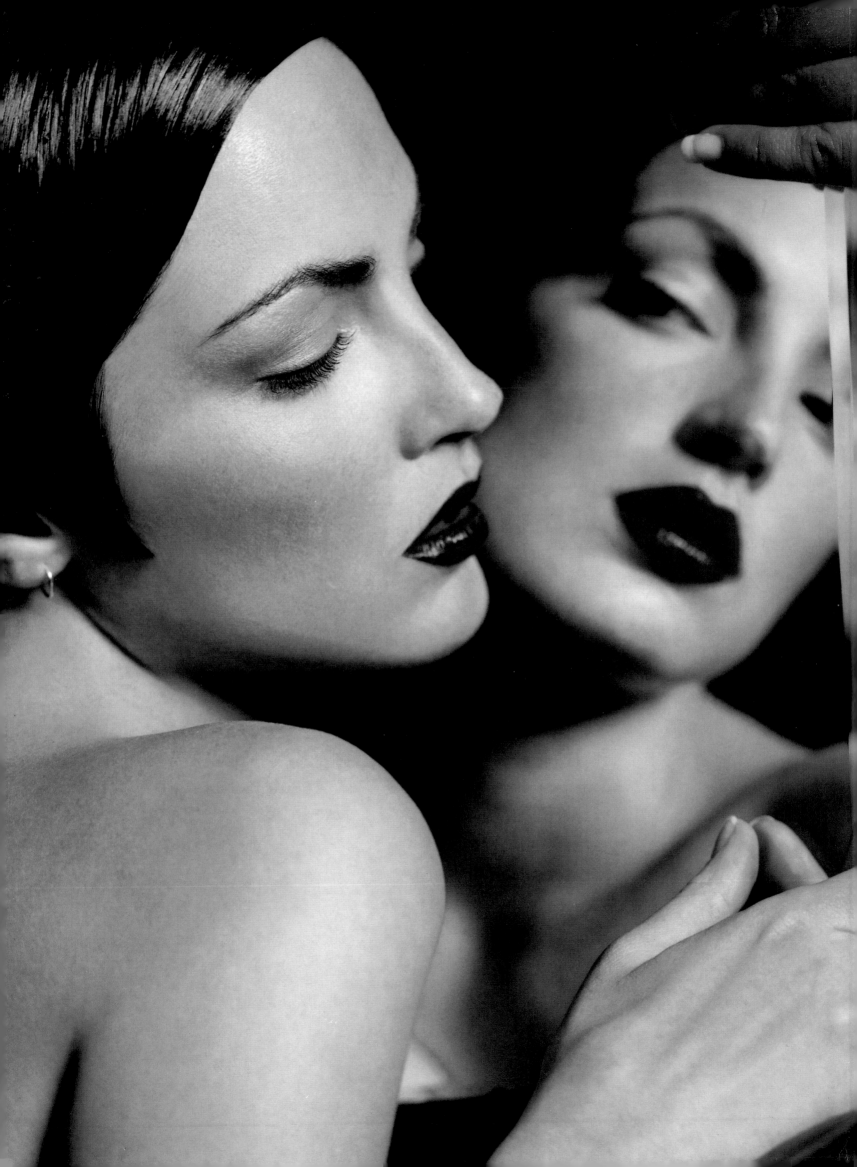

making faces

KEVYN AUCOIN

Little, Brown and Company

New York Boston

Cover and preceding page, Shalom Harlow; this page, Chandra North

Little, Brown and Company
Time Warner Book Group
1271 Avenue of the Americas,
New York, NY 10020
Visit our Web site at www.twbookmark.com

Originally published in hardcover by
Little, Brown and Company, 1997

First paperback edition, 1999

Library of Congress Cataloging-in-
Publication Data

Aucoin, Kevyn.
 Making faces / Kevyn Aucoin. —
1st ed.
 p. cm.
 ISBN 0-316-28686-9 (hc)
 ISBN 0-316-28685-0 (pb)
 1. Beauty, Personal. 2. Cosmetics.
 3. Face — Care and hygiene.
I. Title.
RA778.A873 1997
6462.7'2 — dc21 97-12658

10 9

IM-HK

Printed in China

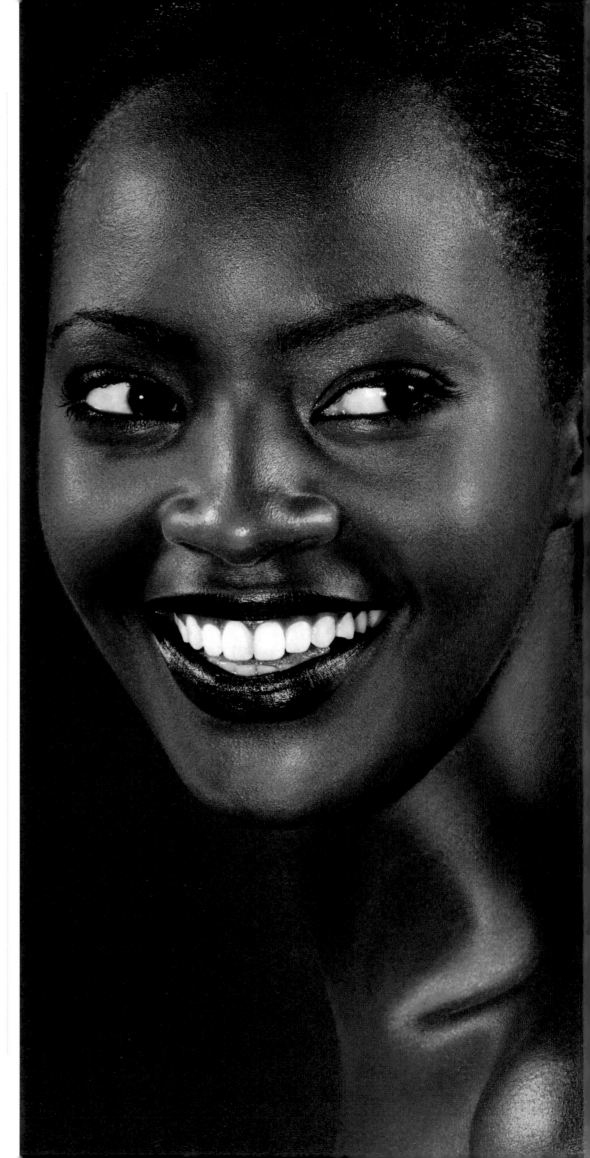

I dedicate this book to my mentor, the late Way Bandy, whose innovative and breathtaking makeup artistry motivated me to pack up my brushes and move to New York City to pursue my dreams.

This book is also dedicated to Alberto Fava, Pat McGrath, Stephane Marais, Linda Cantello, Mary Greenwell, Laura Mercier, Dick Page, Tom Pecheux, Tyen, Rick Gillette, Heidi Morawetz, Fran Cooper, Ariella, Billy B, Topolino, Kathleen Berkeley, Ron Berkeley, Bari Dreiband-Burman, Thomas R. Burman, Ruby Romaine, François Nars, Mathu Andersen, Vincent Longo, Barbara Daley, Shu Uemura, Angie Parker, Laurie Starrett, Eugenia Weston, Jo Strettel, Paul Starr, Berta Camal, Sandy Litner, Rumiko, Charlie Green, Marie-Josie LaFontaine, Diane Kendall, Serge Lutens, Miranda Joyce, Ashley Ward, Vincent Nasso, Joanne Gair, Fulvia Farolfi, Linda Mason, Joe McDevitt, Margaret Avery, Christy Coleman, Lamar Fulilove, Brigitte Reiss-Andersen, Max Delhome, Frank Toscan, Carol Shaw, Adele Fass, Christina Smith, Cathy Ann McAllister, Kay Montano, Leslie Chilkes, and all the other makeup *artists*, past and present, who continue to inspire and teach me.

Kiara Kabukuru

5

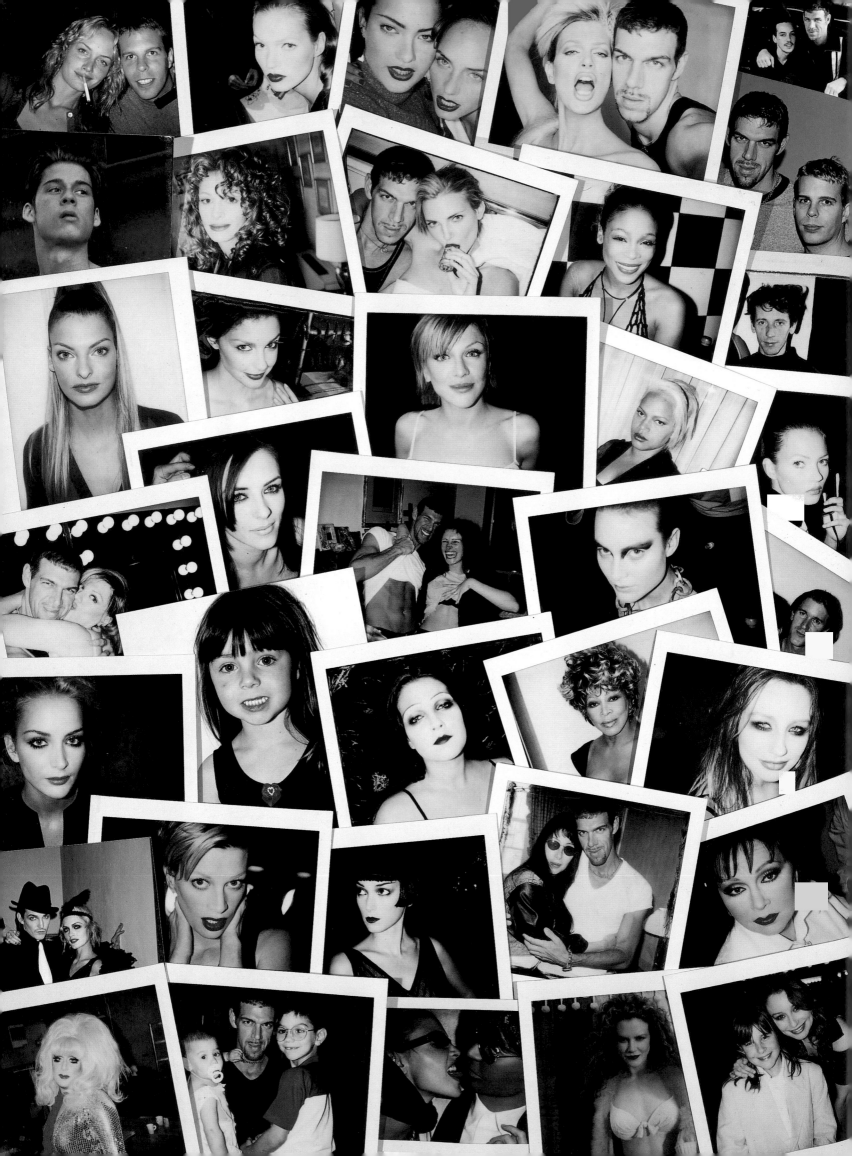

making faces

written by
Kevyn Aucoin

creative direction and illustrations by
Donald F. Reuter

art direction and design by
Kevyn Aucoin
Donald F. Reuter

featuring the photography of
Miles Aldridge, Patrick DeMarchelier, Billy Jim, Kei Ogata, Sante D'Orazio, Thierry LeGoues, Peter Lindbergh, Herb Ritts, Eric Sakas, Patric Shaw, Michael Thompson, Eddie Wolfl and Firooz Zahedi

all other photography by
Kevyn Aucoin

all makeup by
Kevyn Aucoin

opposite, from top left, row one: Amber Valetta with my boyfriend Eric Sakas; Kate Moss; Amber and Shalom Harlow; with Kristen McMenamy at Patrick DeMarchelier's studio; on location with hairstylist Orlando Pita; Eric and I. row two: my best friend, Todd Littleton; Julia Roberts in Venice; with Nadja on a shoot in Monte Carlo; T-Boz on the set of her video "I Touch Myself;" Julien D'Ys. row three; timeless Linda Evangelista; my musical twin, Ashley Judd; sexy Courtney Love; the "shocking" Karen Binns; Kate Moss. row four: getting a kiss from Courtney; sultry Elizabeth Hurley; Julia Roberts wins the "abs" contest; Shalom at Irving Penn's studio; my brother Keith. row five: Georgina Grenville in Paris; my niece Katarina in Louisiana; chameleon Drew Barrymore; ever-fabulous Tina Turner; genius Tori Amos for her "Hey Jupiter" video. row six: Amber and Jesse Hanbury; Kristen McMenamy on the Concorde; Winona Ryder for a Steven Meisel Vogue shoot; with Cher in London; Roseanne. row seven: the fabulous Lady Bunny; holding my niece Fallon and nephew Ian; Nadja Auermann kissing a mannequin in Monte Carlo; Nicole Kidman on the beach; Tori and my godchild Samantha.

"Collage," photographed by Billy Jim

contents

Gregory St. Cerin

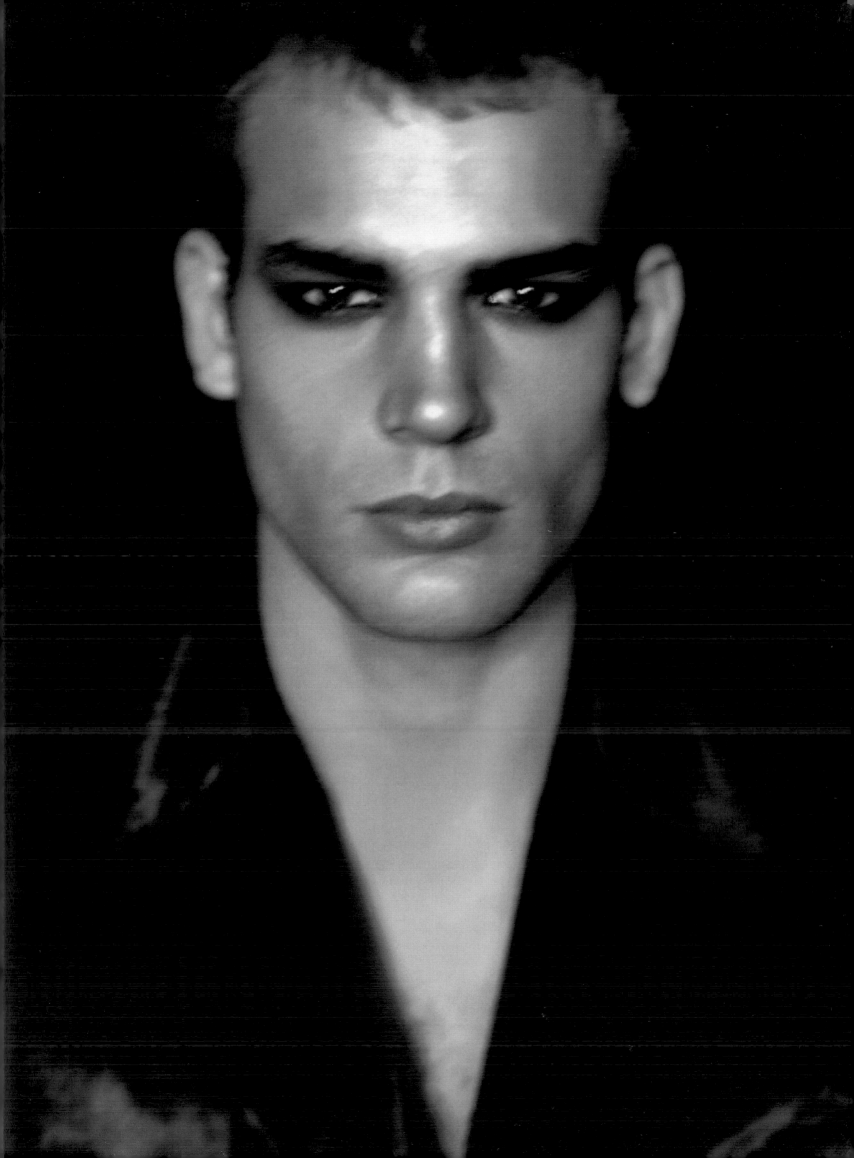

foreword by gena rowlands

I distinctly remember my first experience with makeup: it was the summer after eighth grade, and I was finally allowed to try some Tangee lipstick. It was thrilling; it was also a very bright pink, and since then makeup has always held a little magic for me, and reminded me of coming of age as a woman. I think women need a lot of variety in their lives, and makeup, whether it's coral lipstick or false eyelashes or simple brown eyeshadow, is a way of achieving that. It lightens the mood, it's fun and I'm very glad we have it. I always feel better with makeup on, and I hate getting caught without it, even by the Federal Express man. Over the years I've experimented with everything: I have to—without makeup, I look like a goldfish—and learned a great deal from the makeup artists I've worked with, particularly Kevyn. I've been watching him very carefully ever since the very first time he made me up, for a party on the set of a movie I was doing a few years ago in South Carolina. I was playing the role of a woman of my own age, studiously nonglamorous, and I said to Kevyn, who happened to be in town: "I'm pretty sick of looking like Miss Plain Jane here, can you do something with me?" And he said, "Oh, I'd love it," because Kevyn loves to put on makeup and he loves women, and when he was through with me, the crew didn't recognize me. I was that glamorous! He's both deeply skilled and generous, generous about making women feel beautiful, and generous about sharing his secrets, as he does in this book. There are so many things in the world that you have to face that aren't so pleasant, that being able to learn something and have a little fun and feel better about yourself, all in the time it takes to get from one page to the next, is a special and wonderful combination.

Gena Rowlands

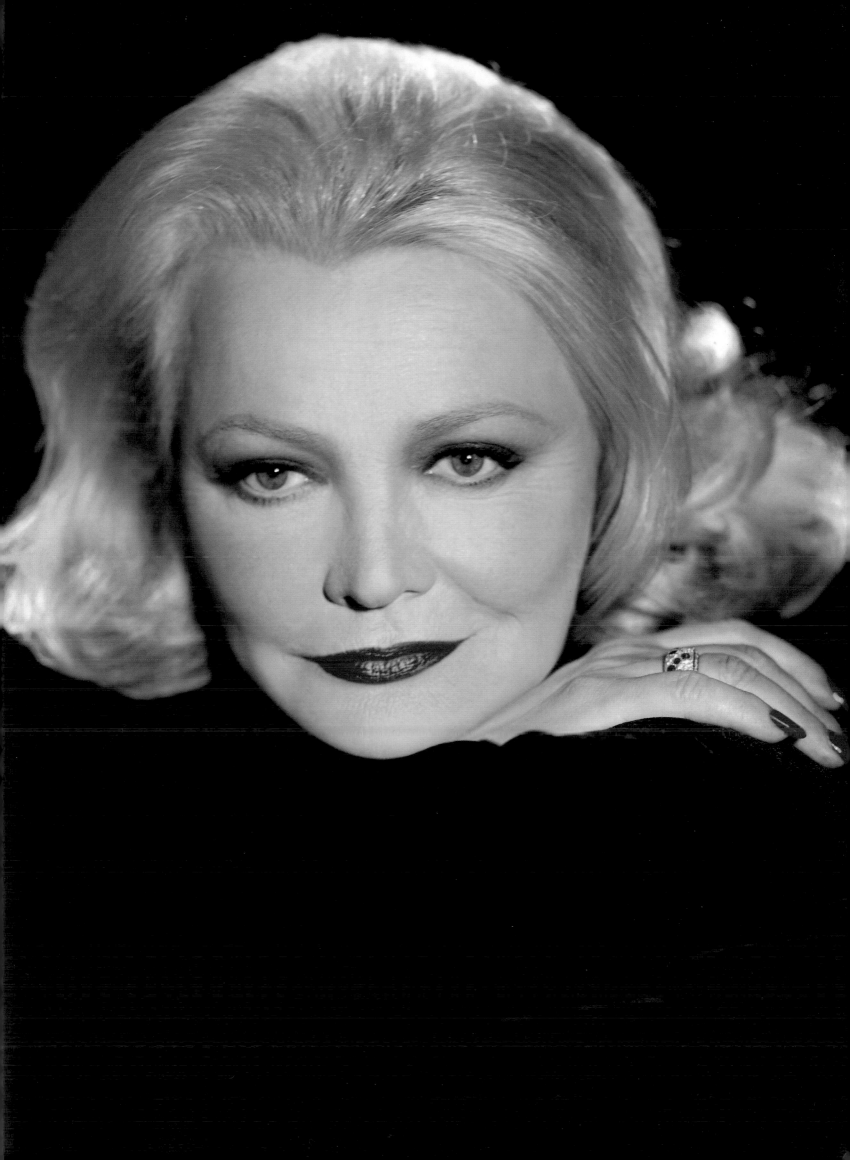

introduction

First of all, let me say that I believe there are no rules when it comes to makeup, besides the obvious: "Don't curl your eyelashes in a speeding vehicle," or "Don't put lipstick in your eye," etc. ...(but those aren't really "rules," they're more common sense). Experts seem to be popping up everywhere with strict dictates and "philosophies" that frighten people into thinking there is only one way to wear (and do) makeup that is "acceptable" and "normal" (two words I hate!). "Never wear black lipstick," "Makeup should never take more than five minutes" and "Never touch up your makeup in public" are just a few of the oppressive and, frankly, ridiculous "words of wisdom" frequently handed down by these self-appointed cosmetic police. In a world of constant change, with ethnicities blending together, I feel the goal should be to expand our definition of what we consider "acceptable," "normal" and "beautiful." The future will belong to those with open minds and open hearts, who can appreciate beauty in all its forms.

Growing up in the South during the Sixties taught me a lot about exclusion and bigotry. Those who were "different" were (and often, still are) thought of as "bad." Conformity was the rule, forcing those too weak or too afraid to be themselves to disown their uniqueness and subjugate themselves to whatever the current popular stereotype was at the time. Today we realize that self-repression just for the sake of fitting in can lead to confusion, depression and sometimes suicide. If we've learned anything in this age of communication it is that being true to yourself is the only real road to happiness and fulfillment, and as luck would have it, I was blessed with the inability to hide my true self. (Anyway, trying to conceal the fact that I was a gay, effeminate, hyperactive, adopted child with a serious lisp in southern Louisiana would have been like trying to hide Dolly Parton in a string bikini!) This revelation led to verbal, emotional and physical abuse, as well as incredible determination, tenacity and, eventually, self-respect.

While the other boys in my school dreamed of traveling to the moon or winning the Super Bowl, I dreamt of glossy red lips and sparkling skin. By the age of eleven I knew I wanted to be a makeup artist. My

upper right, me and my brother, Keith, holding baby Carla; followed by her school pictures shown side-by-side with photos I took of her at the same age

left, my sister Carla and I

first model was my six-year-old sister, Carla, and my first makeup tool was a single tube of tangerine lipstick. Armed with my father's Polaroid camera and endless curiosity, I enthusiastically began what was to become my career. The fashion magazines I collected had an endless array of talent to choose from, but I only had one girl on my roster, so I set out to create as many looks as my limited resources would allow. Carla became my guinea pig for haircuts, perms, home-made clothing and endless hours of amateur photo sessions. Over the years, she and I experimented with every look imaginable. Through it all, both Carla and I learned not to be afraid of taking chances (and, in the process, I learned how to do makeup). We had no real teachers, only photographs from fashion magazines. I would tear out my favorite "faces" and try to replicate them on Carla (or, for that matter, anyone who came within range of my mascara wand). Learning to do makeup through trial and error taught me that my "mistakes" were often exciting revelations. I came to realize that rules and words like "never" and "always" were (and are) sure death for creativity. And while I believe that education is very important, I am grateful for my lack of formal training in makeup. The journey itself may have taken longer but along the way I discovered things I could not have been "taught." For me, new and exciting ideas are most often created when chances are taken and rules are broken.

All of the people in this book are real people. Whether they are actresses, housewives, working mothers, writers, designers, singers, lawyers, or models, they are here as an inspiration. I learned a long time ago that comparing oneself to others can only lead to frustration and misery. You can always find someone more fortunate or less fortunate than you, so what would be the point in trying? As you read through this book you will see a wide variety of individuals who exemplify beauty in its many (and truest) forms. This book, above all else, is about ideas and possibilities, with "looks" ranging from the most natural to drag-queens, from your average businessman to grandmothers. It was with a sense of passion, excitement and adventure that this book was produced and it is my hope that you will find yourself, or rather, your *selves* inside.

left, more side-by-side portraits of Carla and with her daughter, my godchild, Samantha

Carla Aucoin

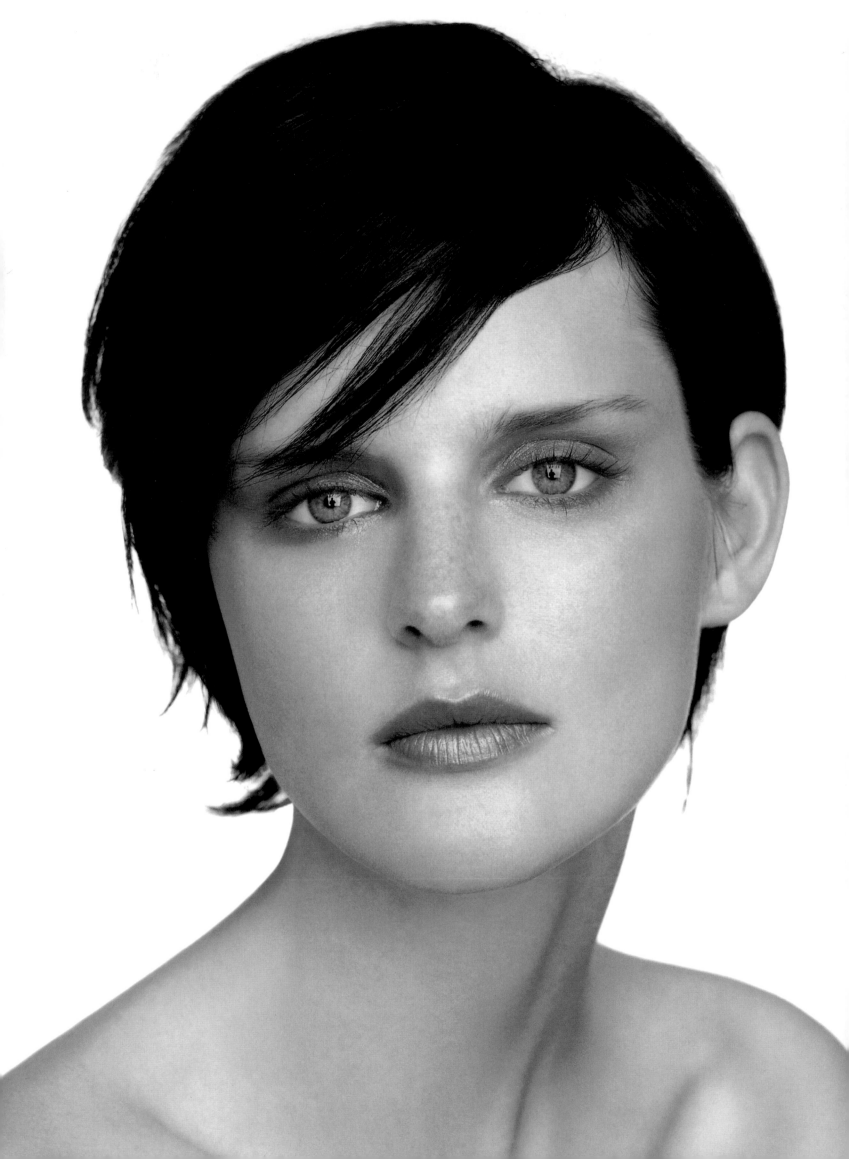

making the face

This section of the book offers some basic (and not so basic) ideas about enhancing, defining and even altering your features with make-up. Actually, all makeup alters your face to some degree. Not many people are born with natural brown eyeshadow, mascara and lip gloss. Anyway, it's up to you to decide to what degree you want to enhance or define (whichever word you want to use) your own face.

The word "modern" has been painfully overused, so pardon me when I say that to me modern makeup is any look from RuPaul to k. d. Lang, as long as it makes you feel good about yourself. It seems ridiculous to even have to say these things, but beauty is one area where a lot of people are insecure and, therefore, vulnerable to beauty "bullies" ..."You're a Winter, so you can only wear lilac or puce!"

This book is about ideas and suggestions, geared to help anyone achieve their own special look (whatever that may be). I don't look at people and think rigid beauty thoughts like "I can't believe she wore that lipstick with those gloves!" or "White shadow never looks good with pale, pale lips!" That kind of thinking is born out of rigidity and a desperate need for rules and guidelines. Most of us were taught at a very early age that fitting in should be our number one goal and to hell with our individuality. I've always tried to fight conformity as a thoughtful assessment of my true feelings, as opposed to a fear of not fitting in. Watching movies, looking at magazines and checking out people on the street help to form my ever-changing ideas on beauty. I always try to stay open to the endless combinations and boundless possibilities. It seems once you think you know it all or develop a rigid philosophy, you stop growing and learning.

So now I'll share some of my favorite ideas, tricks, techniques and thoughts on makeup, all the while encouraging the process of mixing ideas, ignoring those you don't like or those that don't apply, and using those that do as a springboard for your own creativity.

On the left, Stella Tennant is wearing only a touch of concealer, followed by the sheerest application of loose powder. Her stunning blue eyes are made more vivid with the application of warm-toned creme eyeshadows. Liquid blush adds a soft glow without looking too powdery. The finishing touch was a transparent application of pink lip gloss.

Stella Tennant, photographed by Mark Abrahams

skin care and preparation

cotton balls -
great for removing makeup

eyedrops -
(for irregular use only)
Whitens and helps remove "gook"
from eyes

moisturizing mask-
for dry- to extra-dry skin

light moisturizer-
for normal to dry complexions

cotton swabs -
can be used for blending, correcting
mistakes and removing "gunk" from
eyes
(note: when using in the eye area,
moisten to prevent stray fibers from
ending up in your eye)

astringent -
removes excess oil pollution from skin.
Good for helping makeup last longer on
those with oily complexions

tissues -
most tissue is 2-ply - I separate these
into one sheet for blotting lips evenly.
Also, good for blotting oil-based founda-
tion and excess mascara from the wand

I've been fortunate, through my work, to have met and developed close relationships with some of the world's most knowledgeable and renowned beauty experts. What amazes me about these men and women is that not only are they at the pinnacle of their professions, expertly trained and miracle workers in extreme cases but that they are also wonderful people. This is the case with Dr. Pat Wexler. Her sense of humor and easy manner, along with her qualifications, has made her one of my favorite people and a favorite among top celebrities and models, who regularly seek out her dermatological advice.

While there are some advanced cases of skin irritation or irregularity that might require aggressive steps, there are many simple, sensible measures we can apply toward better skin without much time commitment or trouble.

Personally, I love being in the sun so much that if I could broil myself like a steak under an open flame I would. However, I know from working with people's faces, that the sun has long-term effects that we just don't want to deal with. Being "kissed by the sun" is a great feeling; however, being mauled by the sun can cause irreparable damage, the least of which is wrinkles, the most of which is melanoma. This is not to say the sun is all bad but that we must, as Dr. Wexler puts it, practice "safe sun." Always wear a sunscreen and moisturize areas that require it.

When asked about moisturizers, her answer debunked an old myth. Skin, she says, does not have a clock. Meaning, a day cream *is* a night cream and a night cream *is* a day cream. What is problematically dry at 11:00A.M. is the same amount and type of trouble at 11:00P.M. So finding a single product that works well for you is all that is needed morning, noon *and* night. Also, "body-dipping" into a product isn't necessary; apply it just to the areas where it's needed. Try not to be coerced into buying things you won't use by the overmarketing of cosmetic and skincare products.

Dr. Wexler also says, in relation to skincare products, that we should expect any given application to work only for a certain period of time. *Skincare is not cosmetic surgery.* The toner that created a fresh, tight appearance yesterday morning has only a temporary effect and today your face may need another splash. As another example, skin blemish creams may vanquish the pimple, but not necessarily the underlying (internal) cause of acne-prone skin. Skin, too, has a way of adapting (and responding with greater and lesser success) to the active ingredients of a product. Remember, skin is not static. While possibly appearing porcelain or alabaster, it is not. It is constantly evolving in relationship to what we eat, drink, how we exercise, how we sleep *and* how we feel. For these reasons, our moisturizing, beauty treatments and makeup needs should change as well. Change is good.

Therefore Dr. Wexler concludes, the best skincare tips are really about rest, diet and exercise. Our skin is an outward reflection of what is happening inside our bodies. So drinking large amounts of water throughout the day to clean up our systems so that toxins don't build up; staying away from dehydrating elements such as alcohol and smoking; eating foods that include fruits, grains and vegetables and getting some exercise that keeps the blood moving through the most-looked-at organ of the body — your skin — will help you to put your best face forward.

To the left are some of the things you might want to have around before, during, after, and even if you're *not* wearing makeup. Throughout this section of the book, I'll be showing you many of *my* favorite tools and products. However, these items are not brand specific. I believe it is important that choices are made based on personal taste, preference and desires.

facial structure

It is very important that you know your own face as well as possible. Take the time to study it (without makeup). Close your eyes and feel for the structure and placement of the bones underneath. Once you have a good idea of what you are working with physically, it becomes much easier to enhance your overall appearance.

The places designated on Chandra North's face, to the right and in sketches below, are the "maps" I use to reference specific features throughout the book.

> **Sheer** foundation, at its best, like that worn on Chandra's face to the right, gives our skin the appearance most of us would like to have naturally. That is to say, soft and subtle without appearing oily. In fact, if used properly, and placed only where needed, it practically disappears into the skin. Colors that will work best should be chosen to match the skin perfectly.

Years ago, foundation was used specifically to alter the color of the skin, re: "rosy glow." But the trend of the last few years has taken us from what intentionally changed the wearer's natural coloring to products that match the tones perfectly; to now, wearing even less and less. In this book and in my own work today, I most often use little or no foundation. I find that concealer, applied to any spots or discoloration, followed by a light powder, is the most natural-looking and attractive finish for the skin. Still, if you choose to wear foundation, there are two important things to consider when selecting a product:

The "look" you want to achieve and that it matches your skin. (Don't forget to check the color in daylight to make sure it matches your neck.)

But again, there are no rules. When it comes to the selection of any cosmetic product, whatever suits your needs and taste is what's best.

● ●

Most of my summer days as a child were spent outdoors. My brother Keith and I rarely wore shoes or shirts as we climbed the enormous pine trees in our backyard, making forts and swinging from ropes. The only real drawback, besides the occasional broken bone and impossible-to-remove pine sap, was the incessant mosquito bites. *(continued on page 21)*

Chandra North

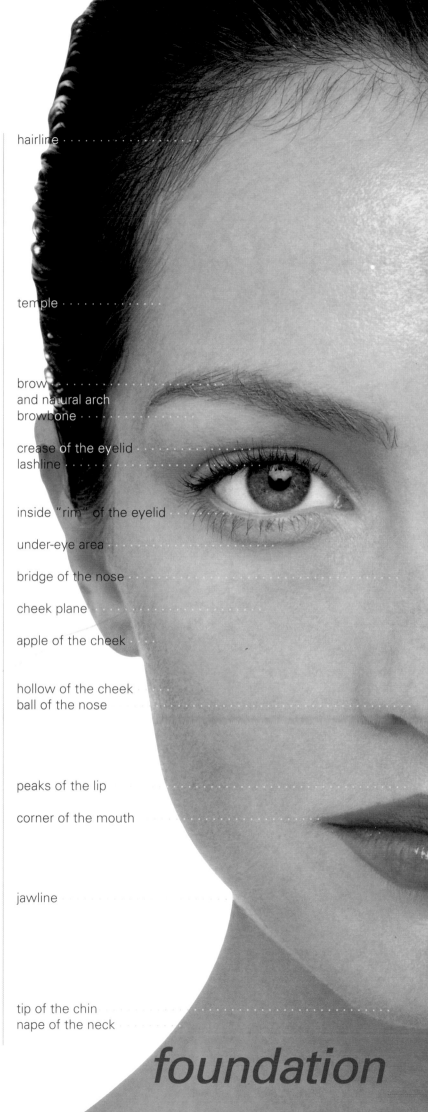

hairline ·········

temple ·········

brow ············
and natural arch
browbone ······

crease of the eyelid ···
lashline ············

inside "rim" of the eyelid ···

under-eye area ·········

bridge of the nose ·········

cheek plane ···········

apple of the cheek ·········

hollow of the cheek ·········
ball of the nose

peaks of the lip ·········

corner of the mouth ·········

jawline ·········

tip of the chin ·········
nape of the neck

foundation

foundation

I use my fingers when applying foundation (and concealer); however a sponge is very useful for blending and also wiping away any extra product.

Oil-based foundations tend to separate, so they need to be shaken for a smoother application.

I prefer little or no foundation for everyday use. Too much foundation can give the face an artificial, heavy look.

Creme foundation can create the look of having a milky complexion.

If your foundation formula is too oily, try adding a few drops of astringent. This will make the foundation a bit sheerer, but does cut down on the oiliness.

A little foundation on the eyelid, blended well and followed by loose powder, creates a smooth surface for powder shadow to glide on, making the application last longer and blending easier.

foundation sponge - *for applying foundation and blending larger areas*

creme foundation - *gives the most coverage.*

iridescent stick/liquid foundations - *adds light or a glow to the complexion*

liquid foundation - *a medium coverage product with a light moisturizing effect*

sheer foundation - *light coverage*

Chandra, to the left, is wearing a very light application of liquid foundation. Many women choose this type of foundation because it looks and feels quite natural. It can also become somewhat beneficial to the wearer because many of the best ones contain moisturizing ingredients.

Chandra North

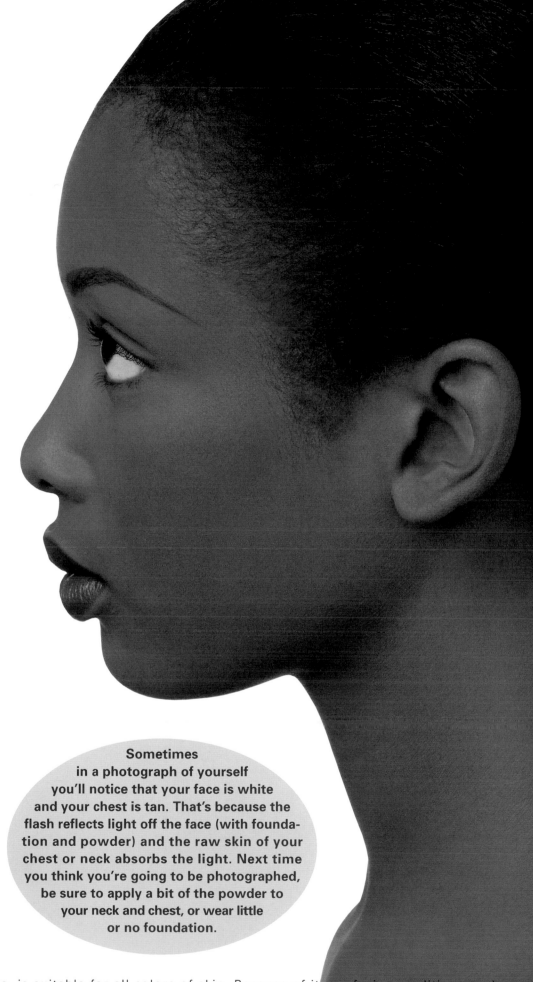

(continued from page 19)

This meant that one of us (or both, usually) were covered in calamine lotion. (You know, that strange-smelling, anti-itch lotion that dries to a cakey, whitish-pink paste.) A couple of weeks before I began first grade, my mother took me shopping for school clothes. This was the day I was allowed to buy my infamous lime-green patent leather loafers (which I hid from my father, but he eventually found them and threw them away). After hours of trying on clothes and choosing those with the brightest floral prints, my mother allowed me to push the shopping cart all the way to the checkout counter. And, as was customary, my mother made me stand in front of the cart, away from the seductive candy display, with my hands outstretched toward the clerk, to make sure she wouldn't think I had stolen anything. As my eyes left my mother's protective gaze, they fell upon the somehwat disconcerting sight of a woman who had apparently been attacked by a legion of mosquitoes. "Ma'am! Look! My legs have calamine lotion all over them too!" I exclaimed, happy to have a cohort in misery. Before my mother could stop me, the cashier's puzzled expression led to the unfortunate release of the words "You know, all over your face, ma'am!" On the car ride home, my mother explained that mosquitoes played no part in the cashier's appearance and that what she had on was "makeup." Now, three decades later, I'm still baffled. Why anyone would choose a foundation so far from their natural color seems inexplicable. But, then again, that was 1967 and choices were quite limited. Luckily things have changed and now ny brother and I wear mosquito repellent whenever we climb trees.

• • • • • • • • • • • • • • • • •

If, and when, you use foundation all over the face, be sure to blend into your jawline and slightly onto the neck. Otherwise, you'll have a distinct line between the two, and it will make you look like you have a mask on.

Sometimes in a photograph of yourself you'll notice that your face is white and your chest is tan. That's because the flash reflects light off the face (with foundation and powder) and the raw skin of your chest or neck absorbs the light. Next time you think you're going to be photographed, be sure to apply a bit of the powder to your neck and chest, or wear little or no foundation.

Matte foundation, as seen here on Adia, is suitable for all colors of skin. Because of its surfacing qualities,powder eyeshadows, etc., tend to go on smooth and easy. However, if applied too heavily it can make the face seem rather lifeless. While iridescence can create a beautiful dewy look, it can also bring out unevenness in texture (such as acne scars, severe lines and blemishes). Matte foundation tends to even out skin texture. Also, women with dry skin should apply moisturizer before its use.

Adia Caulibaly

21

powder

When using powder products such as eyeshadow or blush, a light application of loose or pressed powder first is the best way to ensure smooth blending. Powder eyeshadows or blushes applied directly to the skin will "grab" in the oily areas, creating a blotchy application.

Loose powder, alone, can act as a sheer foundation, by toning down the shine and evening out the skin.

To avoid uneven distribution, shake off excess powder from the sponge or brush before applying to the face.

Adding extra loose powder, like I've done on Valerie, just under the eye, down the bridge of the nose and right under the bottom lip, at the start of your makeup application, can result in the subtle highlighting of these spots when you're finished. Powder, under the eye, also helps catch falling shadow and mascara, which can be easily brushed away when you're done.

Valerie Celis

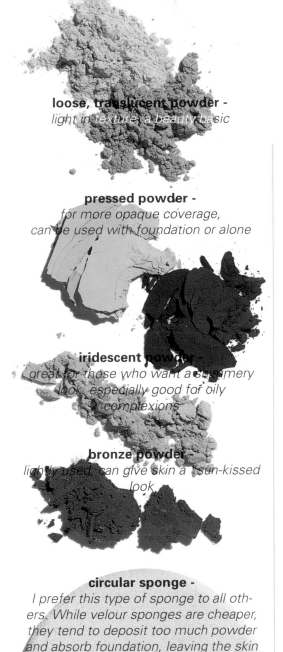

loose, translucent powder -
light in texture, a beauty basic

pressed powder -
*for more opaque coverage,
can be used with foundation or alone*

iridescent powder -
*great for those who want a shimmery
look, especially good for oily
complexions*

bronze powder -
*lightly used, can give skin a "sun-kissed
look*

circular sponge -
*I prefer this type of sponge to all oth-
ers. While velour sponges are cheaper,
they tend to deposit too much powder
and absorb foundation, leaving the skin
streaky and blotchy*

powder brush

Concealer works so well because it is made of a denser composition than most other cosmetics. Therefore, it has more staying power. However, it's not meant to be a cover-the-entire-face product. So use caution; a little goes a long way.

Colors for concealer come in a variety of shades and should match the skin itself. But many concealers have a pink base. When placed over under-eye cir-cles, which tend to be bluish or purple, they look gray. Golden-toned conceal-ers counteract purplish circles and end up looking like natural skin. There are instances, though, where you may want to go slightly lighter. As an example: dark circles under the eye, that are many shades deeper than your normal skin coloration.

I prefer a concealer that is completely opaque and slightly dry in texture, to ones that are liquidy. (I find that these don't adhere to the skin as well and, therefore, tend to "travel" on the face. They are also prone to rub off or fade quickly.) This way, I only have to use very little to cover pim-ples, birthmarks, spider veins, under-eye circles or anywhere there is red-ness or discoloration on the face.

I
find applying
golden-based concealer
just to the places where it is
needed, like red spots or
under-eye circles (using a small
brush or your fingertips before
softly powdering) can easily
create the look of natural,
beautiful skin.

concealer brush -
small-tipped for accuracy in application

concealers

Using a small brush (like the one shown) or your fingertip, dab or lightly draw onto the area you wish to conceal. Blend well into the skin. Then if you wish, set with powder.

Sometimes
foundation is enough
to cover under-eye circles.
However, if the circles are dark,
foundation, because it tends to be
transparent, isn't usually enough.
This is where concealer will give
better coverage. Besides, if you
have to layer foundation for cov-
erage, you run the risk of the
product creasing and
looking heavy.

**Concealer
can be mixed
with creme or liquid
eyeshadows, creme
blush or lip colors to
pale down or dilute
the applica-
tion.**

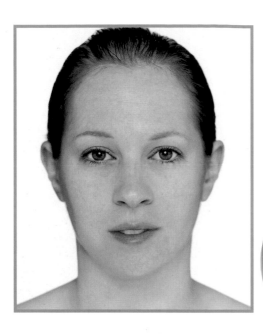

This photo is really an illustration of the contours of the face. The application is exaggerated and not to be taken too literally. It's just to show how highlighting and contouring (when sparingly applied and carefully blended) can add definition to the face. You can use this photo to understand your own bone structure and make the most of it. Practice at home in daylight and test your progress. You may never do this for everyday life, but for special occasions or photographs, it can really make a difference.

Either apply these products directly from the tube with a brush or use your fingertips. Blend with your fingers (or a sponge). While blending, concentrate on keeping the product in the general area where it was applied, but use enough to eliminate any obvious lines.

Shimmer and pearlized powders make great highlighters!

shading *and highlighting*

contouring brush -
for powder highlighters and shading products

for highlighting -
The browbone
Center of the eyelid
The center of the forehead and down through the bridge of the nose
The cheekbone plane and under the eye
Around the corners of the mouth
The center of the chin up under the lip
The collarbone
The inside curve of the breast

for shading:
The hollows of the cheek
Under the chin and down the neck
Sides and under the tip of the nose
Into the crease of the eye
The temples
The center of your cleavage
The hollows above and below your collarbone
Around the hairline

A longtime friend and the premier cosmetic surgeon to some of the world's most famous people, Dr. Daniel Baker, is the one plastic surgeon who, without hesitation, I can recommend to any person in search of that, otherwise unattainable, aquiline nose. What nature did not give you, Dr. Baker can.

Deciphering the arcane language of blepharoplasty, rhytidoplasty and rhinoplasty, and making magic from it, with subtle work, artistic eye and skilled hand, Dr. Baker has been working in the specialized field of reconstructive surgery, cosmetic improvements and aesthetic enhancements for over two decades. Involved in such radical procedures as limb reattachment as early as 1979, his past work was primarily focused on posttraumatic reconstruction. However, as Dr. Baker confides, he has come to understand the work he does now often has an equally life-altering and life-affirming impact on many of his patients.

Once thought to be the domain of the rich and famous, eyelid lifts, face lifts and nose jobs (listed above in technical terminology) are being sought by people of all ages and walks of life. This is due in part to it's affordability, as compared to several years ago, and its broadened social acceptability. If you can feel better about yourself, why feel bad? Putting a fresher face forward is no longer a taboo for men, as well as women.

I think we all have those days when we look in the mirror before stepping out of the door for work in the morning and wonder what happened to our faces while we were asleep. What horrible transformation rearranged the bones so there is a bad Picasso head looking back at you rather than yourself. Those days when all that can be seen in the line of vision is that thing perceived as a physical shortcoming. Plastic surgery can alter that perception as surely as it alters the flesh.

As Dr. Baker says, the greatest alterations made through cosmetic surgery are the internal ones. Wonderful, beautiful women such as Anjelica Huston can carry a strong profile because of who they are inside. She would not be able to be who she is if she did not have her unique, stunning beauty. Plastic surgery should not be about homogenizing beauty, but about realizing a person's total potential. For that reason, Dr. Baker points out, he often discourages someone from undergoing elective surgery. What that person needed was not an eyelid lift—something altering their natural and individual beauty—but instead suggestions for something as simple as tweezing the eyebrow (in a way that enhances an already lovely brow line) or consulting a professional about the proper application of makeup.

When visiting a plastic surgeon, this is what you should expect: A thorough intake evaluation, so that the physician can ascertain your desires and the motives behind them. If you consult a surgeon who agrees with everything you want, one who will nip, tuck and pull anything, without hesitation or concern, run for your life. What you can also expect is that the doctor will take you to the mirror and show you what can be accomplished through the application of his science. Then again, he may lead you to the mirror and say you are perfect as you are. Cosmetic surgery is not for everyone and a reputable surgeon will tell you that honestly.

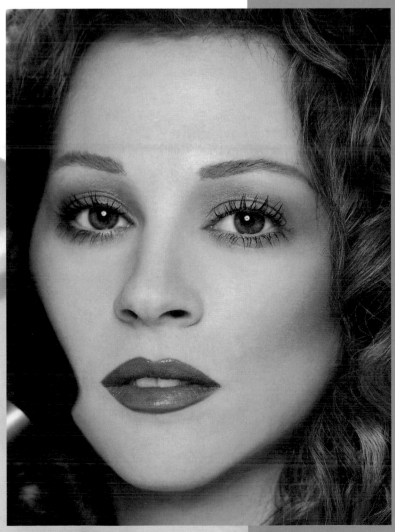

Carla, "before, during, and after"

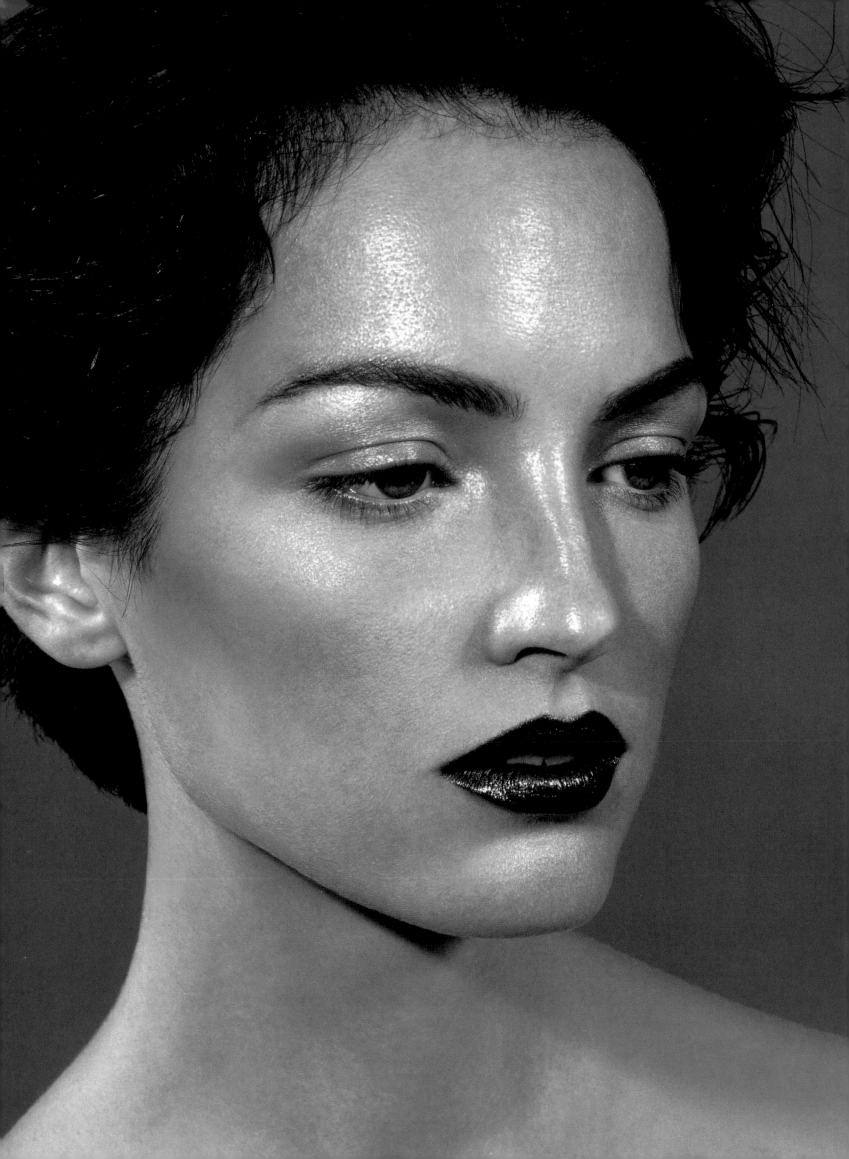

For as long as I can remember I've been obsessed with eyebrows - from that first grade school paper (the last page of the book) to my first photo session, all the way to today, I'm simply drawn to people's eyebrows. In the seventh grade my friend Michelle came to class one day, her eyes sparkling and glistening. "What did you do to your eyes?" I asked. Beaming that someone noticed, she proudly replied, "I've tweezed my eyelashes!" Taking her word for it, and not realizing she had confused eyelashes with eyebrows, I sat on the bus home envisioning the new glistening, sparkly eyes that were only a tweeze away. Pondering, in the mirror, which eyelashes would need to be extracted in order to attain this exciting new look, I chose a nice, thick black one in the dead center of my eye. Now for those of you who have never experienced an eyelash being ripped out of your head, count your blessings. Besides nearly pulling my eyelid off, the pain was indescribable. The gruesome sight of my rapidly inflating eyelid saved that lucky fourth lash from its demise. Needless to say, I learned to listen and observe more carefully when it came to beauty tips from a twelve-year-old. Anyway, while some may hesitate and balk at the idea of changing one's brow shape, one only needs to think of Marlene Dietrich, Elizabeth Taylor, Audrey Hepburn or Diana Ross to realize how altering the shape can help create a signature look.

● ● ● ● ● ● ● ● ● ● ● ● ● ● ● ● ●

Brow hairs do not grow back thicker. If anything, constant plucking may cause the individual hairs to stop growing altogether.

If you are sensitive to plucking, try rubbing a small bit of toothache medicine over the area to numb the skin.

A simple brow lesson.

First, decide on the shape you like. Following the brow's natural arch is the most direct course. To do this, take a close look at how the hairs (generally) curve along the *top* of the brow. Using that as a guide, mirror the shape along the bottom by eliminating the most obvious hairs.

Sometimes it is helpful to mark the hairs you want to remove with a white pencil or concealer (area indicated below red-dashed line).

Pluck. (It's easier and less painful to remove the hairs in the direction that they grow).

Then take your sharpened pencil and draw in any open spaces with short, irregular-length strokes to simulate real hair.

My favorite shape is slightly squared off at the beginning, tapered to a fine but not overextended point at the end, with a graceful arch in between.

Brush your brows up, and, if you like, keep them in place with a little sweep of clear mascara, mustache wax or hairspray.

brow pencils - *for shaping, filling in, darkening or adding warmth to brows*

Thinking of lightening your brows and want to see what they would look like first? Try using colored mascara in the shade you'd like them to be.

colored mascaras

tweezers

brow brush

Chandra North

Marilyn - shapely, voluptuous and curvy, as seductive as a brow could get

Marlene - tweezed within an inch of its life, or plucked out completely and drawn back in

Elizabeth - a smaller, compact, "pert" version of Marilyn with a distinct peak, but every bit as sexy

Brooke - boyish and slightly unkempt, a real-life example of the Gamine's brow

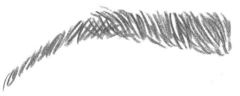

Clara - straight and then down. Almost sad-looking; very waifish and vulnerable

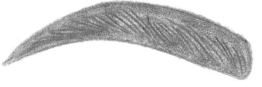

Audrey - drawn over and around the real brow. Youthful and tomboyish

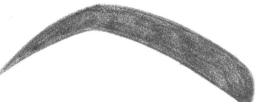

Divine - as in the larger-than-life late drag queen. Shape has no basis in reality, but that's the whole point

covering the brows

To achieve some of the more adventuresome looks in this book, such as "the Sophisticate" and "the Showgirl," it is necessary to change the shape of the brows completely. This can be accomplished in two different ways. The first is to either completely pluck or shave your brows off. Although this will give you the best surface, it does seem a high price to pay for "the Big Party" or the weekend drag show. So, if being cast in the title role of "The Marlene Dietrich Story" is not in your future plans, I suggest covering your brows. While this is a technique that is mostly used by "movie stars" and "gender illusionists," and the "naturalist" may find it appalling, I thought I would include it just in case you ever get the urge. This way you can have all the drama without the aftermath.

Even when you do master the application, just like Cinderella, you'll only have a few hours before it starts to show signs of wear. Still, if you have a party to go to or some other fantastic function, it can make all the difference.

eyebrow wax

eyebrow sealer

brow brush (optional)

concealer or foundation

loose powder

brow pencil

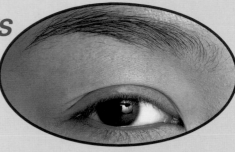

The "natural" brow, tweezed, if you like.

Draw over with sealing wax.

"Paint" over waxed brow with sealer.

Allow a few moments to dry.

Cover over sealed brow with foundation.

Lightly powder. Then…

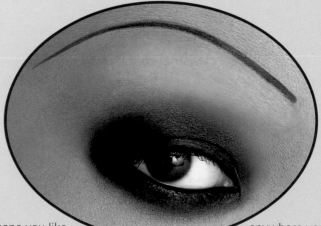

…draw on any shape you like, …anywhere you want!

Valerie Celis

bleaching the brows

A great way to change the look of the face (also by altering the brow) is to bleach them, as seen here on Christina Shimizu-Morrison. By lightening them, using facial-hair bleach, you can affect the entire mood of the face. A bleached brow will soften the expression, as opposed to dyeing them (a darker color), which can make them look stronger.

> **If you feel your brows are too low or close to the eyes, bleaching them can "open up" the face.**

Bleaching the brows is quite simple, but you must exercise caution. Overusing the bleach can seriously weaken the hairs (sometimes causing them to break off). So it is best to test the effect of the bleach (and see the color change) by removing a bit of the product and uncovering the hairs underneath every few moments. Also, when you are finished, clean away all the bleach with soap and water, followed by mild antiseptic, and use a tiny bit of hair conditioner on the brow to help keep it supple.

Christina before…

…during…

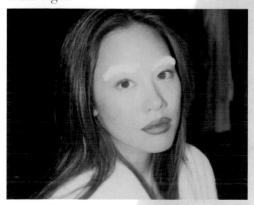

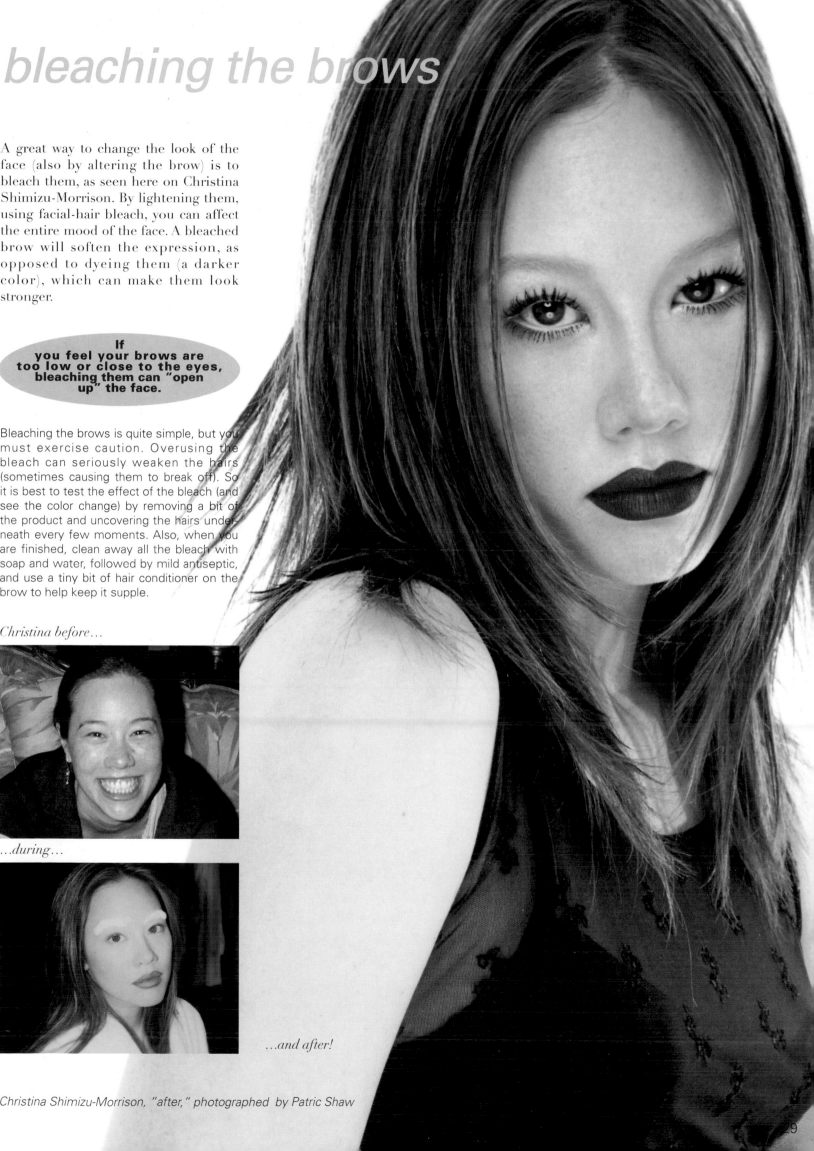

…and after!

Christina Shimizu-Morrison, "after," photographed by Patric Shaw

eyes

loose powder eyeshadow

powder eyeshadow

creme eyeshadow

liquid eyeshadow

sponge-tipped applicator

eyeshadow brushes

Soften and blend the edges of any eyeshadow shape you create (with a sponge-tip applicator, eyeshadow brush or powder sponge) to make it look more natural and less hard.

Eyes are an area where you can really have fun and be quite creative. Unlike the lips, which can be altered only slightly in shape before they start to look awkward, the eyes have no real set limitations. Each shape you create, whether with shadows, pencils, or liner, can take you into completely different realms. From "smoky" to "defining," subtle to high-drama, depending on the face you choose, the eye area is integral for a successful look.

If possible, you should remove contact lenses before working on the eye area and put them back in when you're done.

Contour

To create the "alluring" eyeshadow shape (*see page 33*) shown on Julia Roberts to the right, you'll need the following tools and products:

concealer and face powder
powder sponge
black eyeliner pencil
black powder eyeshadow
neutral beige powder eyeshadow
sponge-tip applicator
eyeshadow brush
eyelash curler and black mascara
apricot blush and blush brush
neutral lip color and lip brush

Use concealer sparingly, followed by loose powder applied with a powder sponge (not velour). (Optional: leave a little powder under the eye, to catch falling shadow.)

Apply black eyeliner pencil to upper and lower inner eye area. Smudge pencil gently into the lashes.

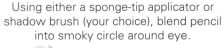

Using either a sponge-tip applicator or shadow brush (your choice), blend pencil into smoky circle around eye.

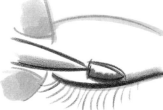

First, using the eyeshadow applicator, softly retrace penciled area (from lashes outward) with black eyeshadow. The idea is to smoke up the area. Remember to use as little as possible to get the best results.

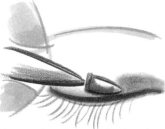

Next, using the eyeshadow brush, arc into the crease of the eyelid, under and softly outward from the corner. (Concentrate the shadow on the *outer* half of the eye.)

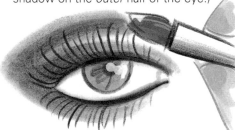

Use beige powder eyeshadow to highlight browbone and eyelid. (You can even sweep a little bit slightly down the side of the nose and under the eye.)

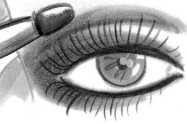

Curl the lashes and apply black mascara.

Finally, fill in the mouth (using a lip brush) with neutral lip color (in Julia's case, for this photo, no lip pencil outline was necessary), and dust the cheeks with apricot blush.

Julia's brows were bleached. (This is always optional, but see how it, with the pale mouth, softens and affects the overall balance of the face.

Julia Roberts, photographed by Peter Lindbergh

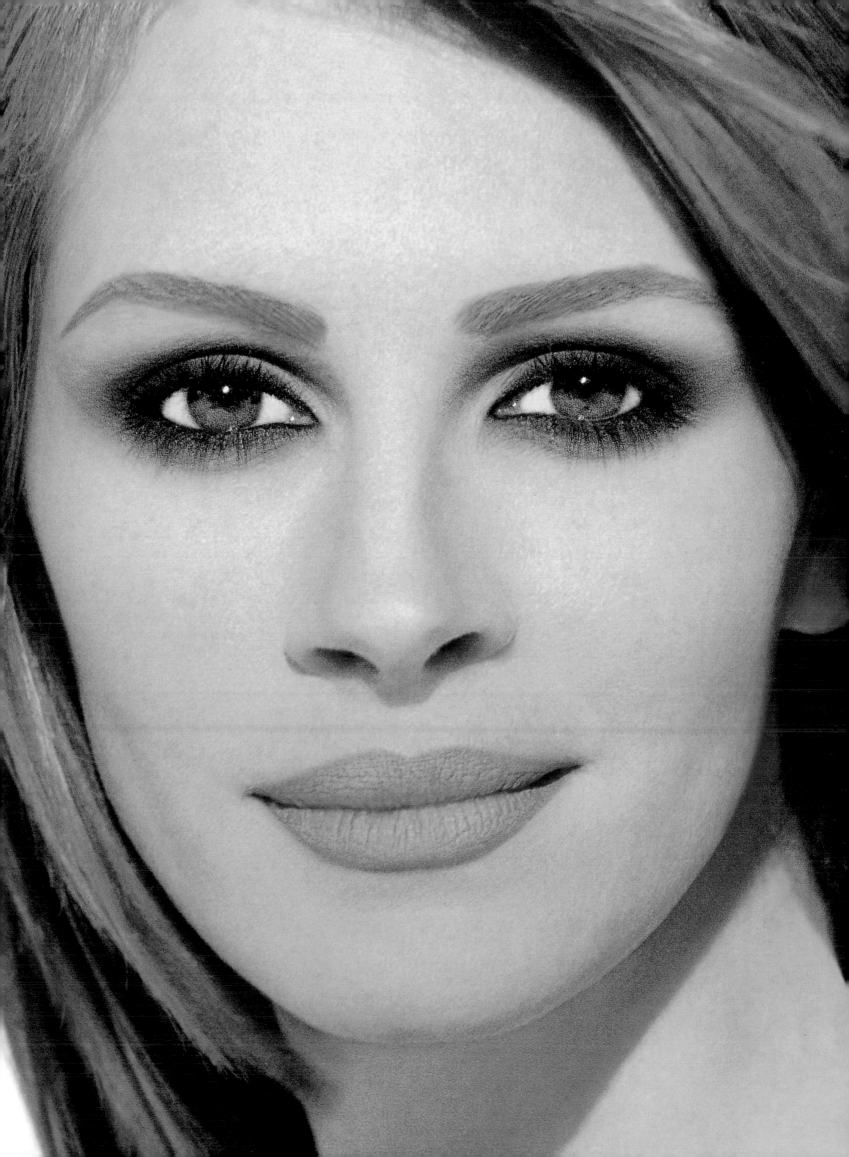

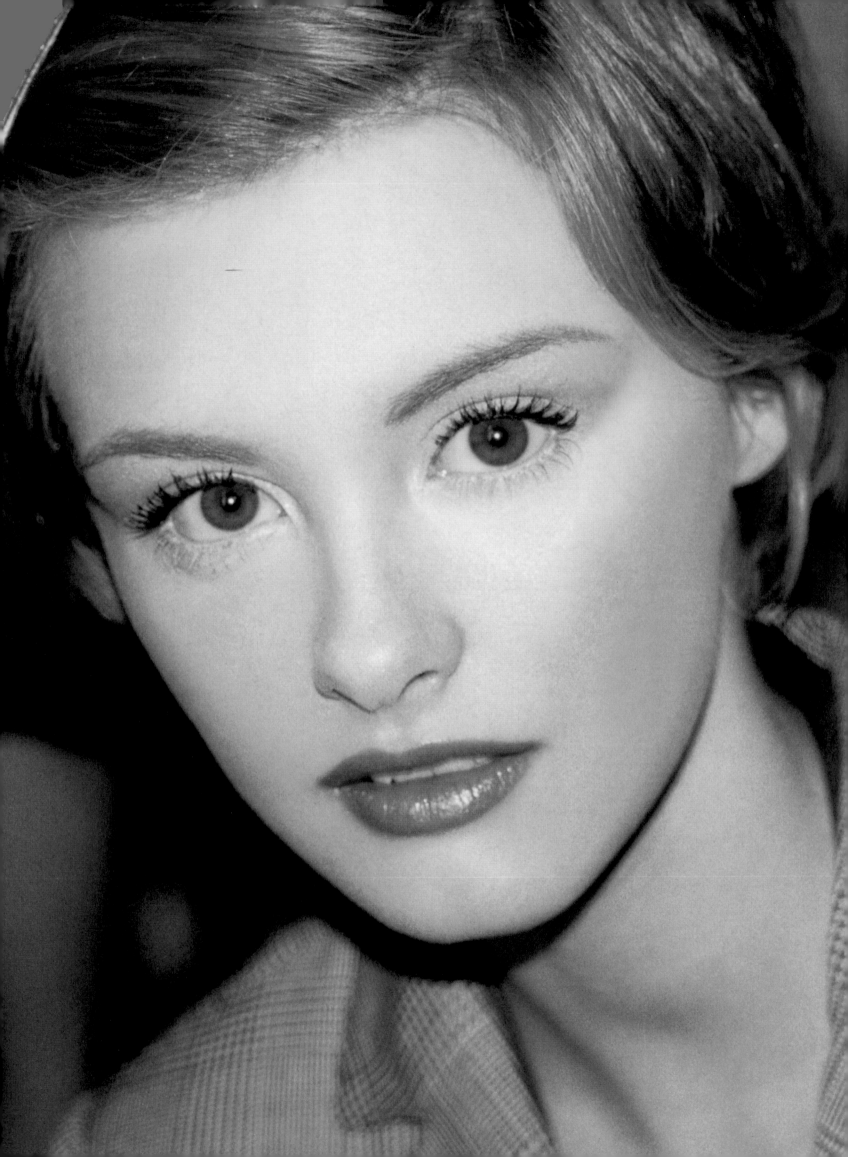

The eye area is always a popular choice for the use of color. However, a little will go a long way. Regardless of what colors you actually choose (from blue to brown, red to black) remember that your attention will immediately go to the "colored" areas. For instance, on Trish, to the left, I used a soft powder blue eyeshadow. You're instantly drawn to the eyes. In order to balance the face, a soft pink blush and clear pink lip gloss were chosen; while enhancing the cheeks and lips, they allow the eyes the "spotlight."

There are dozens of eyeshadow shapes and each one can effect a completely different mood. Most are fairly simple to do, and only a handful are complicated. (But remember: practice, passion and persistance make perfect.) For our purposes, I narrowed them down to six categories (Contour, Wash, Smoky, Downturned, Bi-colored, and Winged). From them you should be able to create any shape you like.

The effect of a smoky eye can be either soft and subtle, like the effect on Julia (*on page 31*) or mysterious and dramatic (*see* Janet Jackson, *on page 42*). The first uses eyeshadows in a contouring manner. The second uses dark shades in a more highly concentrated area.

This look is also known as "bedroom eyes," made famous by seductresses throughout history. It consists of a pale lid (your color choice) and browbone with a sloping crease. The outer eyelashes are played up to accentuate the overall sleepy effect.

Wash

Smoky

Downturned

To re-create the eyecatching shadow shape on Trish Goff, to the left, the following is a guideline when choosing an eyeshadow color: the lighter, more pastel shadow will look softer; the darker, more primary shadow will be more dramatic.

Using a sponge-tip applicator, use the following drawings as guides:

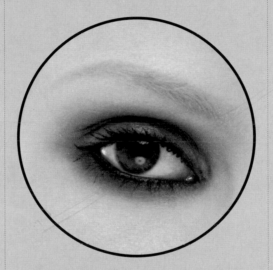

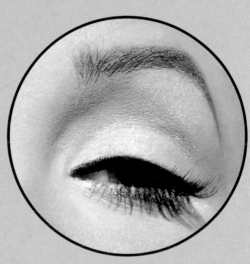

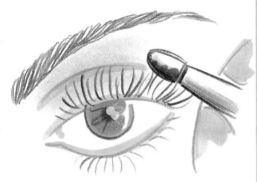

Then soften and blend away any hard edges.

This shape is popular for creating a fuller, more rounded eye. By emphasizing the outer eye area with a dark, smoky shadow that fades as it moves inward toward the brow, the eyelid and browbone are softly separated, giving the wearer a wide-eyed look.

For centuries women have affected this look to accentuate their more exotic side. From Cleopatra to Madonna, this shape has signified power and sensuality. Using any color, from pastels to deepest black, this "upturned" eye adds instant drama to any face.

Bi-color

Winged

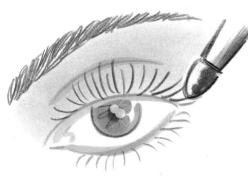

(Remember, when using color products, it's easier to use less at first and increase, layer by layer, until you get the exact color depth and shape you want.)

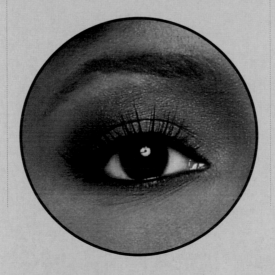

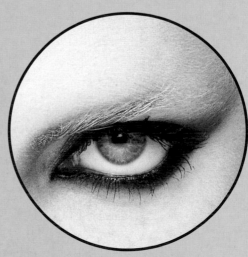

Trish Goff, photographed by Eric Sakas

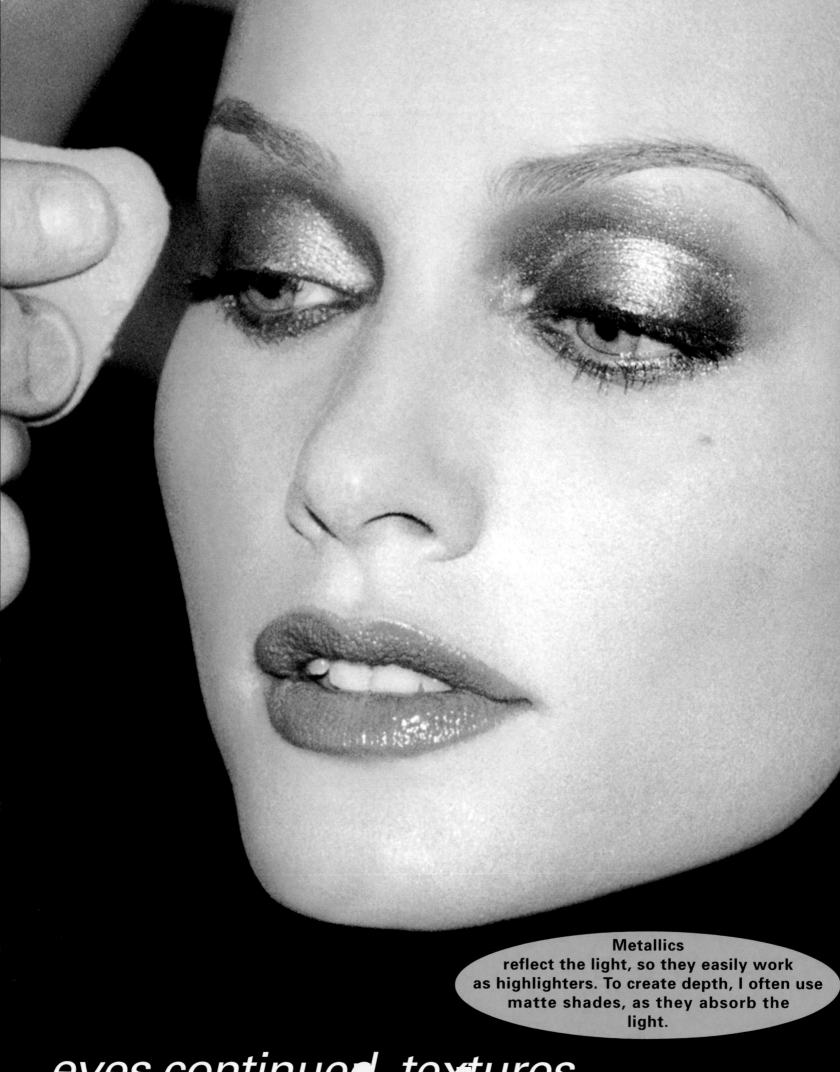

Metallics reflect the light, so they easily work as highlighters. To create depth, I often use matte shades, as they absorb the light.

eyes continued, textures

From shimmery to a precious-metal effect, metallic eyeshadow (in liquid, creme or powder) can create rich and opulent or subtle and surprising effects.

metallic

To the left, Amber Valetta's lids were made up using these three metallic liquid shadows:

burgundy metallic liquid eyeshadow
beige-white liquid shimmer eyeshadow
gold metallic liquid eyeshadow

Burgundy metallic liquid shadow was apllied with a large eyeshadow brush over the entire lid, blending beyond the crease and under the eye.

Next, a pale beigey-white liquid shimmer was lightly applied with the fingertips to browbone and all along the burgundy edges.

Then gold metallic liquid shadow was applied to the center of the eyelid, using the *center* finger and allowed to dry with eyes looking down.

When applying eyeshadow to the crease of the eye, I recommend keeping the eye open. Besides being able to see the shape you are creating, the color will go into (and slightly above) the crease.

Amber Valetta, photographed by Eric Sakas

A soft, liquid brown eyeshadow was sparingly used to enhance the natural eye shape. Carefully blend in to create an almost "stained" effect.

Creme shadow can help to bring the eyes forward, while retaining a skin-like texture that (depending on color) can look from "approachable" all the way to "edgy."

A popular choice, matte shadows (when applied to an already lightly powdered eyelid) can be one of the easiest to apply. (Tip: if you're having trouble blending, you may want to try another brand, as some companies' matte shadows feel like pressed dust!)

A favorite of Old Hollywood and top makeup artists, this look does require a lot of upkeep. If using petroleum jelly (as many makeup artists do) after a while the gloss, and whatever color is under it, tends to "travel" into the crease. For everyday life, try loose powder shimmer shadows with high shine.

Similar to "natural," this look involves a halo of color surrounding the eye. Again, color selection is according to personal taste and style. The feeling is sensual and fresh. This texture can be accomplished with cremes, liquids, creamy powder eyeshadows or a combination of the three.

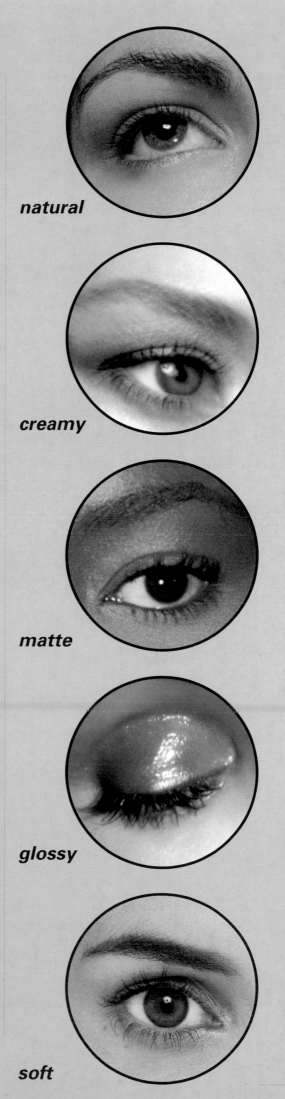

natural

creamy

matte

glossy

soft

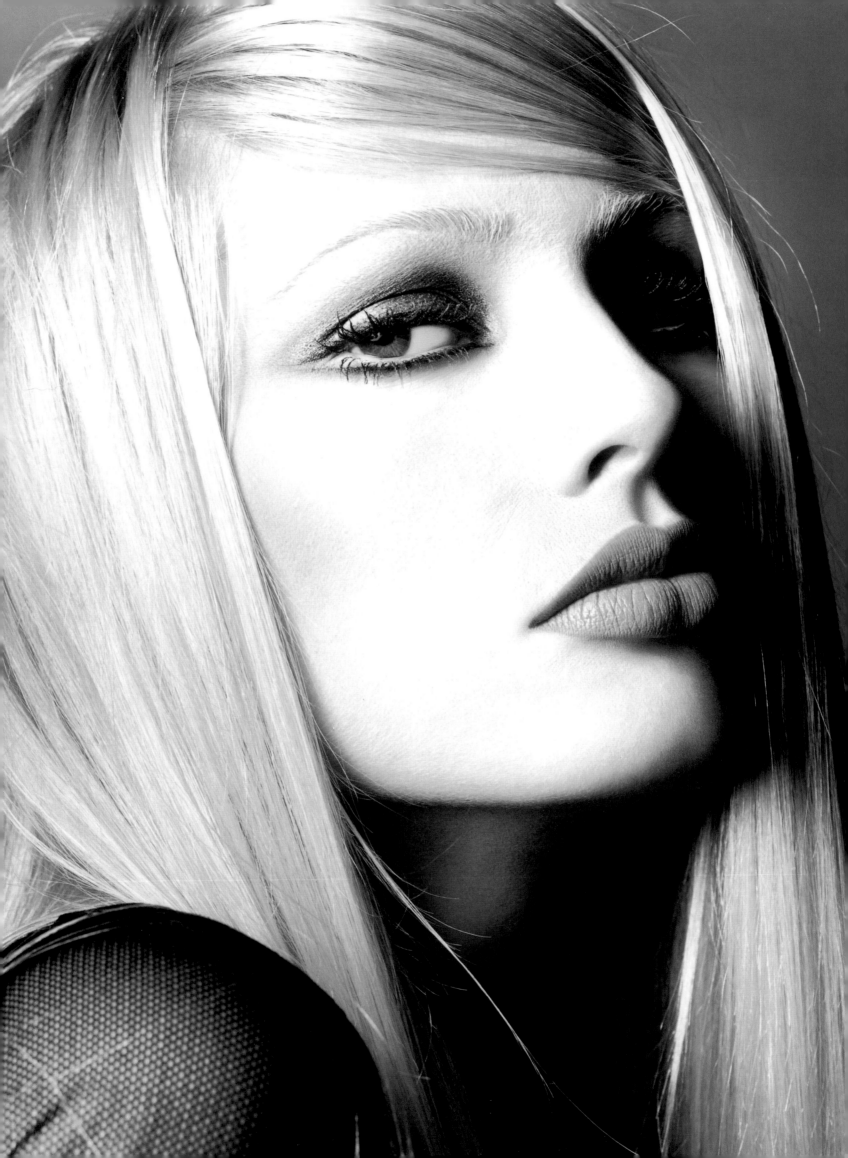

eyeliner

liquid eyeliner

black eye pencil

brown eye pencil

white eye pencil

1

Seated in front of magnifying mirror,

2

pull lid taunt with free hand.

3

Draw across in one continuous thin line. (Retrace for larger lines.)

Applying liquid eyeliner to someone else is hard enough, but it's even more difficult applying it to yourself. Again, especially with this specific makeup technique; practice, persistence, and passion make perfect. 1.) Begin by placing yourself in front of a mirror magnifying your eyes to the size of Jupiter. Seriously, magnification truly benefits a smooth application. 2.) Using your free hand, pull your eye taut and slightly downward. I find that whichever way the liner is pointing naturally when I pick it up is where I begin on each eye. (*For instance, I am right-handed, so the tip of the eyeliner points left most easily. For the left eye, I begin on the outer corner and on the right eye I begin on the inner corner.*) 3.) Draw across in one continuous fine line. (For thicker lines, retrace.) This has worked for me, but of course whatever works for you is best. Believe me, more than one large bottle of makeup remover has been sacrificed in an effort to teach my mom how to apply liquid liner herself. (Actually, we both used a bottle after she insisted I try it myself to see how hard it was.) Anyway, a simple black liquid line on the eye, with a little mascara and lip gloss, and you'll be off on your own "Roman Holiday."

Kirsty Hume, at left, features a thin line of black liquid liner on both top and bottom. The sides opened with white pencil rimming the eyes and trailing outward. On her lids, she is wearing a green liquid metallic eyeshadow, complemented by a bleached brow and matte brownish-pink lips.

Apply eyeliner as close as possible to (and even into) the lashes, to avoid the white line you get when liner and lashes don't connect.

Rimming the eye with white or beige eye pencil helps to extend the whites of the eyes and has been a favorite of everyone from Marlene Dietrich and Marilyn Monroe to Gena Rowlands and Gwyneth Paltrow.

To apply, gently pull lid away from eye and draw a line along upper and lower inner eye rim.

For easier application, try softening the tip of the pencil by drawing a few lines, first, on the back of your hand.

Kohl-rimmed

This makeup technique has its origins in ancient Eastern cultures, and the name "kohl" itself refers to the black powder used to encircle the eye (photo detail from Jewel *on page 55*). Using a finger from your free hand, gently pull your lid away from the eye. Then, using your choice of pencil (with a tip that's not *too* sharp), apply a line to upper

and lower inner rims, from corner to corner. Next, with your fingertip, sponge-tip applicator or eyeshadow brush, smudge and blend to create a smoky effect. If you like the effect as is, finish with a light application of loose powder to set it. If you desire a stronger effect, follow with your favorite eye color in liquid, creme or powder.

Kirsty Hume, photographed by Miles Aldridge

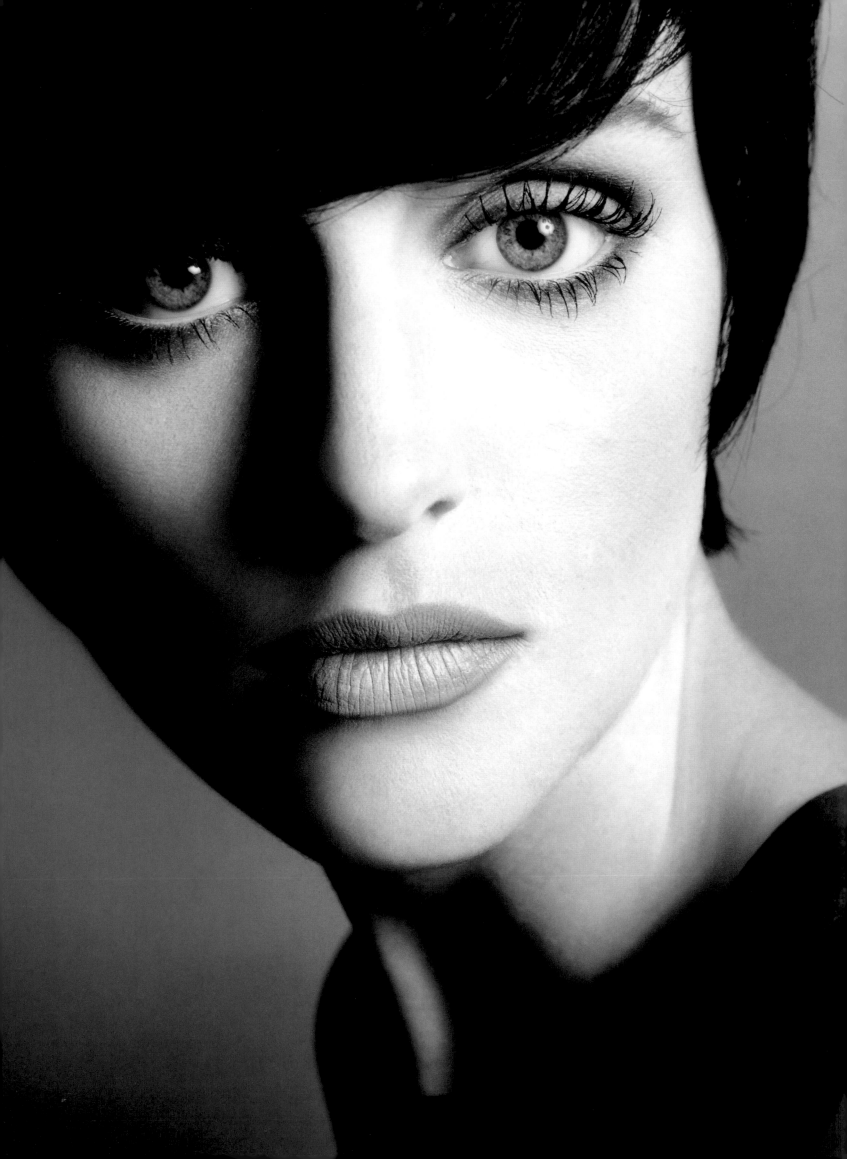

A few simple steps to follow to give your eyelashes that wide-eyed, sparkly look, like Stella Tennant, on the left.

First, put the eyelash curler as close to the base of the lashes as you can get. Squeeze tightly for a few seconds, release and then walk the curler out along the length of the lashes, squeezing as you go. (Don't squeeze in one place too long or you'll give your lashes a harsh right angle.)

Next, with your wand, apply mascara to the base of the lashes. (If you like, you can clean off the wand with a tissue first, to remove any dried mascara, which might clump on the lashes.)

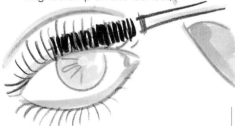

Deposit the mascara by rubbing the wand first from side to side, then brush outward.

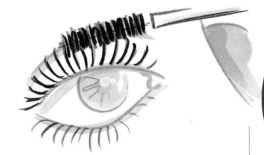

Finally, if necessary, separate lashes with a lash comb.

Stella Tennant, photographed by Miles Aldridge

Curling your lashes is an extremely effective makeup technique. It doesn't involve any superfluous equipment or products. It doesn't hurt (unless you slip and pinch your eyelid) and the change is instantaneous, even if you choose not to follow up with anything else (mascara, etc.). So, why not try it? Curled lashes can make you look awake (and more vibrant) and for women with lashes that grow straight forward or down, it is, literally, an eye-opener. Followed by mascara, the effect is even greater.

Concentrating mascara at the base of the lash root, then sweeping outward and upward, creates a thicker lash look with the ends separated and the base well defined.

Try experimenting with mascara colors other than the usual blacks or browns (*see* Kate Moss *on page 56*) to create different looks. Light colors for floaty, optical effects; bright colors for bold statements.

Pumping air into the mascara tube (to get more product on the wand) *unfortunately* will only dry out the product sooner. Try twirling it around instead.

mascara wand and black mascara

dark-brown mascara

mid-brown mascara

lash comb

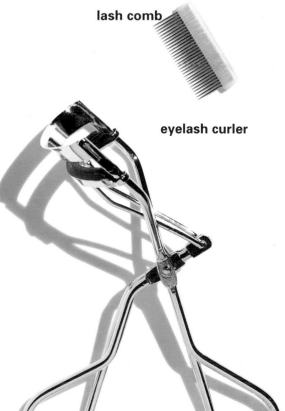

eyelash curler

lashes, continued

Both false and individual lashes are much easier to apply than you have probably been led to believe. Each creates a different effect. Full false lashes add immediate density to the whole lash area. Individual lashes are best when you want to fill in sparse areas or, even better, for creating a fluttery-eyed look, as seen below on Valerie Celis. However, remember this: false lashes tend to be easier to apply, but look less natural. Individual lashes are more realistic looking, but some find them more difficult to work with. Either choice should be followed up with a quick curl (together with the real lashes) and a lick or two of mascara (if you choose to use it).

One of the best ways to conceal a false lash is to first apply a smoky line of color to the base of the lashline. Next, curling your own lashes, slightly, helps to hide the glue. This also helps to keep the lashes from falling and holds them in place.

Applying false lashes

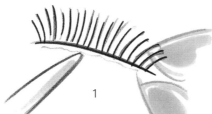

1

Apply a thin line of adhesive to lashband and allow it to become "tacky." (I apply glue using the back of a makeup tool.)

2

Holding the lash hairs (away from the lashband and glue), apply the false lashes as close to the natural lashline as possible, starting at the outer corner of the eye.

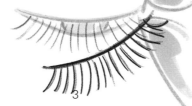

3

Once the outside corner is adhering, work inward, pressing false lashes to lashline until entire band is affixed.

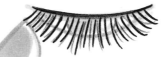

(Be careful not to squeeze eyes shut too hard, until glue is dried.)

False and individual lashes look better (and more natural) if the sizes (small/med/large) are mixed together, with the longest in the center.

Curl and apply mascara to lashes after you've applied false or individual ones.

When applying false or individual lashes, allow the glue to set a moment, or to get a bit tacky, to make them easier to attach.

On Trish Goff, to the right, I used a small pair of scissors to snip away irregularly at the tips of a pair of strip lashes to create a more natural look.

individual (single)

individual (cluster)

bottom lashes

full, false lashes

adhesive

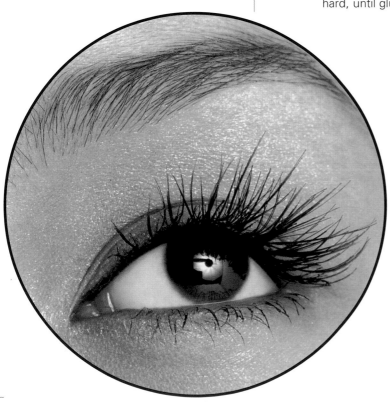

inset, this page, Valerie Celis Trish Goff photographed by Miles Aldridge

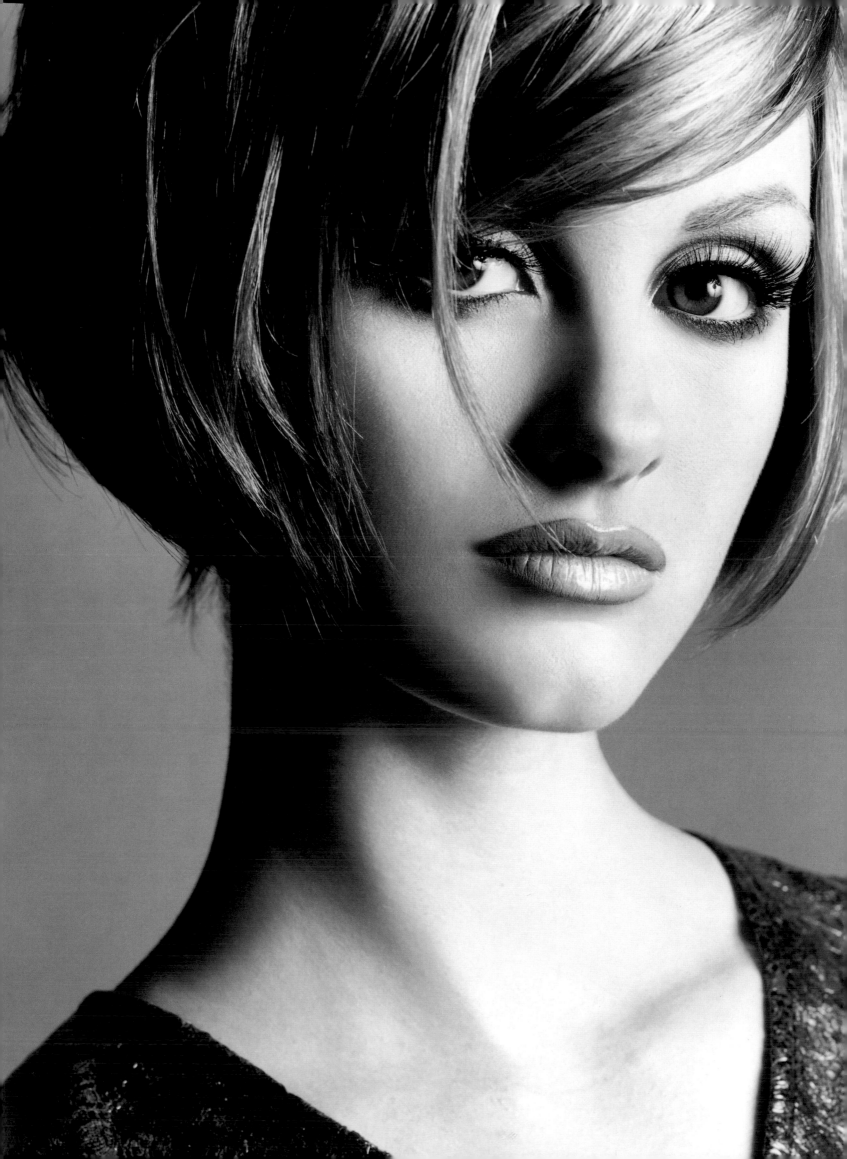

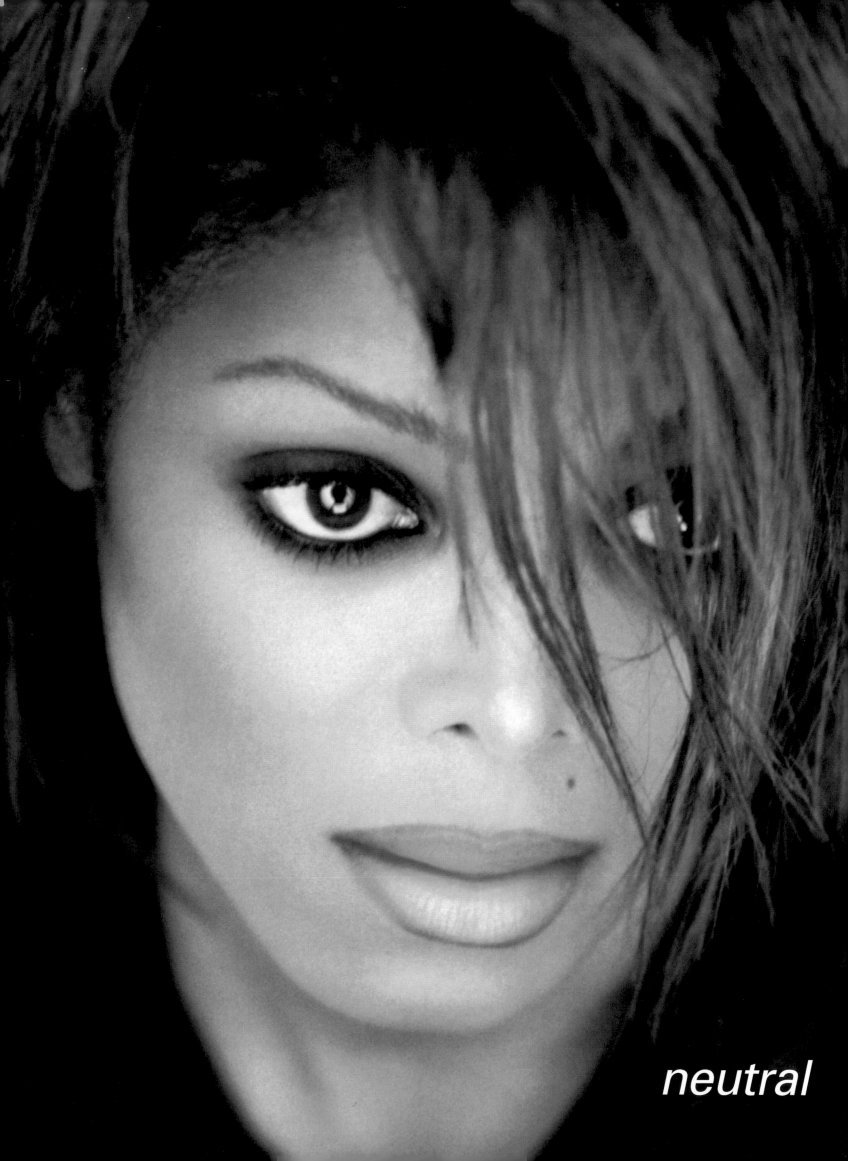

neutral

lips

lip pencils -
light flesh tone
medium flesh tone
dark flesh tone

matte -
sophisticated

creme -
always a popular favorite

sheer -
to let the natural color show through

shiny/glossy -
sexy and v...

metallic -
dramatic and three-dimensional

semi-opaque gloss-
to give a glow and heighten the natural color

clear red -
super-sexy

iridescent -
great for an unreal effect

clear lip gloss -
simple and always effective

lip brush -
a must for accurate shaping of the mouth

Janet Jackson, photographed by Eddie Wolfl

I guess I've always been fascinated with lipstick because of its candy-like appearance. I remember climbing onto our bathroom counter and opening the medicine chest in search of my mom's orange lipstick. Since smells can be deceiving (her tube had a distinct floral scent), I naturally decided to have a bite. The waxy texture yielded not a single iota of orange taste. After spitting out all but what had melted between my teeth, I quickly set about reshaping what was left of her lip rouge. Not realizing quite how delicate the bullet of color was, I suddenly found myself holding the lipstick and the container in different hands. I wish I had a picture of me as my mother entered the bathroom to find everything in sight colored coral. I've learned a lot about lipstick since then, so here are some tips and ideas.

• • • • • • • • • • • • • • •

The mouth is an immediate attention getter and the effect lipstick can have on creating the right mood is amazing. From "erotic" to "demure" the selection of the right product (and shade) can be great fun. Here, on these three pages (42, 43 and 44) I've chosen to highlight eight different textures: neutral, creamy, sheer, glossy, metallic, matte, penciled and stained.

I prefer to use a lip brush when filling in the mouth (it gives me more control than using the tube itself), and I like to "sample" my lipsticks in a box (by colors). I actually break them off and smush them in. This way they appear more like an artist's palette and I can be more creative *and* they're easier to get to!

Make sure your lip pencil is sharpened and of a fairly firm texture in order to clearly define and draw across the small lines around the mouth. Lining the lips will also help to prevent your lipstick from bleeding.

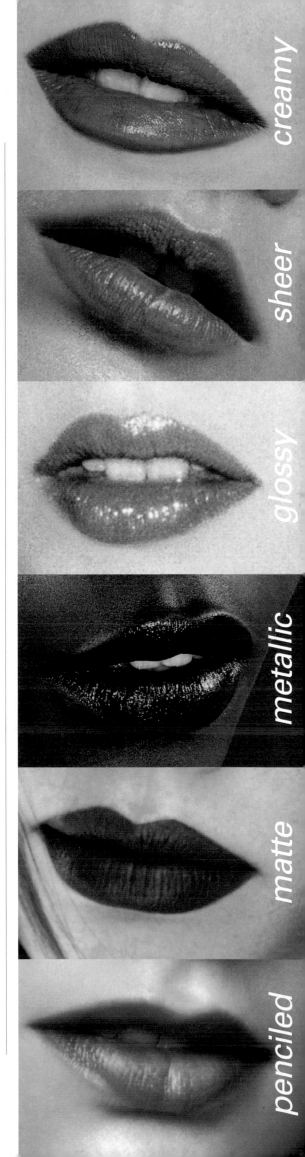

creamy

sheer

glossy

metallic

matte

penciled

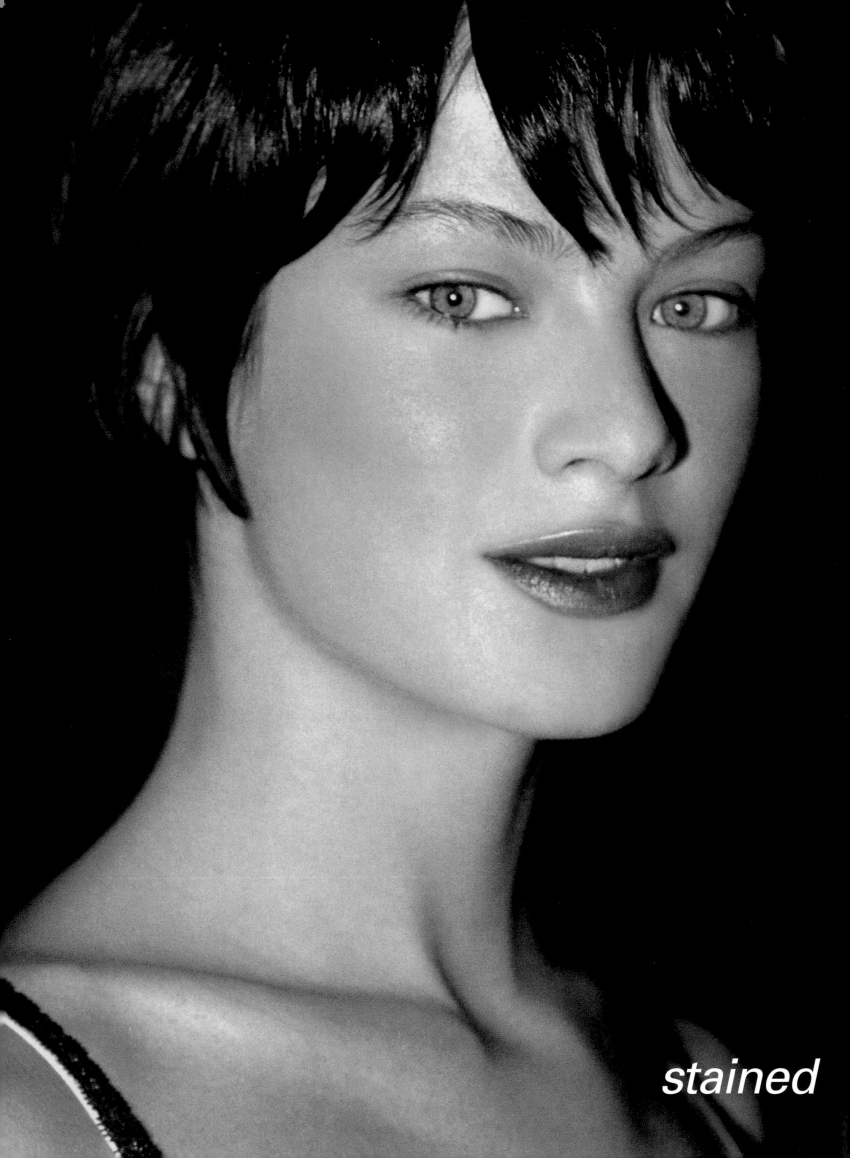

stained

lips, continued

A basic lip lesson

Line the lips, using your choice of pencil, keeping to the natural lip line.

(*If you choose to reshape the mouth, a bit of concealer covering the natural lip line will help make the finished shape look more realistic.*) Then, fill in the entire mouth with the pencil.

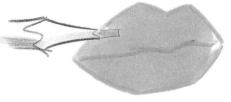

Next, take a lip brush and fill in the entire mouth up to the same edge as the lip pencil.

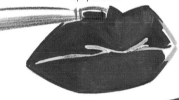

Finally, blot with the single ply of a tissue…

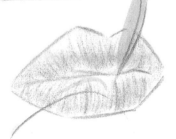

…re-apply and blot again.

A three-dimensional mouth (like the one on Janet Jackson, *page 43*) is created by lining the lip with a pencil darker than the lip color. First, with the pencil, define the lip line and *lightly* fill in the rest of the mouth.) Then, cover the *entire* mouth with the lighter lip color (creamy ones work best), up to the edge of the darker lip line, but staying a hair's breadth away. Next, take a *lighter* shade of gloss or lip color and apply it just to the center and inside of the lip (top and bottom). Finally, blot and re-apply.

Carolyn Murphy, photographed by Eric Sakas

Putting powder over the top of the first coat of lipstick, then re-applying will help it to last longer.

To blot lips more evenly, separate a 2-ply tissue and use one sheet at a time. Blot your lips, then re-apply lipstick, then blot again. This absorbs excess oil and leaves the pigment. Good for your own smudge-proof, long-lasting effect.

Play with the balance of your face by using dark colors on the eyes and light colors on the mouth or vice versa. See how it also changes the proportion of your features.

I personally prefer to line the lips with a neutral lip pencil, even if the lip color over that is a bright shade. This way the finished mouth looks more natural and if the color fades or is "chewed" off, the layer underneath is not a bright orange or red.

Quick tip: When going from your day look to evening, try simply recurling your lashes and adding a stronger lip color.

natural lip
A basic well-rounded and symettrically shaped mouth.

Cupid's bow
Very exaggerated and feminine. Curves drawn inside and out of natural lip lines.

Uni-lip
No peaks on top lip. Full and voluptuous. Very Naomi Campbell *and* Kate Hepburn.

Bee-stung
Takes the name from the look of a real bee sting welt. Very early Twenties.

the Smear
Forties. Drawn outside the peaks on the top lip. Very dramatic, à la Joan Crawford.

"Bonnie Parker"
More a naturally occurring shape than one drawn in. Late Sixties née Faye Dunaway.

Glamour girl
Fifties, all the way. Marilyn would overdraw the top lip to heighten its seductiveness.

a jewel -
for a special eyecatching effect

Blush can bring a glow or the bloom of youth to your face. Coloring is simple, too. Pink and apricot are my favorite colors. Occasionally, I'll use something else for a special effect, but more or less, it is foolproof. And don't just apply it to the cheeks either. A light application of blush, as you see on Amy Wesson below, to the temples, forehead and chin brings the face together. I've found the best way to apply powder blush is to shake (or blow off) any excess from your blush brush first, then sweep it across the areas I mentioned. Liquid or creme blush is best applied before powder. That way it blends in easier and with loose powder over it, it looks like it's coming from within.

> **Highlighting** sticks and lotions come in many shades from warm to cool tones; it's up to you to decide which effect you want to achieve. They can be used all over the face or on specific areas, like the cheek or browbones, to give them a luminous, shapely quality (*for more info, see pages 24 and 25*).

For a special look, try a bit of glitter spray as your finishing touch, like the picture opposite of Adia. The effect is quite exciting and, because of the qualities of the glitter, you get great shadows and highlights. It's also very easy to apply. Just spray it on after your makeup is finished. Special note: It will get on your clothing, so be prepared for a little "pixie-dust" in your life for the next couple of days.

glitter powder -
for that "stardust" look

iridescent liquid -
to create some beautifully subtle highlighting effects, especially on cheekbones and browbones

liquid blush -
for strong, concentrated coloring

> **The** legendary Marlene Dietrich insisted that real gold dust be spilled in her hair for many of her films.

creme blush -
easy to apply and control

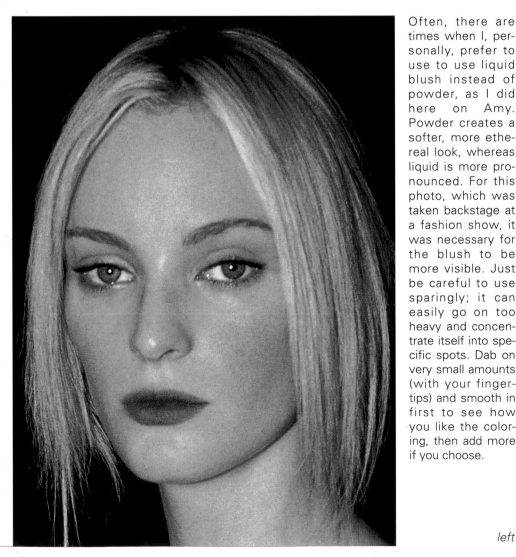

Often, there are times when I, personally, prefer to use to use liquid blush instead of powder, as I did here on Amy. Powder creates a softer, more ethereal look, whereas liquid is more pronounced. For this photo, which was taken backstage at a fashion show, it was necessary for the blush to be more visible. Just be careful to use sparingly; it can easily go on too heavy and concentrate itself into specific spots. Dab on very small amounts (with your fingertips) and smooth in first to see how you like the coloring, then add more if you choose.

mango powder -
for women with darker skin tones, to add a "glow."

apricot powder -
and pink, are my two favorites

large powder brush -
for quick and easy application

left inset, Amy Wesson, photographed by Eric Sakas; right, Adia Caulibaly

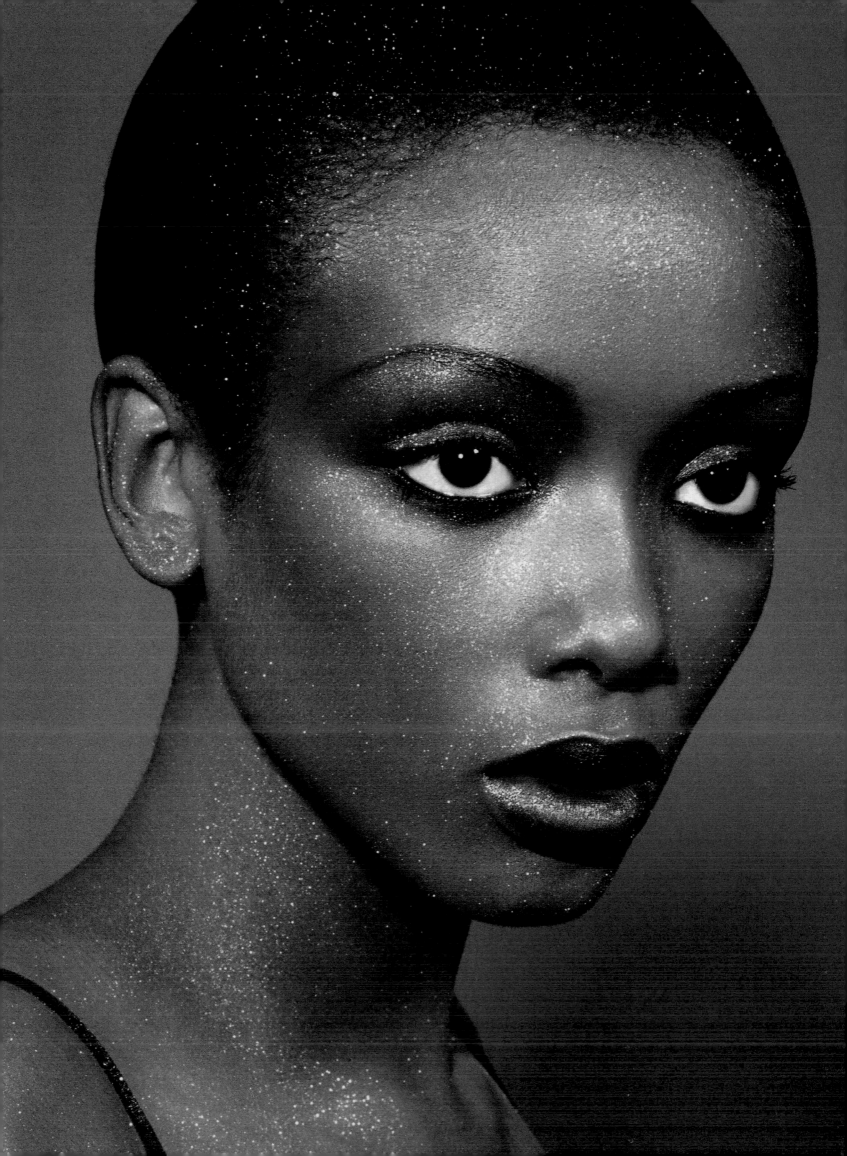

simplicity

Challenge yourself: If you are used to wearing a full face of makeup every day, try the minimal amount you feel comfortable with—and vice versa—if you never wear makeup at all, try a dark lip or smoky eye.

Having covered each feature, one by one, this next section is a selection of different "total" looks. Any of these looks can be modified or altered to suit your personal taste or skin tone. You may choose to intensify or soften the application. Mix different looks together or pick just one aspect of the face that appeals to you. But most of all, have fun.

The first look is all about radiance. Chandra's skin was enhanced using only a small amount of carefully placed concealer and liquid blusher. This approach is the most natural, next to wearing nothing (which is always an option). For those who prefer the un-made-up look, this is a nice option.

concealer and sponge
soft brown creme eyeshadow
sponge-tip applicator
eyelash curler and black mascara
flesh-toned lip pencil
pink liquid blush

1

Carefully apply concealer, sparingly, to even out the skin tone and remove any discoloration or redness.

2

Soft brown creme eyeshadow in the crease of the eyelid (from the inner to outer corner). Blend well.

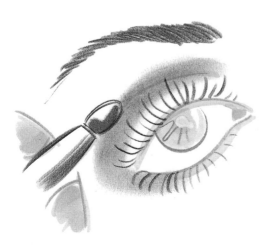

3

After curling lashes, apply a light coat of black mascara. (For this photo, I did only the top lashes.)

4

Apply pink liquid blusher to cheeks, temples, chin and lips.

5

Use a flesh-toned lip pencil to even out the lip shape and fill in softly. (This is optional.)

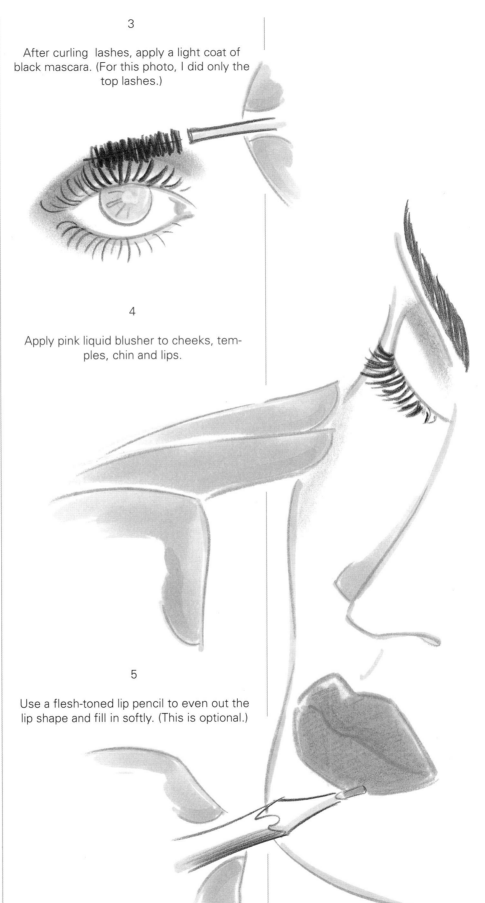

Chandra North

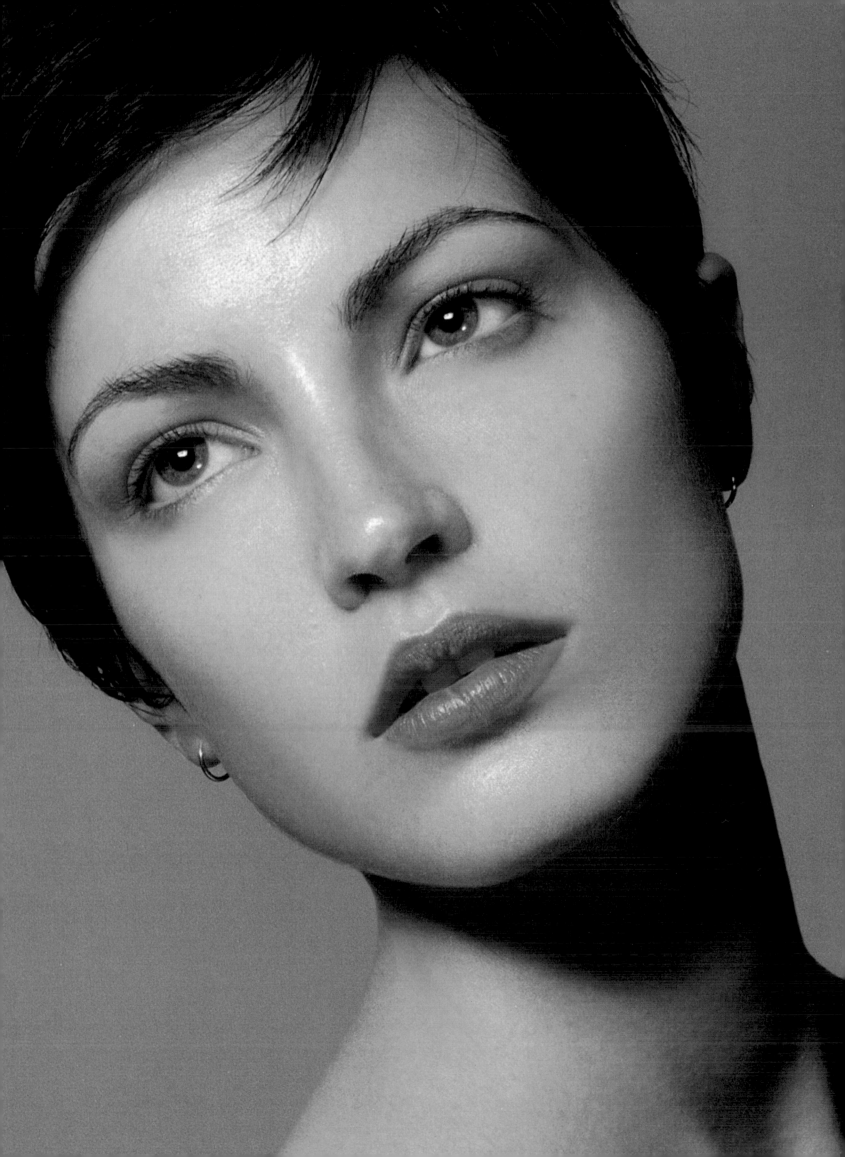

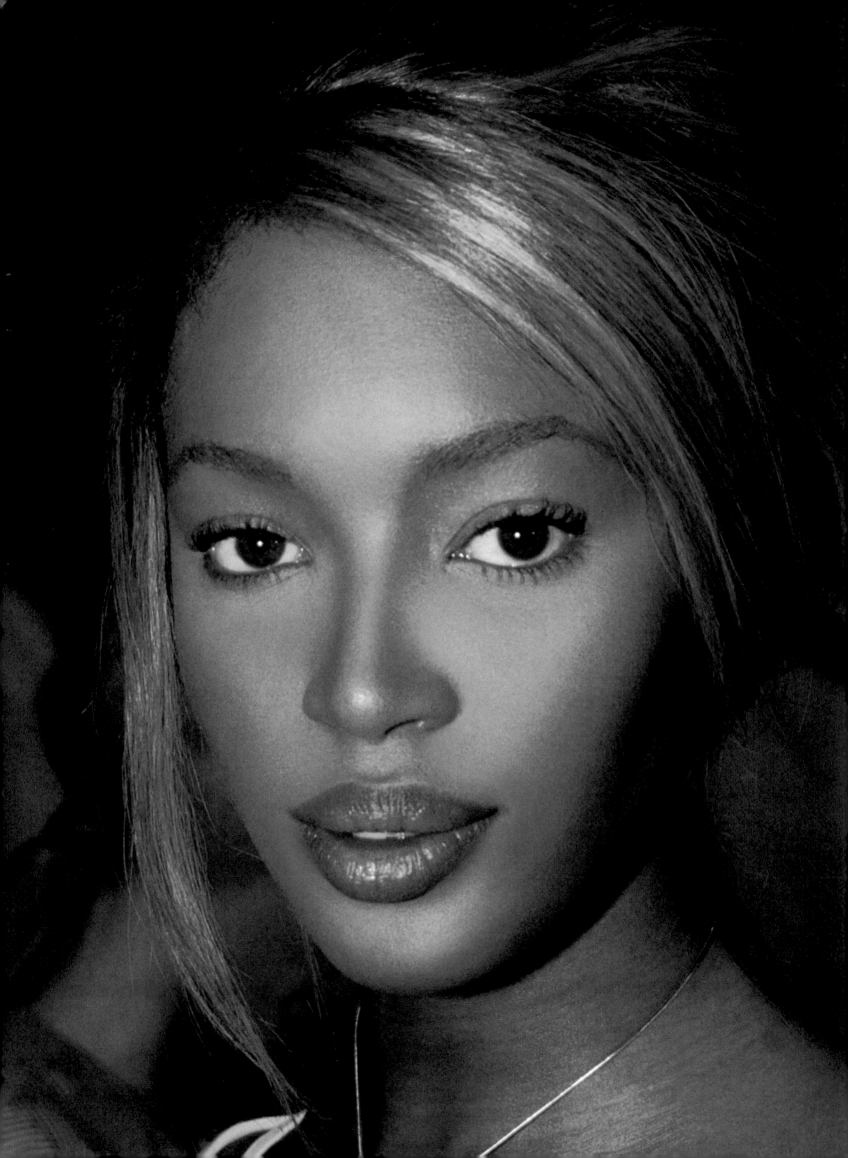

I've always been a big fan of neutral colors (especially for the eyes). Neutral tones are typically light beige to dark brown-based colors and, therefore, are found naturally in the skin. These shades enhance the features when lightly applied, because they tend to resemble your own natural shading and contours. When used with more intensity, neutrals can add drama without adding too much color (if that is your goal). In my opinion, it's hard to go wrong with this look.

Naomi, as you can see, wears neutral makeup extraordinarily well and you can see how the wearer's best features are spotlighted.

warm-toned foundation
face powder and circular sponge
neutral-toned brow pencil
brow brush
neutral brown powder eyeshadow
pale flesh-toned eyeshadow
sponge-tip applicator
eyelash curler and brown-black mascara
apricot blush and blush brush
neutral-toned lip pencil
neutral pinky-beige lip color
(lighter shade) neutral lip color

1

Using the sponge or finger, take your warm-toned foundation and spread (in a semi-circular arc) under the eyes (starting from alongside the nose out toward the cheekbones), around the mouth, the center of the forehead and down the bridge of the nose. All of these areas have now been brought forward. However, in order for this to look natural, blend the foundation well into the skin, making sure there are no distinct lines.

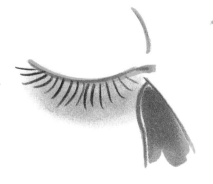

2

With your sponge, apply translucent face powder.

3

Groom the brows, fill in with the pencil of your choice and brush upward.

4

For the eyes, use the sponge-tip applicator to apply a neutral brown powder eyeshadow to the inner eye area, under the bottom lashes and around the outer corner—only slightly on the inner corner.

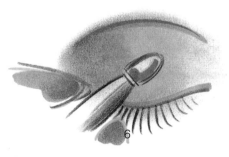

5

Now take a pale flesh-toned shadow and stroke a soft line down the center of each eyelid. Again, blend well.

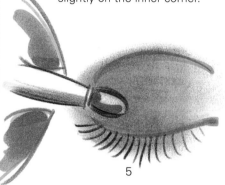

6

Curl the lashes and add mascara to both the top and bottom lashes.

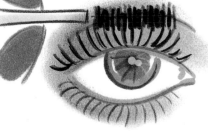

7

With the blush brush, dust apricot blush onto the cheekbones, temples, chin, sides of the neck, and the hairline.

(The previous step, if done lightly and well, adds to the "warming" effect of the makeup.)

8

Using the neutral lip pencil (slightly darker than your skin tone), draw in your lip shape. Fill in with the same pencil.

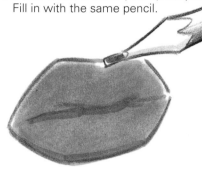

9

Over the pencil, cover with the neutral pinky-beige lip color, just to the edge of the lip pencil (use a lip brush for accuracy). Blot, re-apply, then blot again.

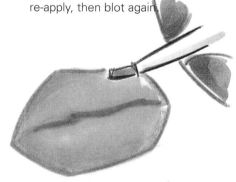

10

With your fingertip, dab the lighter shade of neutral lipstick, just on the center of the lips. (This step creates the illusion of added fullness and the finished mouth is one example of a three-dimensional mouth.)

Naomi Campbell, photographed by Eric Sakas

shimmer

The shimmer face utilizes dewy foundations with iridescent and metallic pencils and cremes. It's also an example of highlighting and shading without the use of typical contouring products. Here, you can easily see where the light hits Jaime's face and those areas come forward because of the reflective qualities of the makeup.

Also, don't necessarily think of this (or any other face) in terms of daytime or evening. It's all a matter of application and desired effect.

concealer (if needed)
liquid highlighting lotion and sponge
pink liquid blush
warm-toned brown eye pencil
burgundy creme eyeshadow
pale beige shimmer powder eyeshadow
eyeshadow brush
eyelash curler and black mascara
burgundy mascara
neutral-toned lip pencil
shimmery pink lip gloss

1

Using concealer (only if necessary), spot-touch the face to even out the skin tone.

2

Apply highlighter lotion to the face with fingertips or foundation sponge. (For this photo, highlighter was added to the neck and collarbone.)

3

Apply a very light application of liquid blush to the cheeks and temples, blending well with the fingers or round sponge.

4

For the eyes, start with the warm-toned dark brown eye pencil. Blend into the upper lashes and smudge with your eyeshadow brush.

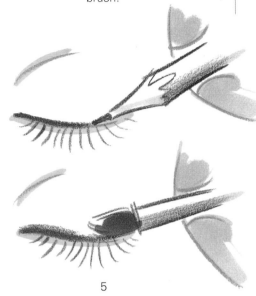

5

Next, the burgundy creme eyeshadow is applied in a circle around the eye with the eyeshadow brush, leaving the dark brown pencil darkest at the lashline. Blend outward in a circular direction.

6

The pale beige shimmer powder eyeshadow is brushed on the brow bone. (Incidentally, no brow pencil was used for this photo.)

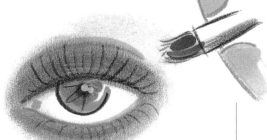

7

Black mascara is then applied to the top lashes, burgundy mascara to the bottom lashes.

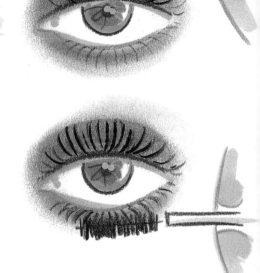

8

After lip pencil is used to define the shape of the mouth, fill in using the same.

9

Shimmery pink lip gloss is then applied as a finishing touch.

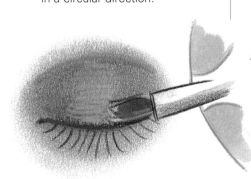

Jaime Rishar, photographed by Michael Thompson

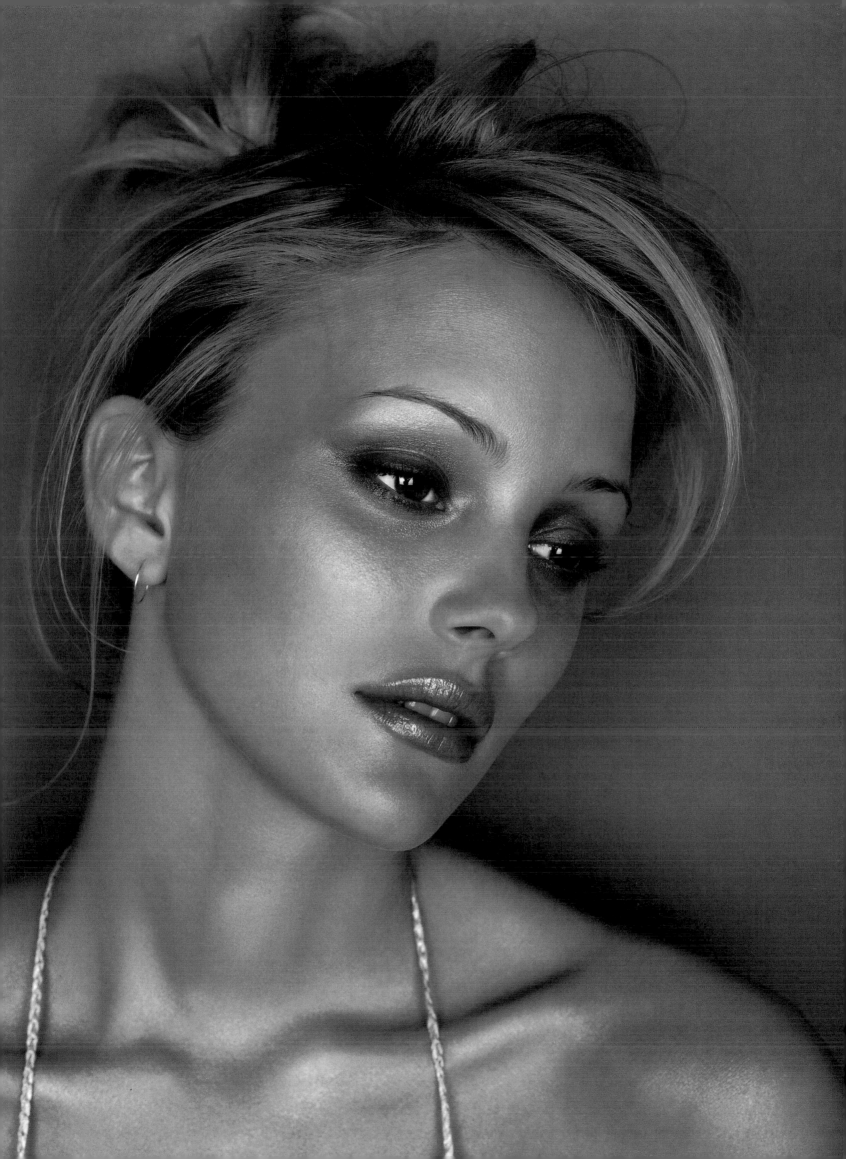

dramatic

When lining the *inner* rim of the eyes, be sure the pencil tip has been blended down a bit. Avoid a very sharp point, for obvious reasons.

This look is simple drama. Very little makeup is used to achieve maximum effect. Here Jewel's smoky kohl-rimmed eyes are the center of attention, amidst a sheer natural backdrop. Often, with such a powerful statement, I balance the face by keeping the lips softer in feeling. That way the face is finished, but other features do not take away from the main focus. (Keep in mind, this can be done in the exact opposite way, by making the mouth the attention getter and complementing with soft eyes.)

Something else to think about: I had decided I wanted to go against type and create a very different look for Jewel, who typically wears little makeup. She was also on a very tight schedule when we got together for this picture, so I only had fifteen minutes to complete the makeup. Luckily, Jewel has flawless skin that was only minimally enhanced.

concealer (if needed)
golden-brown brow pencil
dark brown metallic liquid eyeshadow
kohl black eye pencil
eyeshadow brush
sponge-tip applicator
eyelash curler and black mascara
neutral-toned lip pencil
caramel brown lip gloss

1

Apply concealer only in areas where it is needed.

2

Brows are lightly filled in with golden-brown brow pencil. (This color choice depends on your natural brow color.)

3

Using the eyeshadow brush, lightly apply dark brown metallic liquid eyeshadow to the eyelid and under-eye area.

4

Kohl black eye pencil is applied to the inner upper and lower eyelid rims...

...making sure to smudge into the lashline.

5

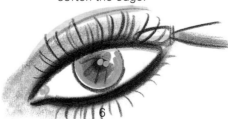

Further smudge black eye pencil with an eyeshadow brush or sponge to diffuse and soften the edge.

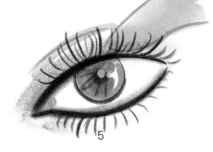

6

Black mascara is applied to curled top and bottom lashes.

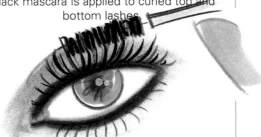

7

After lips are lined...

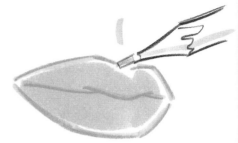

...and filled in with a neutral-toned lip pencil,...

...apply a caramel-brown colored lip gloss.

Jewel

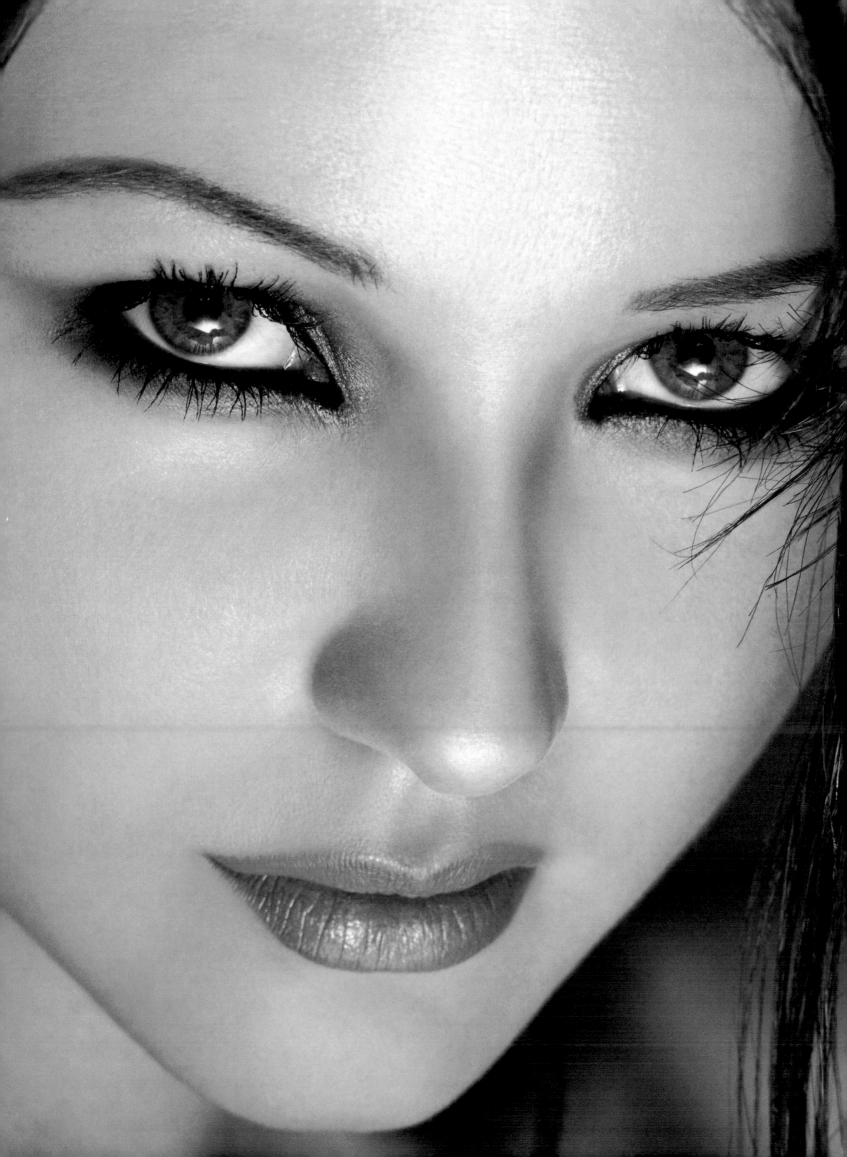

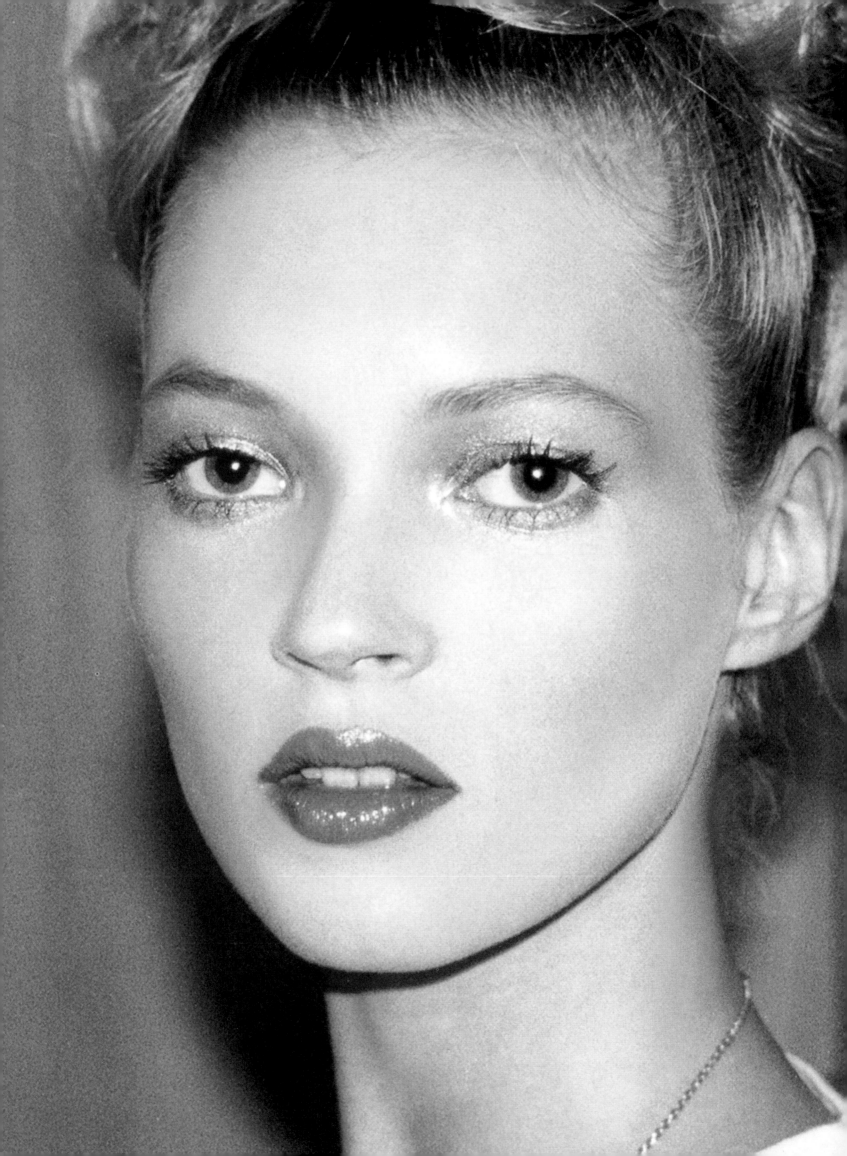

Creme and liquid eyeshadows and blushes will last longer if "set" after with a light application of loose powder.

colorful

Applying color to the face is always an exercise in good editing and product selection. Try less in the beginning and increase as you go along. That way you can see what you are doing and don't have to worry about too much going on too soon.

The colorful face, as seen here on Kate Moss, utilizes three different color shades; green, gold and blue. Most important, though, they have been lightly applied and blended well into the face. Since Kate has such great bone structure, it was necessary that the accents of color never overwhelm or distract from these features.

sheer foundation
pink creme blush
translucent face powder
circular sponge
brow brush
turquoise blue eye pencil
metallic green liquid eyeshadow
metallic gold liquid eyeshadow
eyeshadow brush
eyelash curler and black mascara
turquoise mascara
flesh-toned lip pencil
clear red lip gloss

1

Sheer foundation all over the face.

2

Creme blush is used on the temples, blending *down* onto the cheekbones, using your fingertip.

Kate Moss, photographed by Eric Sakas

3

Loose face powder, sparingly applied with a powder sponge, all over the face.

4

Here, no pencil was used, but the brows were brushed.

5

Use the turquoise blue eye pencil to line the inner rim of the eye, top and bottom.

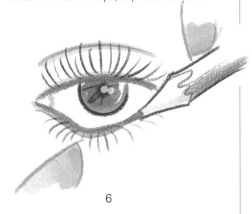

6

Liquid metallic green eyeshadow is "washed" in a circular motion over the eyelid and onto the under-eye area, using an eyeshadow brush. (Make sure to blend well, so that the eyes "fade.")

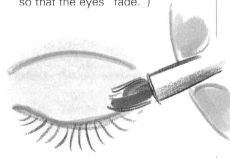

7

Gold metallic liquid eyeshadow is applied to the center of the eyelid and blended in with brush. With the remainder, wipe over the edges of the metallic green, for an even more graduated look.

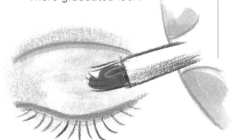

8

Black mascara is applied to curled upper lashes and turquoise mascara to bottom lashes.

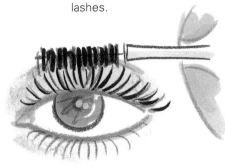

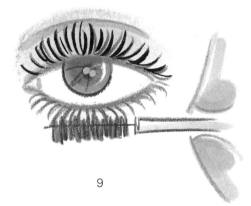

9

Using a flesh-toned lip pencil, shape and fill in the mouth,…

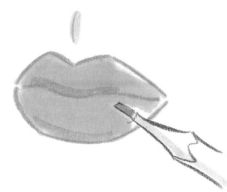

…followed by an application of clear red lip gloss.

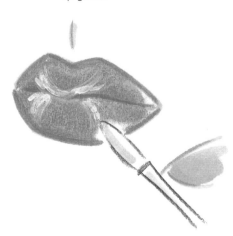

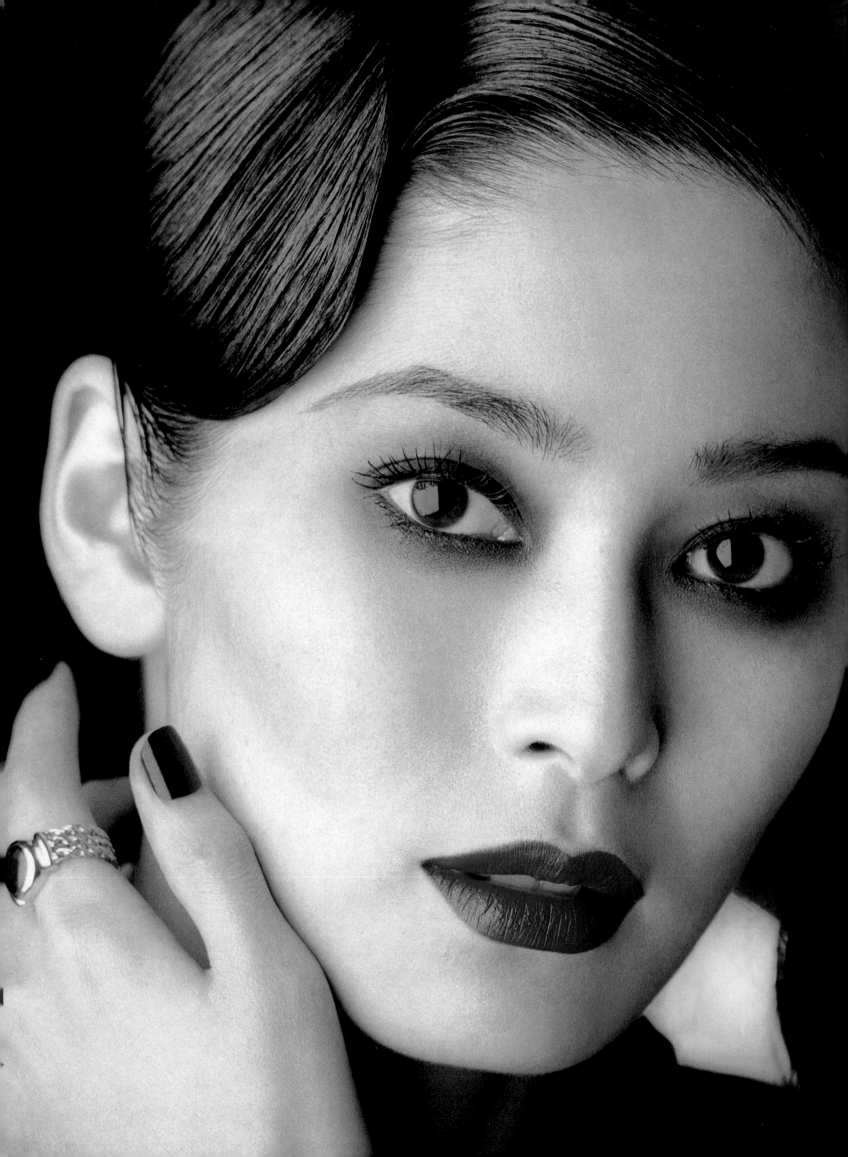

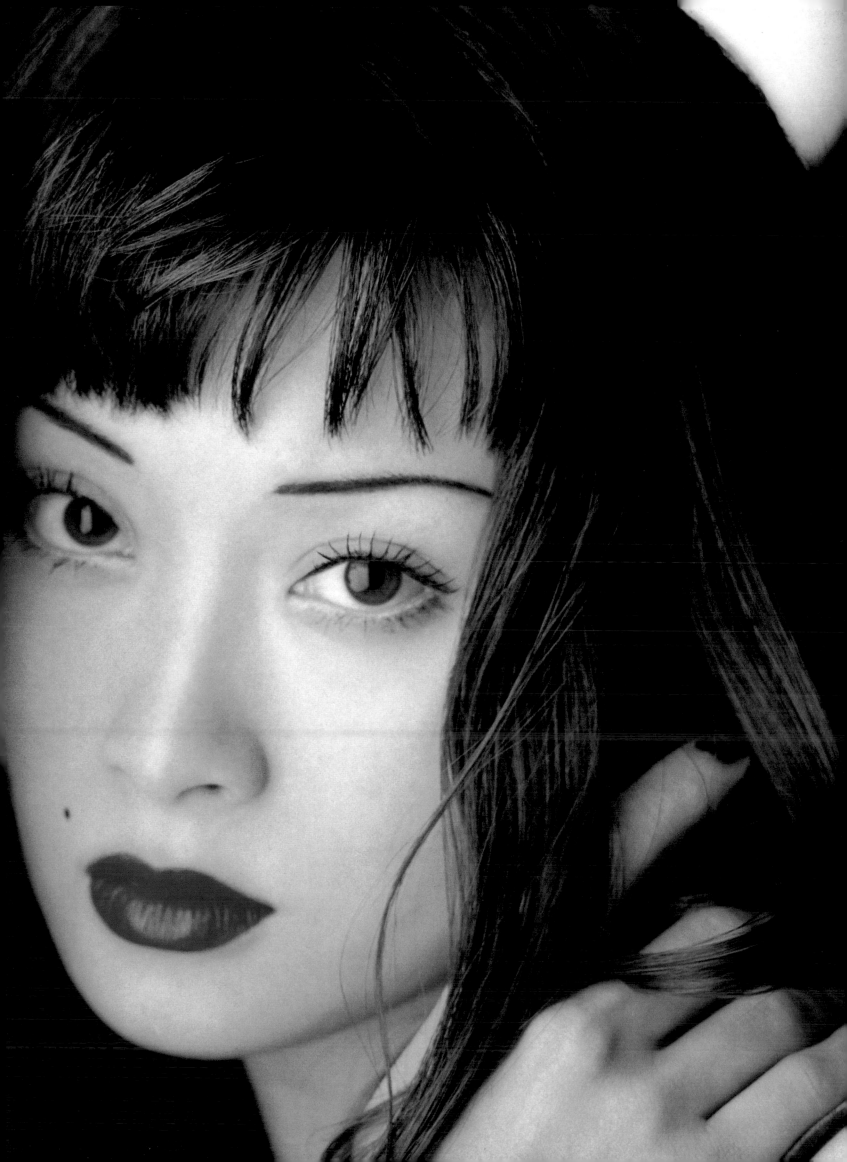

glamorous

The preceding are two versions of the Glamorous face. While there are a million ways to define glamour, I chose to go with two that reflect different sides of the same coin. Both have classic red lips, with Shinya's featuring smoldering eyes and Masako's with a light, golden eyeshadow, emphasizing the lashline and 1930s-thin eyebrows. Each look has its own appeal, while both are decidedly glamorous.

Shinya

concealer
face powder and circular sponge
black brow pencil
black eye pencil
smoky-black powder eyeshadow
smoky-gray powder eyeshadow
sponge-tip applicator
eyelash curler and black mascara
soft pink powder blush and blush brush
natural-colored lip pencil
bluish-red creme lip color and lip brush

Hooded Eyelids

To add depth, apply dark shadow along lashline and curve upward at the outside corner, aiming toward the beginning of the eyebrow and lightly under the eye.

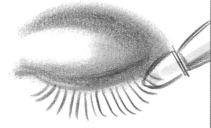

The shadow is darkest on the outside and fading toward the brow. Pale shadow is placed onto the lid and brow bone, bringing these areas forward.

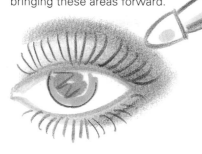

1

Apply concealer (where needed) and apply loose face powder with circular sponge.

2

Apply brow pencil, lightly feathering the natural shape of the brow.

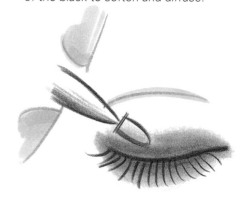

3

Black eyeliner pencil is applied to the lower and upper inside rims of the eye, then smudged into the lashes.

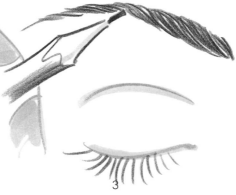

4

Smoky-black eyeshadow applied with the sponge-tip applicator, over the just-smudged eye pencil.

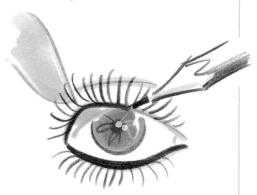

5

Smoky-gray eyeshadow applied to the edge of the black to soften and diffuse.

6

Loose powder is applied to the edge of the gray to soften and diffuse it.

7

Curl lashes and apply black mascara.

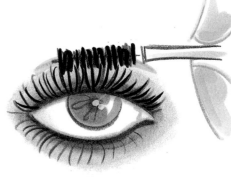

8

Soft pink blush on the cheeks.

9

Natural-colored lip pencil applied to the lips, squaring-off the bottom lip and rounding the upper. Then fill in with the pencil.

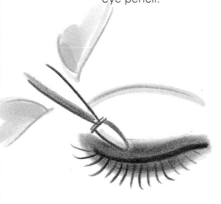

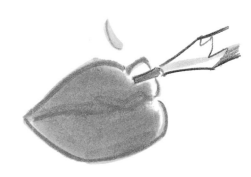

preceding pages, Shinya and Masako Mori, photographed by Kei Ogata

10

Over the pencil, apply a blueish-red lip color, then blot. Re-apply and blot again.

Masako

tweezers
dark brown brow pencil
concealer (if needed)
face powder and circular sponge
golden-brown powder eyeshadow
sponge-tip applicator
black eye pencil
white eye pencil
eyelash curler and black mascara
hot-pink powder blush
true-red lip pencil
true-red lip color
lip brush
black liquid eyeliner

1

Tweeze the eyebrows to create a pencil-thin line that has the appearance of going upward. Then fill in with dark brown brow pencil.

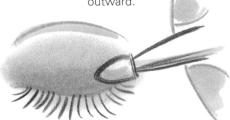

2

Apply concealer (where needed) and loose face powder with the sponge.

3

A golden-brown eyeshadow is applied darkest nearer the lashes, then blended outward.

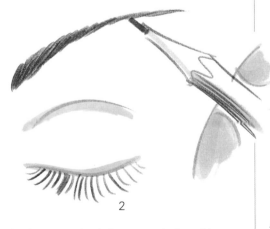

4

Black eye pencil is used to define the lash-line, but only slightly smudged. (The pencil is used only to define the lashline and make the lashes look thicker.)

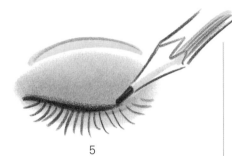

5

White eye pencil is used inside the eyelid (on the rims) to "widen" and "open-up" the eye, for an innocent doe-eyed look.

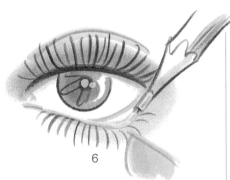

6

Lashes are curled and black mascara is applied to both top and bottom.

7

Hot-pink blush is used sparingly on the cheeks, temple and forehead.

8

Apply a true-red lipstick and pencil to the lip. Blot, re-apply and blot again

9

The finishing touch: a beauty mark applied to the cheek, using black liquid liner.

• • • • • • • • • • • • • • • • •

I've always been drawn to Eastern beauty. Being a tall and skinny, blond-haired, blue-eyed white boy from the South, I dreamed of black hair, upturned eyes, and high cheekbones. While I may have been unusual, I was far from exotic. Interestingly, while traveling back and forth to Japan for quite a few years now, I've met many Asian people who desire blond hair and more height. (Then I wanted to be Hispanic, but that's another story.) It seems the world over, people want to see what it's like to be in another person's shoes. I think that that attitude, blended with a healthy dose of self-acceptance is a wonderful combination—happy to be yourself, yet eager to see the world from another perspective. Realizing from early on that people sometimes have extreme feelings about makeup, my friends and I would try different looks to see how they reacted. It was amazing how easy it was to provoke, disturb, frighten, soothe, and attract based solely on appearance. I guess that's just another reason why I love make-up. Being able to convey your mood or attitude through something that you can wash off is amazing to me. So now I look at Eastern beauty with adoration and not envy. You see, now I can be Japanese one evening and Spanish the next, with just a little makeup application.

• • • • • • • • • • • • • • • • •

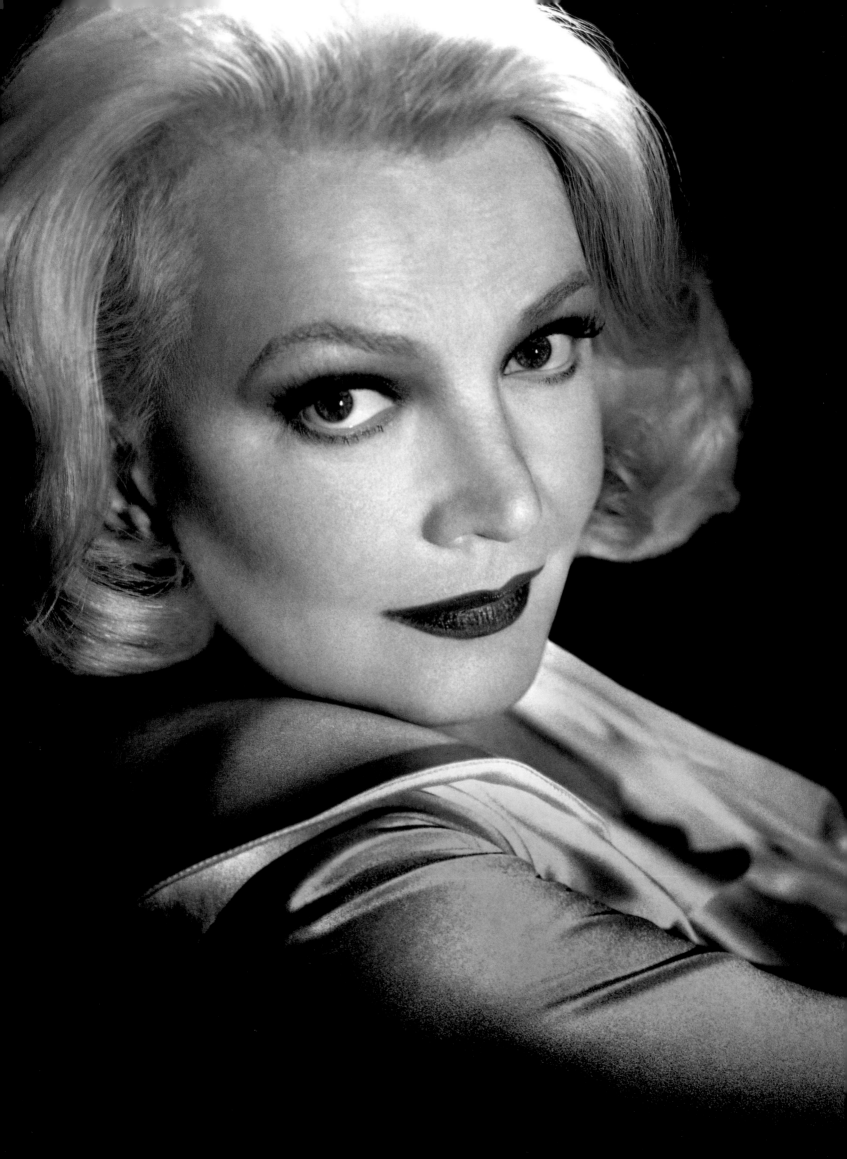

Light-colored clothing helps to reflect light up onto the face.

The word "defining" means to set down boundaries, delineate or trace outlines. Literally, then, the defining face takes this definition and applies it directly to main facial features such as eyes, mouth, cheek, brows, and so on.

This is a consistently popular makeup look, and its "modern" origins can be traced back to the late Forties and early Fifties, when black eyeliner, arched brows and a perfectly shaped red mouth were absolutely *de rigueur*. Today's version, on timeless beauty Gena Rowlands, is updated yet captures a moody elegance.

I confined the defining techniques to two specific places, the lips and the eyes, with a softer application given to the brows and cheeks.

concealer (if needed)
loose face powder and circular sponge
golden-blond brow pencil
golden-blond powder eyeshadow
sponge-tip applicator
black eye pencil
eyeshadow brush
neutral shimmer powder eyeshadow
eyelash curler and black mascara
soft rose powder blush
blush brush
flesh-toned lip pencil
red creme lip color

1

Concealer should be applied sparingly under the eyes and *only* to even out the skin.

2

Loose powder is delicately applied with a sponge (being careful not to use too much) so the skin looks smooth but not dry.

3

Golden-blond brow pencil was used here to accentuate the brows. (Use a color that works best with your own brow color.)

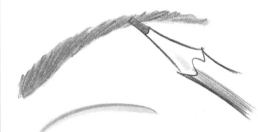

4

Golden-blond eyeshadow is applied "smokily" with a sponge-tip applicator over black eye pencil that is used to line the upper lashline. (Be sure to smudge into lashes.)

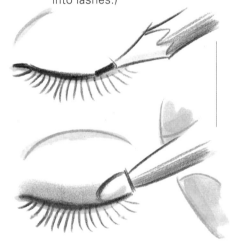

5

With a shadow brush, blend the powder shadow up to the crease of the eye and slightly beyond. Use the remains of the shadow on the brush to lightly emphasize the under-eye area.

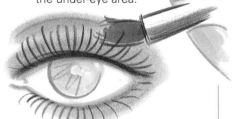

6

Shimmery, neutral shadow is applied to the browbone to separate the eye from the brow, a technique that, in and of itself, helps to define both features.

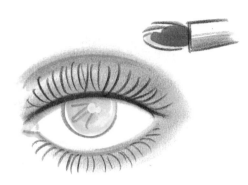

7

Black mascara is applied to curled lashes, top and bottom, heaviest at the base of the lash.

8

Soft rose powder blush is swept over the cheeks and temples to give warmth.

9

Lips are lined with a flesh-toned pencil and filled in with a creamy red lipstick, blotted and re-applied.

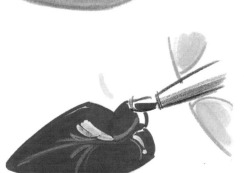

Gena Rowlands

Soft tones in makeup are complemented by warm tones in hair and clothing.

Where the defining face uses "true" colors like red and black to accentuate the features, the softness face does much the same but uses off-tones and shades of these products to give a "softer" effect.

So instead of a vibrant red lip color on the mouth, red lip gloss was used instead. Burgundy-brown eyeshadow was used in place of a neutral brown or black and pink blush was substituted with warm apricot.

The result, as seen here on the ever-fabulous Tina Turner, is a fresh look that takes advantage of the use of color while not overpowering the face and still defines the features without exaggeration.

liquid foundation
concealer (if needed)
warm apricot creme blush
burgundy-brown creme eyeshadow
eyeshadow brush
translucent face powder
circular sponge
golden-brown brow pencil
eyelash curler and black mascara
clear red lip gloss

1

Liquid foundation is applied to the center of the face and blended outward.

2

In this photo concealer was spot-applied to the under-eye area.

Tina Turner

3

Creme blush in a warm apricot color is smoothed onto the cheeks, temples and chin.

4

Burgundy-brown creme eyeshadow is applied with an eyeshadow brush, encircling the eye. (Apply over the entire lid, into the crease and blended outward.)

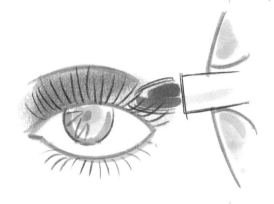

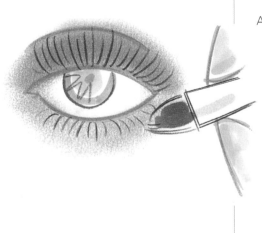

5

Loose face powder is applied over the entire face using a sponge.

6

Brows are brushed upward and filled in with a golden-brown brow pencil.

7

Lashes are curled and black mascara is applied to the top and bottom lashes.

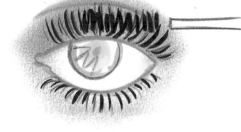

8

As a final touch, the lips are covered only with a clear red lip gloss.

classical

The classical look is one that I see many women wearing—very little or no foundation, red lips, and mascaraed eyes. The roots of this go back to the first women who ever "rouged" their lips, to Marilyn Monroe, up to this modern version on Chandra North. This look is very easy to do, but still gives the face a finished look.

oatmeal scrub (optional)
light moisturizer (optional)
brow brush
clear gold liquid shimmer eyeshadow
eyeshadow brush
eyelash curler and black mascara
lip pencil (to match natural lip color)
matte red lip color

1

(Optional)
For this photo, Chandra's skin was lightly scrubbed (with oatmeal scrub) before the picture was taken, giving her a fresh, healthy glow. That was followed by a light moisturizer on the entire face.

2

The eyebrows are brushed first upward, then downward at the ends.

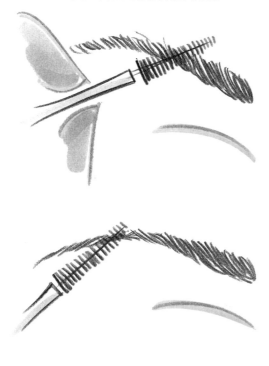

3

Clear gold liquid shimmer eyeshadow is "washed" on the eyelid with the eyeshadow brush.

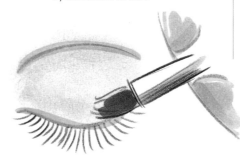

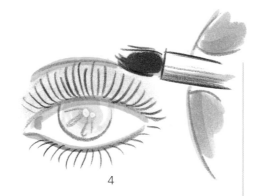

4

Lashes are curled, and black mascara is applied to *top lashes only*.

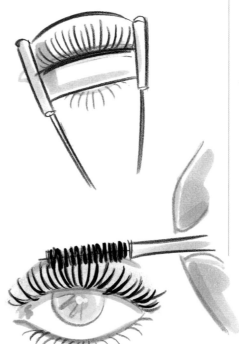

5

Lip pencil (here in a tone that matched Chandra's lips) is used to define the lip shape and fill it in. This is followed by two applications of matte red lipstick...

...and blotting with a *single ply* of tissue to help set the color.

Chandra North

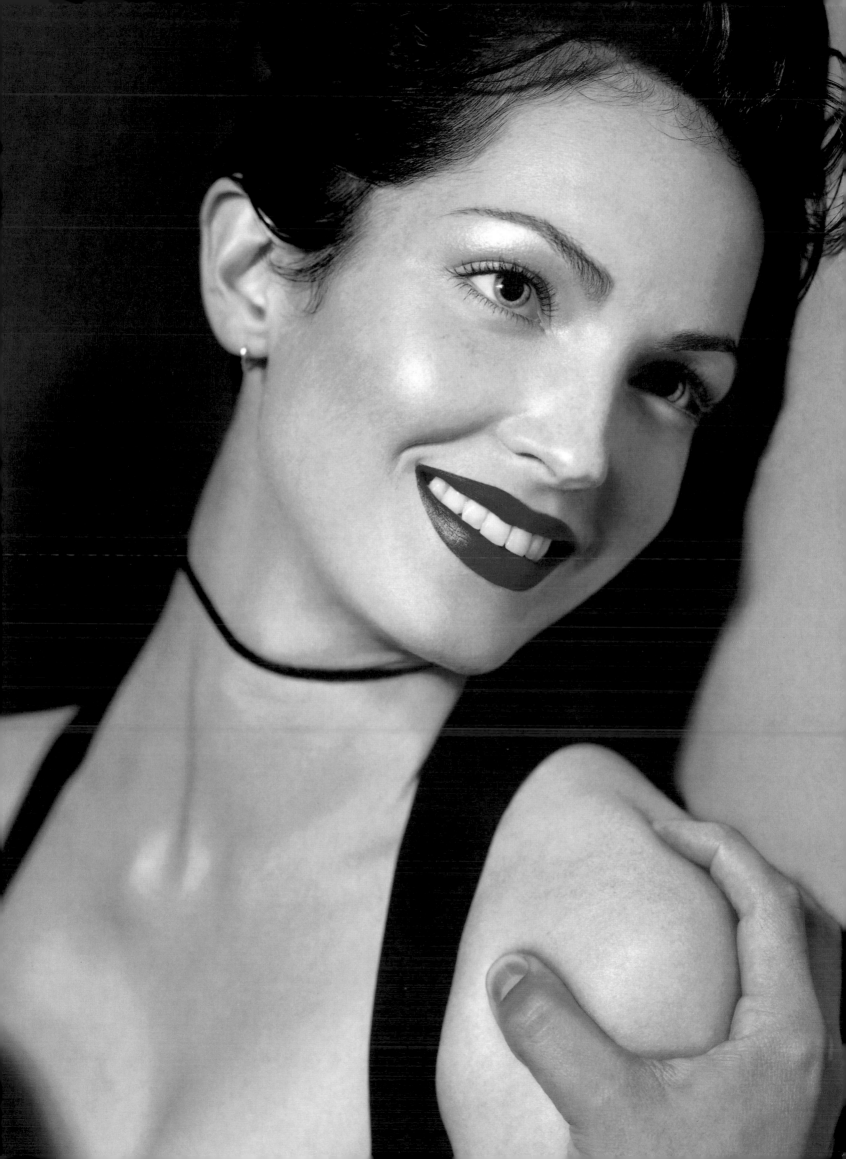

sensual

These modern-day Valentinos, Richard Elms and Gregory St. Cerin, are two of the sexiest men around. Featuring looks that take only two to three minutes to accomplish, they exemplify, to me, the modern male. Insecure men, who are unsure about their own masculinity (or homophobic) may find the idea of eyeliner just *too* threatening. But those, like Richard and Gregory, who are comfortable with who they are, find this (not revolutionary at all) idea to be an exciting option.

black eye pencil
eyeshadow brush
lip balm or moisturizer
loose glass jewel (optional)
black tulle or netting (optional)

1

Black eye pencil is applied to the inner eye rim (both upper and lower). Remember, this takes practice, so take your time.

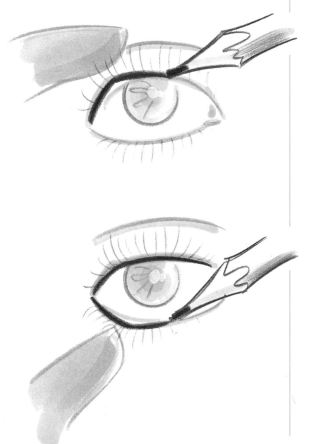

2

Squeeze eyes shut several times. This will distribute the eye pencil outside of the lashline (in a messy-looking, less intentional sort of way).

3

Using (preferably) a round eyeshadow brush, blend in for an even smokier effect. (If you can't get hold of a brush, your fingertip should do just fine.)

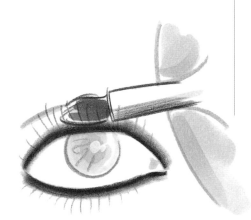

4

Then lip balm is used to give the mouth a moist and sensual look and feel.

5

(Optional)
As a finishing touch for this photo, a clear glass stone was placed on the center of Richard's forehead, using a small drop of lash adhesive. For Gregory, black net was trimmed in the shape of a veil and knotted, at the back of the head.

Richard Elms and Gregory St. Cerin

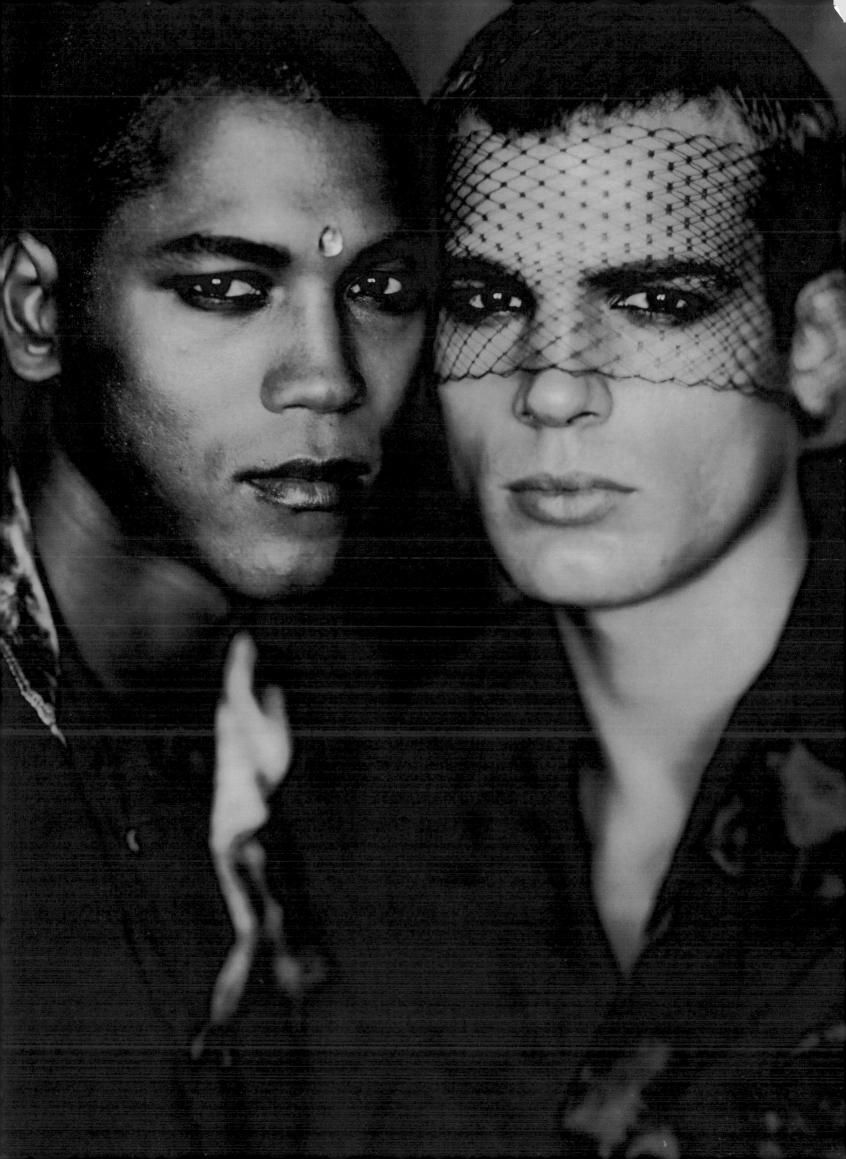

a gathering

Some of my earliest makeup experiences were with my friends in school who weren't cheerleaders or the "popular" ones. Their beauty was so clear to me, yet they were constantly comparing themselves to the "prom queen" or "football hero." (In my school you had to be white, blond, wealthy, and obnoxious to be popular.) Some of my friends had given up on any kind of self-care, feeling that they were hopeless cases. This only fueled my determination to explore, examine, and try to understand the baffling world of beauty.

While I could appreciate the typical All-American "perfect" faces, it was women like Barbra Streisand, Karen Black, Cher, Bette Midler, and Tina Turner who were my beauty ideals. My mission became to help my friends realize their own uniqueness and specialness. Makeup became one of my favorite tools. Sometimes we aren't very objective about ourselves (it took more than seven years of therapy for me to stop thinking I looked like the "Elephant Man") and a supportive and loving friend can often reflect back all the beauty that can sometimes be so hard to see in ourselves. Our physical self is only a part of our being, so, of course, we need to keep a balanced view of its importance.

The "before" pictures show where we started and how changing your hair color, eyebrows and/or makeup can help you achieve a different look. They were taken with the instructions "to dress and make yourself up the way you normally look" and that's what everyone did. Meeting and working with these people was one of the most rewarding experiences I've ever had. Every face tells a story, and to be a good makeup artist, designer, photographer, stylist, or hairdresser, I believe you must be able to "read" the person before you. While it is impossible to completely cover the endless varieties of human skin tone, bone structure, size, and makeup looks that are possible, I tried to select as diverse a group of people as I could. Most came in with a very open mind about what their "look" would be, while some wanted to look "glamorous," "sexy," or "softer." By the way, nothing extreme (such as taping) was done to effect any of these looks. Happily, once the sittings were over, more than one told me that they saw themselves in a whole new way, even without the makeup. Remember that any of the looks in this book can be adapted to any face (with adjustments to suit your own personal taste and style).

"Contact Sheets," photographed by Billy Jim

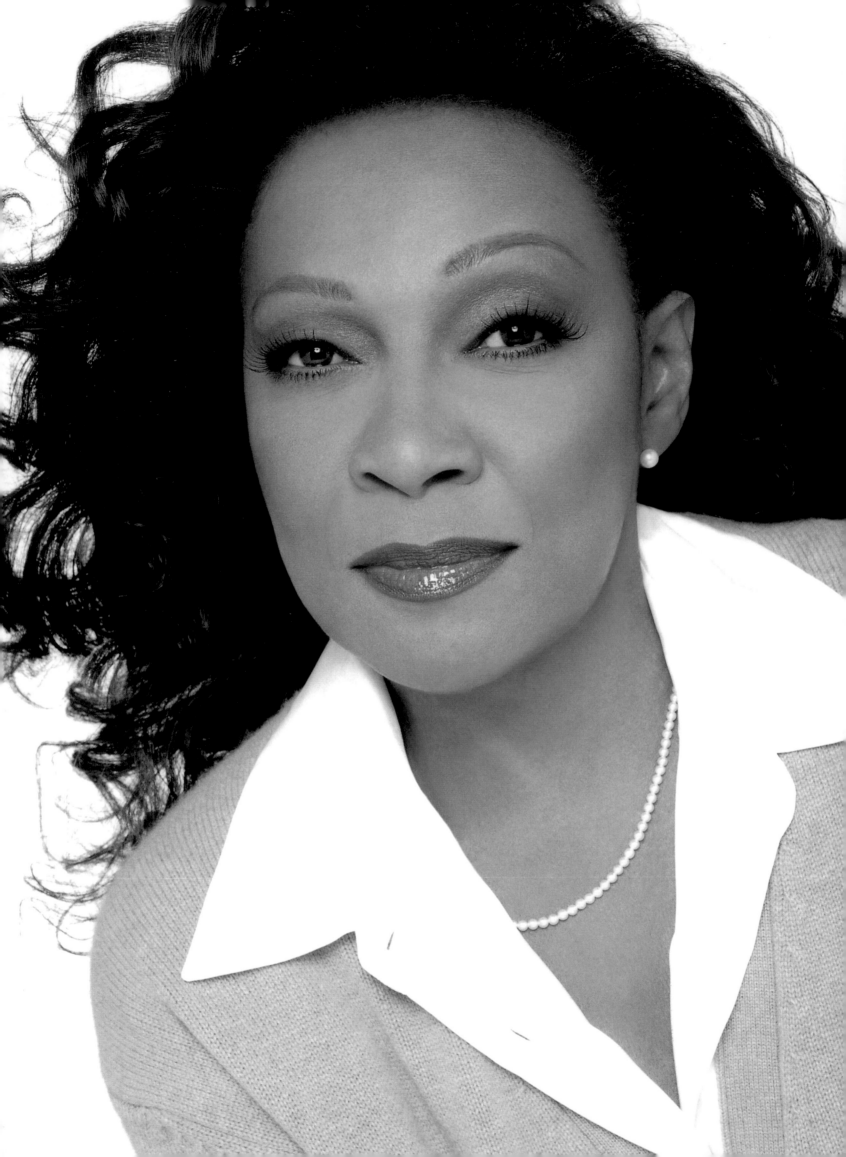

When Sandy walked into the studio, she radiated an enormous life force, and over the next few hours she astonished everyone in the studio. She told us stories about her brother Leopold, creating elaborate hairstyles and makeup looks for her in the Sixties and Seventies, until her son Gregory came along and followed in his footsteps. Sandy told me that her brother had once used so many hairpieces on her head that she literally fell out of a cab and couldn't get up. Then there was the time that Gregory had gone to Paris and spent so much of his money to buy his mother clothes that he had to call her for a money order so he wouldn't get thrown out of his hotel. She recalled how lucky she was to have a son and brother who were also her best friends.

That is why she explained this portrait was so important to her. "This is a tribute, you know, to my son and brother," she said. "I lost both of them to AIDS this year."

When the makeup was finished, she began to cry, wishing that Gregory could have been here to see his "glamorous" mother. Looking in the mirror, she laughingly said, "My brother might have made the hair bigger, but then I might end up on the floor again!" At the end of the shoot, Sandy looked at the Polaroid, smiled and said, "I'm sure Gregory and Leopold are up there smiling with joy."

Sandy has a regal countenance and stature that really shows through in this picture. I chose to enhance the structure of her face with a makeup application that would display her great dignity and strength. I really wanted to bring out her soulful eyes. I began by tweezing her brows, then filling them in. Next, I defined her lashline with a dark brown shadow, carrying it into the crease to draw attention to her beautiful and ample eyelids. The lips and cheeks were emphasized, but were deliberately a step below in intensity to her *expressive* eyes.

tweezers
chestnut-brown brow pencil
brow brush
concealer
warm-toned foundation and sponge
tissue
translucent face powder
circular sponge
medium brown powder eyeshadow
eyeshadow brush
dark brown powder eyeshadow
light golden-brown powder eyeshadow
black powder eyeshadow
sponge-tip applicator
light beige eye pencil
full false eyelashes with adhesive
midneutral-toned lip pencil
golden lip gloss
soft pink powder blush and blush brush

Sandy Franklin

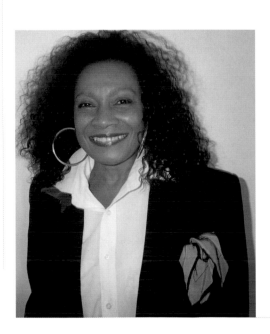

1

First, I groomed the brows, taking care to pare away the "heaviness" from the center of the eye area. (By shortening the brow at the beginning of the eye, the eyes were given a lift and the face a more serene look.)

2

I then filled them in with the chestnut-brown brow pencil, shaping gently. Running a brow brush over the freshly penciled area created a softer-looking application.

3

Concealer was applied with my fingertip to just around the mouth and under the eyes to even out the skin, and along the center of the nose to create a highlighting effect. (Sandy has natural shading that creates a dark semi-circle on the upper sides of her nose. Evening this out allowed her eyes to become the center of attention.)

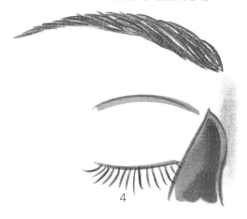

4

Next, I lightly applied warm-toned foundation to the face, being careful to blend into the jawline.

5

Using tissue, I blotted her skin to absorb extra oil. This also allows the pigment to get into the skin.

6

Then the foundation was set with translucent face powder, making sure to carefully blend under the eye right before powdering.

7

Medium brown powder eyeshadow was then applied with a shadow brush to the outer half of the lid and brushed inward along the natural crease of the eyelid.

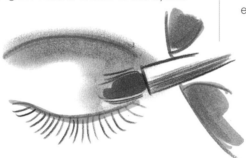

8

Then a darker brown eyeshadow was applied to the eyelid as close to the lashline as possible and extended slightly outward.

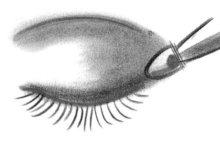

9

Then the same medium brown eyeshadow was stroked lightly along the bottom of the eyes.

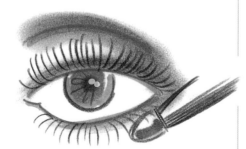

10

Next, a light golden-beige shadow was used to softly highlight the browbone and inner half of the eyelid. (This heavy-lidded shape can create a sophisticated, sexy look.)

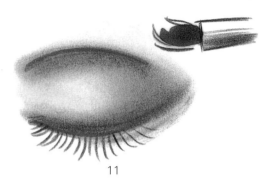

11

I then lined the inside bottom rim of the eyelid with a light beige eye pencil, which helps to "open" and clean up the eye.

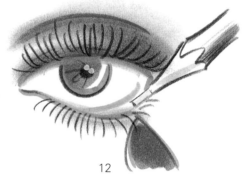

12

Black eyeshadow, applied with the sponge-tip applicator, was used to line the upper lashline. Smudging upward using the same application can create more definition and a thicker lash look.

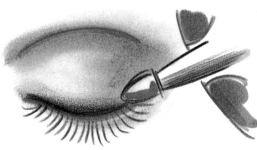

13

Eyeing a pair of false eyelashes on the makeup table, Sandy asked if I would consider using them. I, not being one to stand in the way of glamour, happily complied.

14

Sandy's smile was emphasized with a mid-neutral-toned lip pencil applied over the entire lip.

15

Next, I added only a bit of golden-colored lip gloss (no actual lip color was necessary) just to the center of the mouth to enhance its fullness.

16

A light dusting of warm-toned, soft pink blush was applied to the apples of the cheeks, temples, top of the forehead, and sides of the neck.

17

Finally, for a change from Sandy's naturally full and wavy hair, large rollers were used to set and soften the curl. After the hair was brushed out, I chose a soft, camel-colored sweater that complemented the rich golden-brown tones of her face.

starting at top center; Sandy, age 3; at 19, in her first apartment; wearing one of her famous hairdos; with her son Gregory, out and about in New York City; a mother with her pride and joy; a perfect "10;" with Gregory, after a friend's wedding.

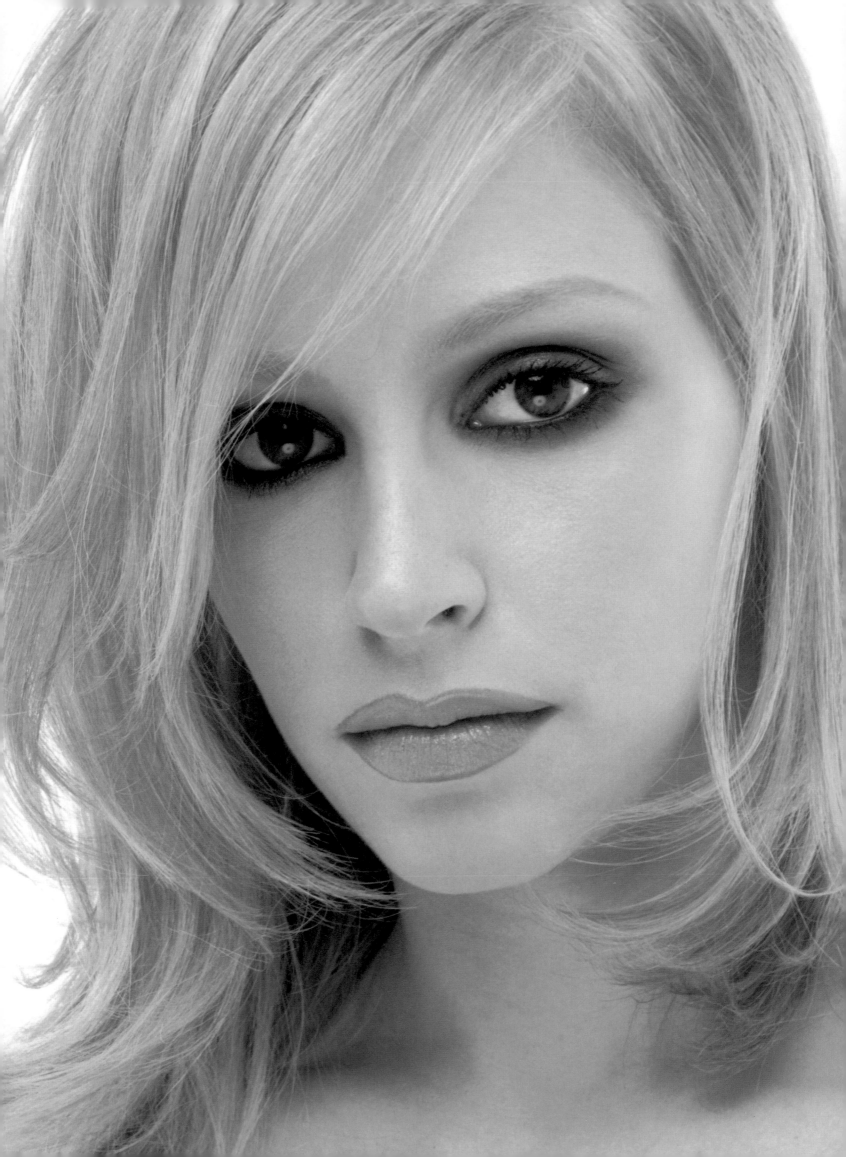

vanessa

The first time I saw Vanessa was in a restaurant, where I was having dinner with my boyfriend. Both he and I were fascinated by her bone structure and beautiful aquiline nose. She was wearing no makeup and her brown hair was pulled back into a simple ponytail. Her eyes had a Bambi quality that drew me in. Interestingly, I was soon to learn, her innocent-looking exterior hid a rather worldly and adventurous interior. When I asked her if she would be interested in letting me try a new sexy-blond-bombshell look on her, she simply replied, "Sure." Being an aspiring filmaker and actress, Vanessa knows how important it is to be open to change.

concealer
translucent face powder
circular sponge
light golden-brown brow pencil
hair bleach (optional)
black eye pencil
(small) eyeshadow brush
(large) eyeshadow brush
black powder eyeshadow
sponge-tip applicator
neutral brown powder eyeshadow
eyelash curler and black mascara
flesh-toned lip pencil
soft caramel-brown lip color
lip brush

1

I began by applying a light arc of concealer to the under-eye area, using my finger, and then only in spots.

2

With a circular sponge, loose powder was used to "set" the skin.

3

Light golden brow pencil was used on her newly bleached brows. (The color of pencil is dependent on your brow coloring.)

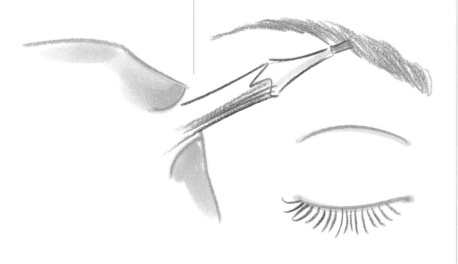

4

To complement her striking new blond hair and eyebrows, I decided to add a bit of seductiveness to her eyes. First, they were lined inside both the top and bottom rims with a black eye pencil, paying close attention to going into the lashline itself.

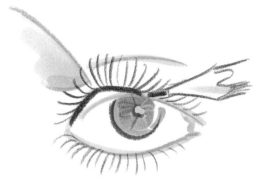

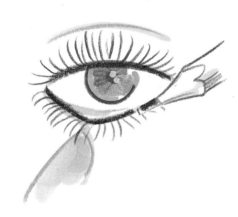

Vanessa Brook, photographed by Patric Shaw

5

Then, with the small eyeshadow brush, the black eye pencil line's edges were softened.

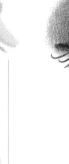

7

Next neutral brown eyeshadow was applied with a larger eyeshadow brush. Encircling the entire eye area, be sure to soften and graduate outward (from the eye itself) for that perfect blended look.

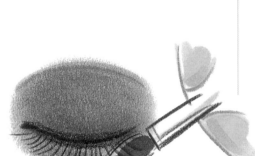

9

The lips were lined with a flesh-toned pencil to match Vanessa's natural coloring.

6

Black powder eyeshadow was then applied (using the sponge-tip applicator) directly over the pencil and smudged. (If you prefer, you can use your fingertip.) *The shadow helps to set and further soften the look.*

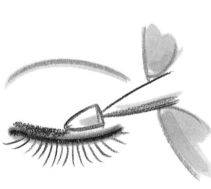

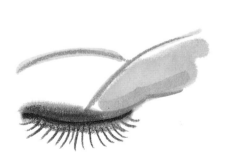

8

Black mascara on curled lashes added just the right touch of sexy delicacy to the over-all look.

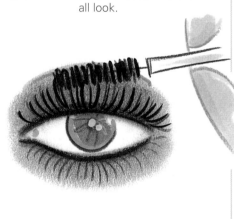

10

Then, using the lip brush, I applied a soft caramel-colored creme lip color to the entire mouth (blotted and re-applied, then blotted again).

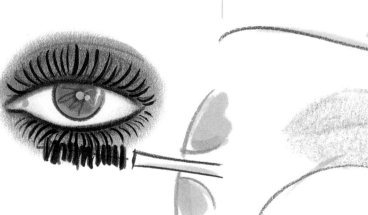

11

Finally, very lightly applied rose blush was added to just the apples of the cheeks to finish the face without taking away the impact of the eyes. The overall effect seemed to be Christy Turlington meets Angie Dickinson.

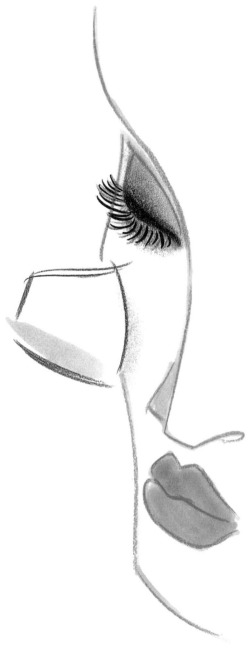

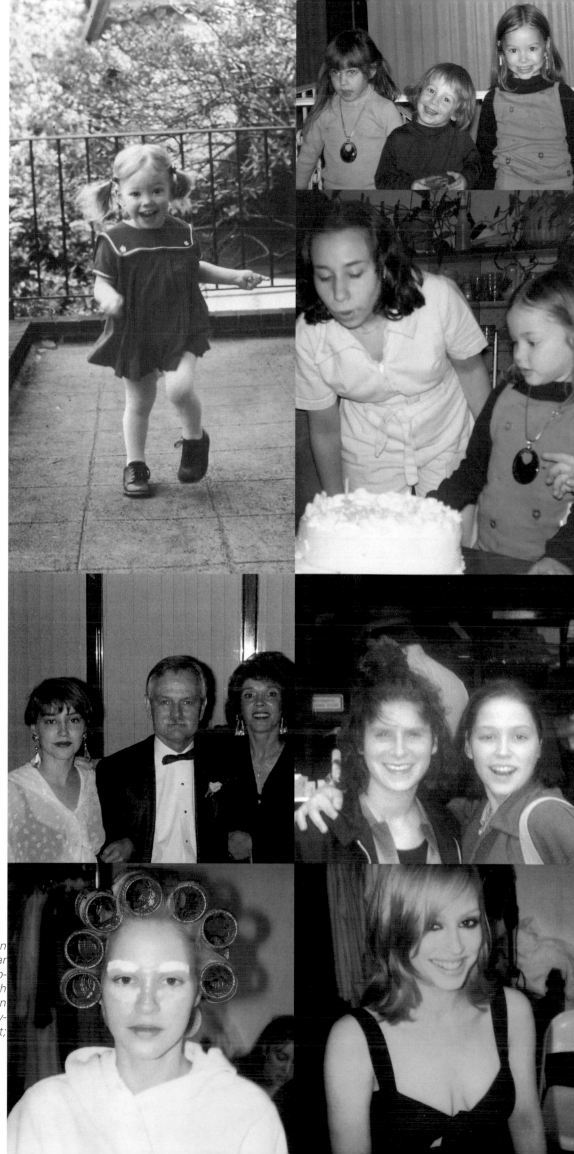

starting at top center; Summer 1974 on Vanessa's front porch; Vanessa, at age 6 (far right) with two cousins; with her aunt, helping to blow out birthday candles; at 19, with her stepfather and mother (1990); a San Fransisco vacation with her best friend; having her brows bleached for this photo shoot; enjoying her new look.

margarita & gigi

Sometimes when you are working on a photo shoot, things don't always go according to plan. If you're lucky, the twist is in your favor. Fortunately, for this portrait, things were definitely going our way! Originally, the portrait was to be just of Margarita. However, when she arrived on the set, she had her daughter Gigi in tow. What a great opportunity. Here I got the chance to show you the exact same makeup applied to two women of different ages. Clearly, you can see that makeup is ageless. And, with slight adaptations to your specific needs, any style can be worn by anyone. For Margarita and Gigi I felt something simple, yet very elegant, would work quite well. Incidentally, that evening they were attending an engagement party for prop stylist Michael Solis (Margarita's son and Gigi's brother). So, the choice worked out well for everyone involved. Together with the slightly stylized hair, "Marcel-esque" for Margarita and "Forties-esque" for Gigi, we were able to create an entire look on two people in less than thirty minutes. So much for the notion that glamorous looks take a lot of time and effort.

(The makeup steps outlined apply to both Margarita and Gigi.)

tweezers
brown brow pencil
clear mascara
concealer
translucent face powder
black eye pencil
(small) eyeshadow brush
cool brown creme eyeshadow
eyelash curler and black mascara
flesh-toned lip pencil
soft pink liquid blush

1

First, we groomed the brows, by giving them a gentle, well-defined but not severe shape.

2

The brows were then filled in with a brown pencil to softly frame the face, again taking care not too make them too hard, and set with a clear mascara.

3

These were foundationless looks. However, I did apply a small bit of concealer, but only where needed.

4

I then set the faces with translucent face powder.

5

Then, so as not to overdramatize the eyes, but still give definition, I applied a line of black eye pencil to the inside *top* rim of the eyelid and asked both Margarita and Gigi to squint hard. This adhered a soft line easily to the bottom rim. Then I gently smudged (both top and bottom) with a small shadow brush.

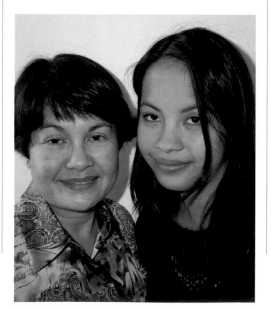

6

Next a cool brown creme eyeshadow was applied all over the eyelid (and gently under the eye), being careful to blend away any distinct edges.

7

The lashes were curled, and a coating of black mascara was given to both the top and bottom lashes.

8

A flesh-toned lip pencil was used to define and fill in the mouths.

9

Finally, a soft pink liquid blush was dabbed and blended onto the apples of the cheeks, chin and temples.

To really emphasize the natural beauty of an upturned eye, try using a smoky color (of your choice) applied slightly downward on the inner corner—encircling the eye and floating upward and outward on the outer corner.

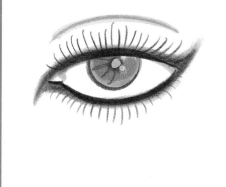

Margarita and Gigi Solis

As the public relations director for Isaac Mizrahi, Dawn crosses my path at least twice a year, usually backstage at one of Isaac's shows, where amidst the madness you can always find calm, cool Dawn. Over the years, we've become friends, and she has seen me apply makeup to hundreds of women. I often would mistake her for one of the models, but there never was an opportunity to do her makeup. So when this book became a reality, I immediately thought of her. For years, I've been telling her how beautiful she is (with or without makeup). I most often see Dawn after a hectic week of fittings that last late into the evening, and on the day of the show she usually forgets glamour in favor of comfort. So together we decided to have some fun and let her see what it's like to be on the other end of the spotlight.

Before the makeup application, Dawn's hair was blown dry; her bangs were cut and extensions were added (glamour length, of course) for a sexy, sultry look.

warm golden-toned creme foundation
translucent face powder
circular sponge
tweezers
chestnut brown brow pencil
neutral-toned powder eyeshadow
black powder eyeshadow
gold-beige shimmer powder eyeshadow
eyelash curler and black mascara
lash comb
bright fuchsia powder blush
dark-toned lip pencil
dark blackberry lip color
lip brush

1

First, I lightly applied a creme foundation that matched Dawn's skin perfectly. (Women of color can avoid "ashiness" with a warm golden-toned foundation.)

2

Loose face powder was distributed all over her face, including under the eyes and on the eyelids, using a circular sponge.

3

After lightly tweezing Dawn's brows, I filled them in using a chestnut brow pencil (for warmth).

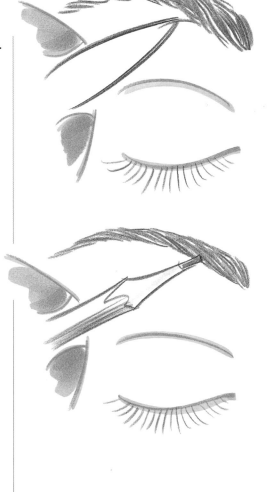

4

Then, to bring out Dawn's bone structure, I chose to use a neutral-toned eyeshadow, which I stroked lightly under the eye toward the outer corner and into the crease toward the nose, using the sponge-tip applicator.

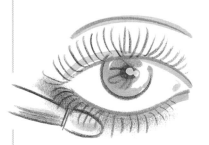

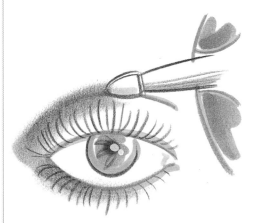

Dawn Brown

5

Black powder eyeshadow was then applied as close to the lashes as possible and smudged to create a more defined lashline.

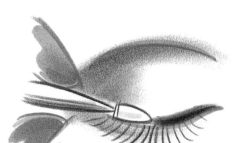

6

Next, a shimmery golden-beige shadow was applied to Dawn's lids (emphasizing the inner half) and browbone, being careful to blend away any harsh lines where it met the other colors.

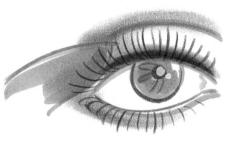

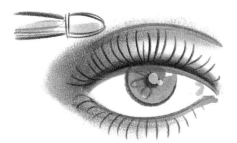

7

After curling her top lashes, I applied black mascara to the base of the lashes and brushed outward.

8

Next, the lashes were separated with a lash comb.

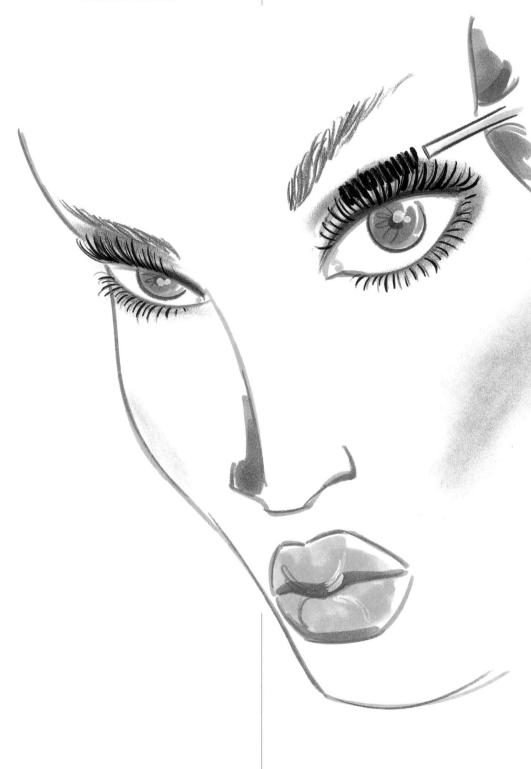

9

On Dawn's cheeks, temples, and chin, a bright fuchsia blush was used to add more warmth. (Bright colors used very sparingly seem to work best on women of color, as muted or pale colors can look chalky or ashy.)

The finishing touch was a dark blackberry
lipstick applied over a dark-toned lip pencil.

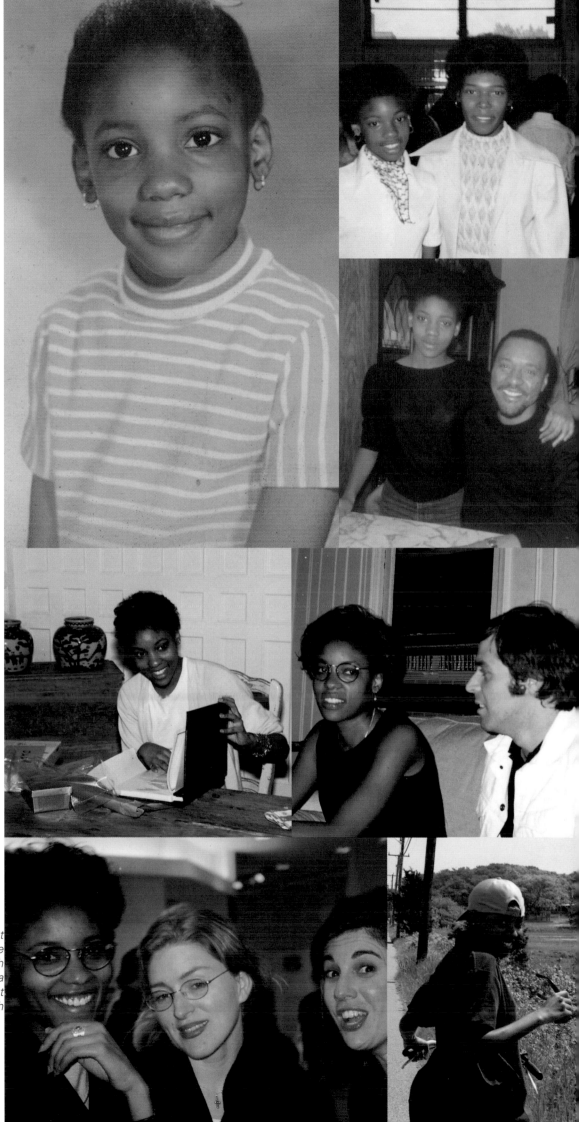

*starting at top center; Dawn at 6, in her first
grade school photo (1971); with Aunt Faye
(1976); with Dad, at home; in South
Hampton opening birthday gifts (1992); at a
party with friend Román; with co-workers at
the launch of the "Isaac" line at Saks Fifth
Avenue; riding a bike on Martha's Vineyard*

kimberly

My sister Kimberly was the last child of the four of us to be adopted. I remember bringing her picture to school for show and tell and explaining to the class that we had gotten the phone call to go and pick up my new baby sister. Since this was to be my third trip to the orphanage, I was completely baffled when my teacher asked, "What hospital is your mother in?" When I replied that my mother was not at all sick and, in fact, would be coming with us to Shreveport to pick Kimberly up, my teacher smiled and quickly moved on to our phonics lesson.

Growing up, Kimberly was quite a tomboy, and convincing her to participate in one of my "photo shoots" was nearly impossible. (The following page offers a couple of photos from those early sessions.) Today she is the mother of two, one of whom she home-schools. Kimberly loves makeup but rarely has the chance or the occasion to look glamorous, so we took this opportunity to really change her "look."

Colorist Christopher-John created one of the most amazing hair color transformations I've ever seen. Kimberly has Hispanic blood and her hair is naturally jet black. Since she has had auburn hair and wanted to try something new, I asked Christopher to lighten her hair to a dark ash blond, and that's exactly what he did. He managed to lighten her hair while retaining her natural shine. Together, Kimberly and I decided to go for dramatic eyes and a neutral lip. During the shoot we laughed over the photos we had done over twenty years ago and how much she now loves and appreciates a brother who does makeup for a living.

tweezers
hair bleach
concealer
small concealer brush
translucent face powder
circular sponge
golden-brown brow pencil
black liquid eyeliner
black powder eyeshadow
sponge-tip applicator
small eyeshadow brush
beige powder eyeshadow
neutral-toned lip pencil
warm pink powder blush
blush brush

1

I began by shaping and bleaching Kimberly's brows the day before the shoot. (Kimberly, like so many people, has very sensitive skin, so we wanted to allow her skin some time to recover. Kimberly cannot stand to have her eyebrows plucked, but loves the openness it gives her eyes. So I usually use cold wax strips, which can be cut into any shape you desire.

2

Concealer was placed under the eye to help counter the darkness in the area. By using a small brush and only a small amount of concealer, I evened out Kimberly's skin.

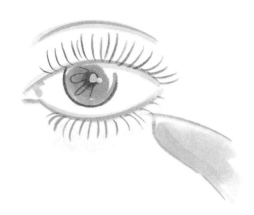

3

The face was then set with translucent face powder using the circular sponge. I applied a bit more under the eye, to the middle of the brow, bridge of the nose and around the mouth, as a subtle highlighter.

Kimberly Trahan

4

Since her eyebrows now matched her hair, I used a golden-brown brow pencil to accentuate and lengthen her brow shape.

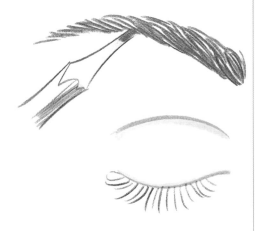

Next we went on to the eyes, using a bit of inspiration from *I Dream of Jeannie*...

Sometimes I encounter women (often Hispanic and Asian) with brows that need extra measures for reshaping. Their hairs grow up in the front and down at the ends and it's hard to tell where they begin and end.

For them, I apply concealer over the brow itself (in the shape that's desired).

Then, using a pair of cuticle scissors I cut all those on the ends that grow down below the concealer.

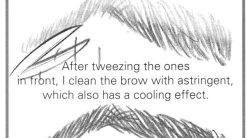

After tweezing the ones in front, I clean the brow with astringent, which also has a cooling effect.

To finish, I fill in with a brow pencil.

5

First a thickish line of black liquid eyeliner was drawn along (as close as possible) the top lashes.

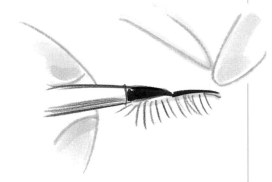

6

Over that, I applied black powder eyeshadow, using a sponge-tip applicator, and further softened, with a small shadow brush.

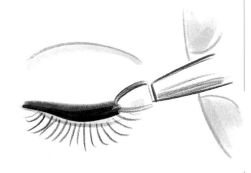

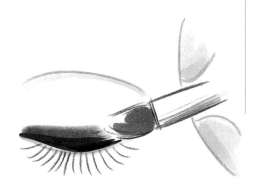

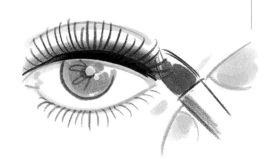

7

Taking the shadow brush from the outer corner of the eye, I drew an arc into the crease of the eyelid (emphasizing the shadow on the outer third of the eye).

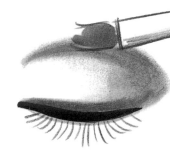

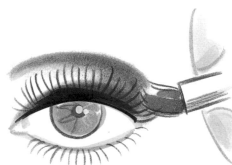

8

The "winged" effect was accomplished by drawing the shadow from the outside corner up and outward into the direction of the temple. Always make sure to soften the look with deft blending, using your shadow brush, a sponge or fingertips.

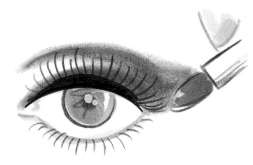

9

Mascara was applied to curled lashes, top and bottom.

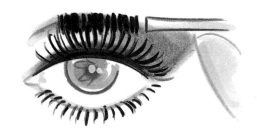

10

Final finishing of the eye calls for a highlighting of the browbone area using a beige powder eyeshadow, applied with a sponge applicator. Applying pale colors last can help to reduce hard edges.

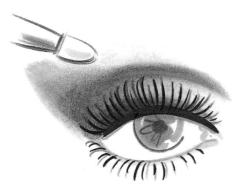

11

All that was used on Kimberly's mouth was a neutral lip pencil, used to line and completely fill in the mouth.

12

To finish, warm pink blush was applied to the apples of the cheek and chin.

starting at top center; one of Kimberly's first photo shoots (I was about 13 when I took this picture), 1974; at age 10, with sister Carla; her first grade school photo; with Carla (left) and me (center) in New York City, (1983); in her mid-teens in Lafayette, Louisiana; with her daughter, Fallon; with son Ian.

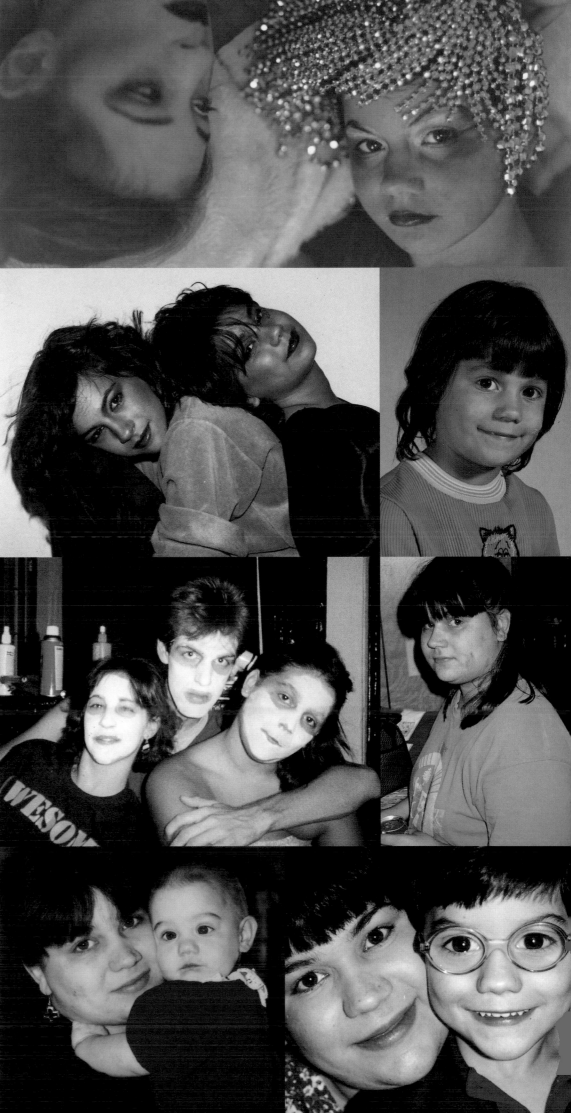

thelma

My mom is my hero. Early on, she taught me to express my thoughts and feelings without judgment. She was the first to encourage me to come to New York to follow my dreams and always the last to criticize. Her enthusiasm and child-like wonder about life keep me centered and eternally grateful. And though I have given her (starting at fifteen) haircuts that made her cry and experimented with makeup looks on her that were best saved for the local production of *Cats*, she bravely wore her new "looks" to the mall. Due to the extreme poverty of my mother's childhood, she often admired beautiful clothing she could not afford. As a teenager, she would gather old pieces of fabric, buy some cheap but brilliantly colored dye, and go about making her own "couture" collection. I think the early ridicule she received, for her clothing and color (lime green) choices made her the perfect parent. She is my favorite travel partner and Scrabble mate. My mother has not allowed convention or tradition to interfere with her own personal growth, opting instead for open-minded, big-hearted curiosity. She is also the perfect example of someone who will not be locked in by preconceived ideas regarding age and beauty. Over the last decade, too, her work within the lesbian and gay communities has shown everyone around her that real beauty comes from courage and inner strength.

Thelma Aucoin

concealer
translucent face powder
circular sponge
tweezers
golden brow pencil
golden-brown powder eyeshadow
peach shimmer creme eyeshadow
small eyeshadow brush
white eye pencil
individual lashes (three lengths)
adhesive
eyelash curler and black mascara
black liquid eyeliner
black powder eyeshadow
sponge-tip applicator
flesh-toned lip pencil
bright berry lip color
lip brush
rose blush and blush brush

1

First I applied concealer in a yellow-based tone that matches skin exactly, only where it was needed.

2

Next the translucent powder was applied all over the face using the circular sponge.

3

Then the brows were groomed and lightly filled in with a golden brow pencil.

4

Golden-brown powder eyeshadow in the crease and softly under the eye.

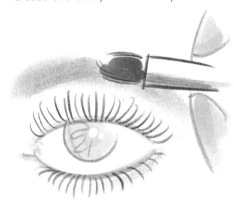

5

With a shadow brush, I applied peach creme shimmer eyeshadow all over the lids and on the browbone.

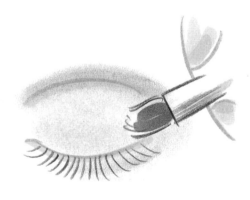

Lifting the eye

To give the eye a "lift," try turning your liner (in either liquid or pencil) up at the corner. Make sure to curl your lashes well, as this can give a significant lift to the eye as well.

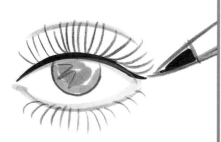

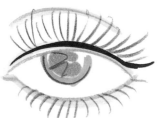

(On the under-eye area, either forgo shadow or use one several shades lighter than your liner. This can give a significant "lift" as well.)

Some makeup tips for mature women

1
Lining your lips can create a more defined shape and prevents bleeding of the lip color. Also, filling in with the pencil increases color depth and helps it last longer.

2
As the shape around the eye "softens," more defining may be necessary. Try keeping the intensity on the upper lashline (with smudged shadows or liners) and a bit less so for the under-eye area.

3
There's no need to overtweeze, but pay more attention to the removal of extra-long and/or unruly brow hairs.

4
Try using concealer that is spot-applied with a brush, instead of an all-over foundation, for a lighter, fresher look.

5
Make sure that all products (shadows, blushes, etc.) are blended well and graduated (with the exception of lip liner) to keep the face from looking harsh or stiff.

6
White eye pencil was then drawn carefully on inside rim of the eyes (top and bottom) to brighten eyes.

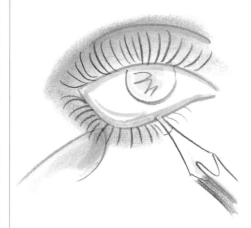

7
For this photo, I applied *three* medium-length individual lashes to the outer corner of each eyelid, using a glue that dried clear.

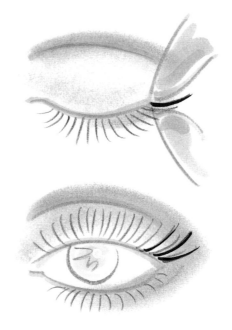

8
Then I curled all the lashes together and applied black mascara to top and bottom.

9
I then applied a thin line of black liquid eyeliner along another thin line of black powder eyeshadow (applied with a sponge-tip applicator) as close to the lashes as possible to *define* the eye, smudging it to avoid sharpness.

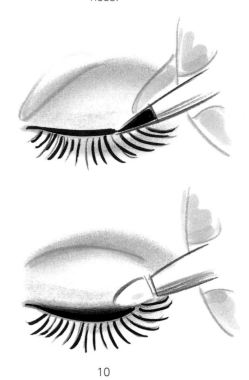

10
The lips were lined with a flesh-toned lip pencil and filled in.

11
Over that, I applied a bright berry lip color with my lip brush, blotted, re-applied, then blotted again.

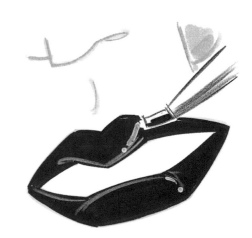

12

I then dusted rose blush on the cheeks, temples and, because she was wearing a low-cut dress, the collarbones.

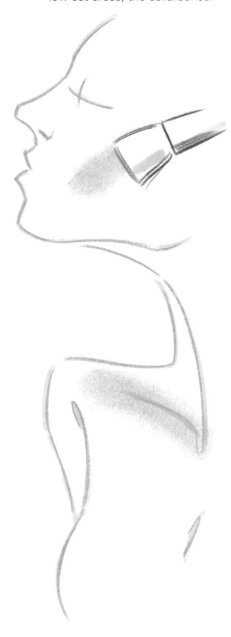

starting at top center; Thelma Aucoin at 18 years old; as a youngster in St. Martinville, Louisiana; with husband, Isidore, in the late 1950s; at a party in New York City; the three of us in Hawaii; with her granddaughter, Samantha; the Aucoins with Eric in Tokyo

alpana

Alpana is a self-made success. She came from India and started her own garment business, here in New York. She also, like many women, prefers wearing light makeup, especially during the day. So what I wanted to show was how easy and effective it can be to stay within those guidelines and still give a beautiful, "finished" appearance. With a little tweezing, concealer, and a brighter lip color, I was able to create a totally new, yet easy to achieve, look.

> **Curling the lashes is very important to "open up" the eyes.**

tweezers
foundation and sponge
light face powder and circular sponge
warm rose blush and blush brush
soft pearlescent white liquid eyeshadow
eyeshadow brush
eyelash curler and black mascara
flesh-toned lip pencil
warm cherry-red creme lip color
lip brush

1

First I tweezed Alpana's brows, focusing on the hairs nearest the nose. The effect of removing a couple of rows of hairs was to *lift* the brows and create a softer expression.

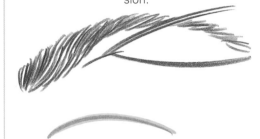

2

I then lightly applied a yellow water-based foundation that matched the skin perfectly, using my fingers first, then blending in with a sponge.

3

I then covered the face with a light powder, using a circular sponge.

4

Warm rose blush was applied to the cheeks.

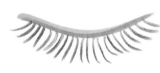

5

On her eyes I used a soft pearlescent white liquid eyeshadow (applied with the shadow brush), which gave her a sexy bedroom-eye look.

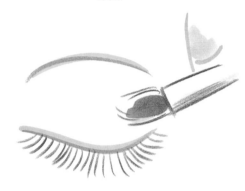

6

Black mascara was applied to curled lashes top and bottom.

7

Flesh-toned pencil was then used to line the lips and fill them in.

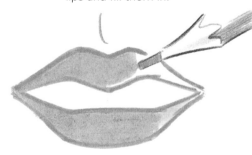

9

Last, a warm cherry-colored creme lip color was used over the entire mouth, blotted, then re-applied.

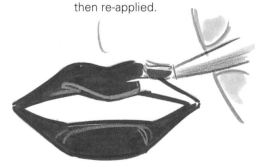

Alpana Bawa

brow brush
concealer and brush
pink liquid blush
translucent face powder and sponge
eyelash curler
dark brown mascara
tinted lip moisturizer

I am not an advocate of young children wearing makeup, except for school plays, Halloween, or fun at home. The idea of beauty pageants for children makes my head spin. But once an adolescent hits puberty, rebellion and self-expression are as inevitable as pimples and hormonal mood swings. Makeup for a fifteen-year-old is most often about concealing a blemish, moistening the lips, or adding some color to the cheeks. But even if a fifteen-year-old has a Mohawk and wants to wear black racing stripes up their forehead (sounds a lot like me as a teen) they're not hurting anyone. Anyway, Denise and Lauren-Claire fall into the lip gloss and blush category. (You'll have to go a few more pages for the Mohawk and racing stripe look.) They are two young teens who enjoy wearing makeup (with their parents' permission). So I decided to show them how a little bit of makeup goes a long way

The same makeup application, with some color adjusting to suit their different skin tones, was used on both.

1

First, I brushed their brows upward and outward.

2

Then, using the small concealer brush, I placed a light touch of concealer on any red spots or discoloration.

3

Using my fingertip, liquid blush was applied to the cheeks for a bit of added color.

4

Next the faces were lightly powdered, using a sponge, with translucent face powder. (Powder is good to help reduce the frequent "oiliness" that affects teens.)

5

Then the lashes were curled and a very light coating of dark brown mascara was applied to the top and bottom lashes.

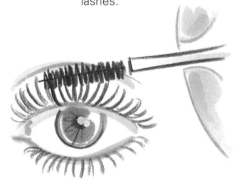

6

I finished off with a lip moisturizer with just a hint of color.

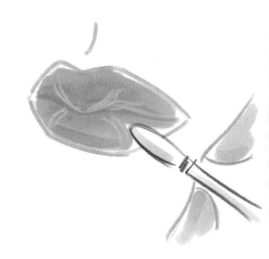

Denise Vasi and Lauren-Claire

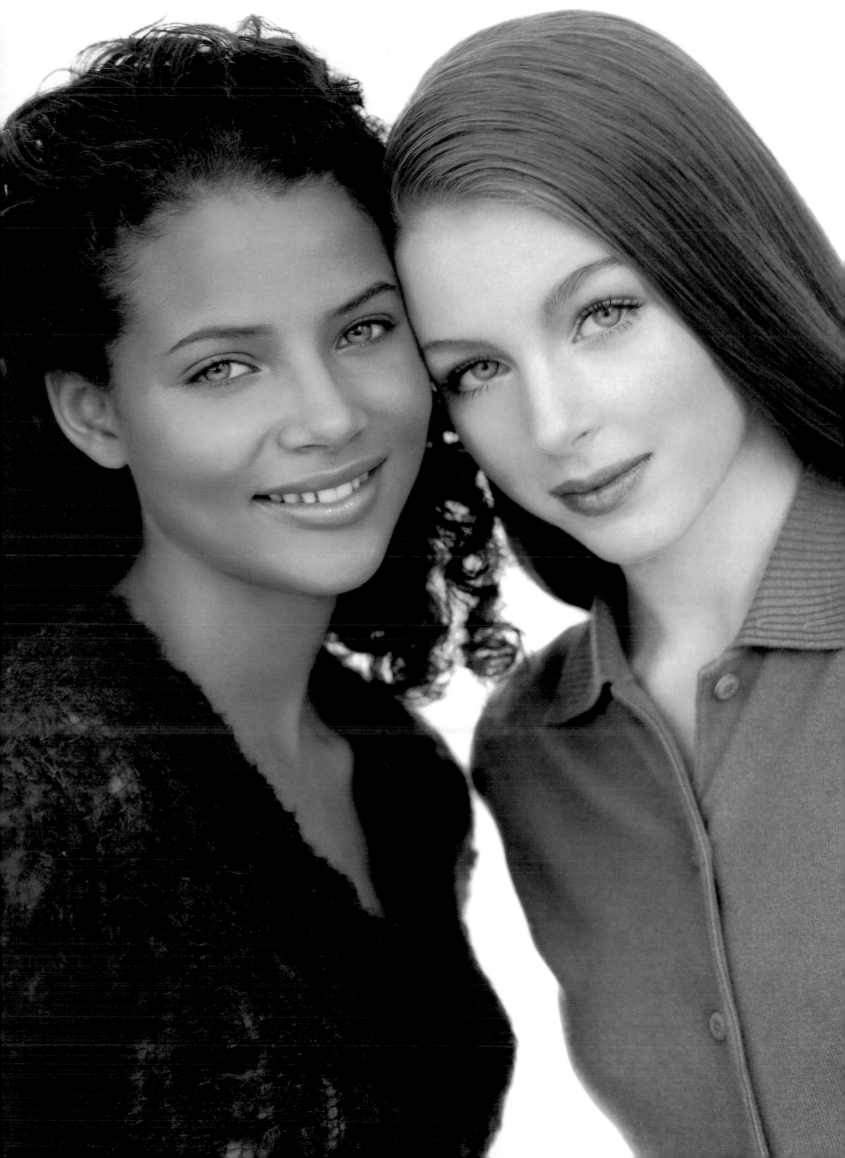

Like many women of color, Joy felt limited in her choices of makeup. Back in Illinois, she consistently wore red lipstick with black mascaraed eyes. This look is fine, but for Joy it had gotten a bit monotonous. She wanted a more sophisticated or grown-up look. First, hairstylist extraordinaire Ellen Lavar added warmth to Joy's freshly cut hair. Then hairstylist John Sahag gave her delicate layers to add softness around the face. Next, I used a variation of the neutral face, playing up the golden-apricot tones in her skin. This helped to expand her makeup vocabulary without drastically changing her routine.

tweezers
warm creamy foundation
light yellowy-orange concealer
translucent face powder and sponge
bright mangoey powder blush
pink powder blush
blush brush
warm brown powder eyeshadow
pale gold shimmer highlighter powder
sponge-tip applicator
eyelash curler and black mascara
flesh-toned lip pencil
warm beige lip color
lip brush
golden-colored lip gloss

1

First, I tweezed Joy's brows. This opened up her eyes and helped to balance out facial proportions.

2

Next, I used a warm cream foundation, sparingly applied with a foundation sponge, to even out the skin tone.

3

A light yellowy-orange concealer was used to highlight under the eyes, down the center of the nose, and around the mouth. (This gives the face a more three-dimensional quality.)

4

Then light loose powder was applied with a sponge over the entire face.

5

To add a golden glow, a bright mangoey blush was swept over the cheeks, temples, chin, and sides of the neck, using the blush brush.

6

Then a warm brown powder eyeshadow was "washed" over and under the entire eye, carefully blended at the edges.

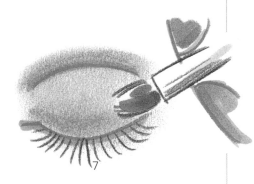

7

Next, a pale gold shimmer highlighter was blended under the browbone. This adds a sense of distance between the brow and the eye.

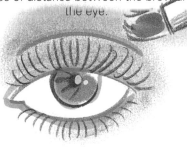

8

Joy's lashes were curled and black mascara was carefully applied to the top and bottom.

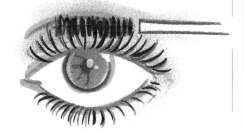

9

On top of the mango blush a light dusting of pink was added.

10

The mouth was lined with a dark flesh-toned pencil and filled in. This was followed by an application of warm beige lip color and the lips were blotted.

11

Finally, a golden-colored lip gloss was placed in the center of the mouth.

Joy Middlebrook, photographed by Patric Shaw

catherine

Today women make choices based on a number of factors: time, lifestyle, comfort and so on. Catherine is one of these women. At forty-four, she felt that she knew how she wanted to look and scheduled her routine accordingly. When we had the chance to work together, I thought a little bit of a shake-up was in order. But nothing earth-shattering. First, her hair was lightened, highlighted and cut, as you can see. Then I bleached her eyebrows to a lighter shade of their natural color (see how it softens the face?). And the rest was easy. In fact, it is another variant on the Neutral face (one of my favorites), using a warmer apricot lip color.

liquid foundation
concealer
translucent face powder
circular sponge
golden-brown powder eyeshadow
eyeshadow brush
brownish-black eye pencil
warm beige powder eyeshadow
sponge-tip applicator
golden eyebrow pencil
eyelash curler and dark brown mascara
warm peach powder blush
blush brush
flesh-toned lip pencil
warm apricot lip color
lip brush

1
First, I applied liquid foundation to the center of the face and blended outward.

2
Concealer was then smoothed onto the under-eye area.

3
Loose face powder was then applied with the sponge, all over the face.

4
Using the shadow brush and beginning at the inner eye, golden-brown eyeshadow was blended into the crease toward the outer eye, then continued along the under-eye area and blended well.

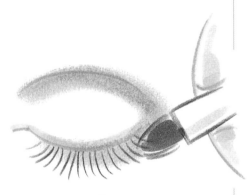

5
Brownish-black eye pencil was applied and blended into the upper lashline, then smudged, using the shadow brush. This helped to strengthen and define the eye.

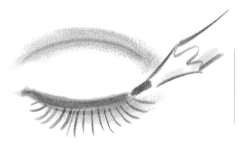

6
Warm beige eyeshadow was then smoothed over the eyelid and browbone using the sponge-tip applicator.

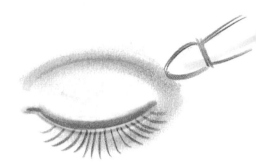

7
Golden eyebrow pencil was used to emphasize and define Catherine's newly bleached brows.

8
Lashes were curled and dark brown mascara was applied to both top and bottom.

9
Warm peach powder blush was dusted onto the cheeks, temples and chin.

10
Flesh-toned lip pencil was used to define and fill in the lip shape.

11
Finally, warm apricot lip color was applied over the pencil for a healthy, soft shine.

Catherine Sherman, photographed by Patric Shaw

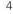

jay

Clark Gable, Humphrey Bogart, John Wayne, Sylvester Stallone, Arnold Schwarzenegger, Tom Cruise, and President Clinton have all worn make-up. As is evident here with Jay, a lawyer from Manhattan, a little touch of powder and concealer can warm up the face and add a matte quality that signals self-confidence and strength. In a world where men are seeking cosmetic surgery faster than their female counterparts, carefully used cosmetics are a nice option. Whether suffering from lack of sleep, jet lag, breakout due to tension, or just a case of nerves before a big meeting, a man can rely on concealer and powder to conceal dark circles, a blemish, even a hickey. For those men out there who might have trouble with this concept, think of face powder as antiperspirant and concealer as six more hours of sleep.

concealer
light loose face powder
circular sponge
lip moisturizer (balm)
small toothbrush (if needed)

1

To even out the skin tone, I applied concealer (in a shade that matched Jay's skin, of course!) to the under-eye area, redness around the nose, and on any discoloration (blemishes, age spots, broken blood vessels).

2

For matte skin, using a sponge, I lightly applied loose powder all over his face and smoothed it in until it completely disappeared.

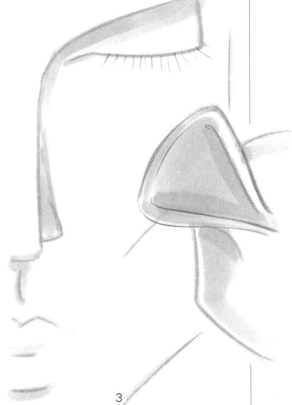

3

Then on Jay's mouth I applied a light coating of lip balm.

4

(Optional)
For dry lips, apply a heavy coating of the lip moisturizer (or Vaseline) to your lips and let it sit for ten minutes. Then take a baby's toothbrush (adult strength for you macho men) and brush your lips to remove any dead skin. Follow up by carrying around lip balm.

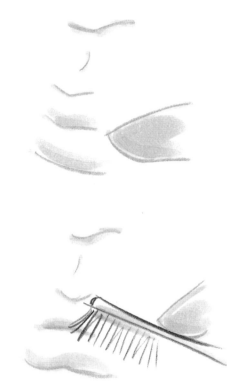

Jay Swanson

103

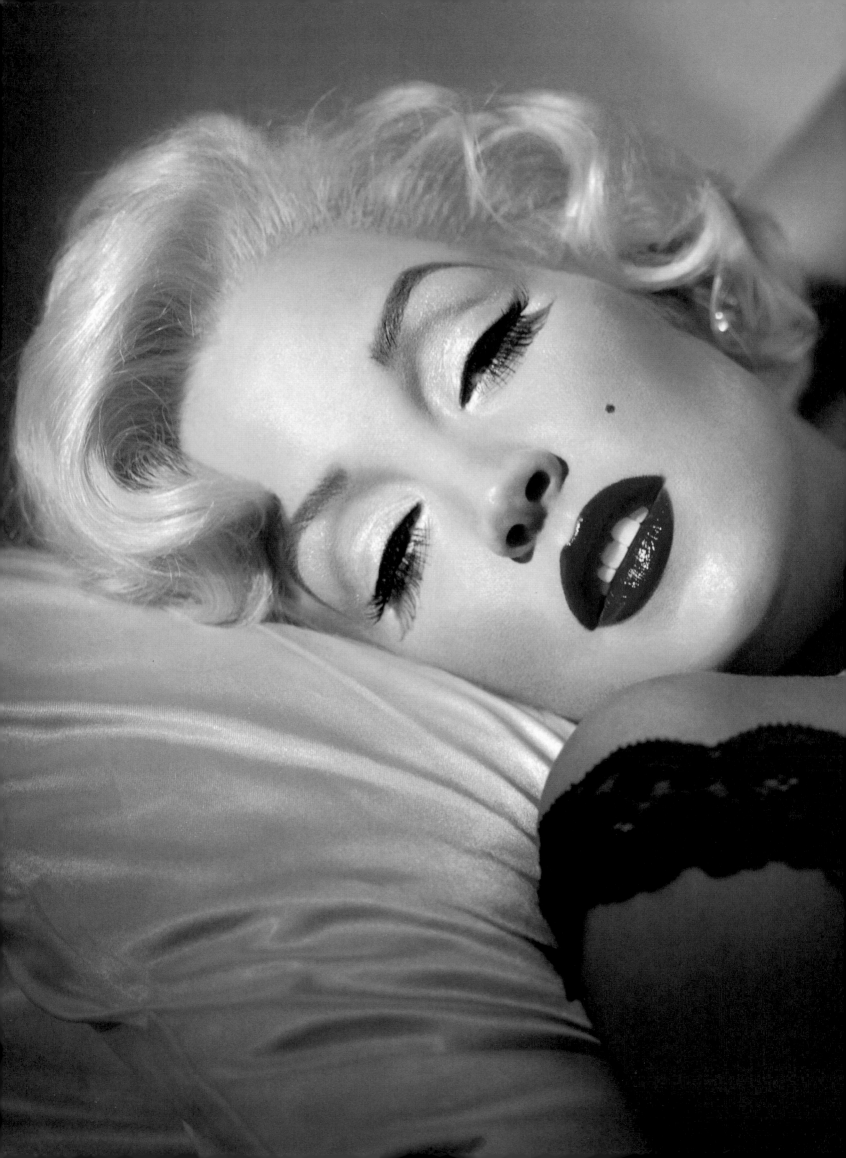

Great Looks

Throughout history every culture has had its icons, those brave and extraordinary souls whose exceptional talent and passion have helped us find our dreams. These icons have, for the most part, shaped our definition of beauty. From "The Innocent" to "The Temptress," from "The Showgirl" to "The Minimalist," history has given us many choices for inspiration. The idea is not to copy (or, especially, compare) but to find those qualities in our heroes that we want to emulate.

The following is my personal selection of makeup styles that I feel have influenced, provoked, and dazzled all of us to some degree.

Instruction is given on how to re-create these looks yourself, but most of these styles are meant as a point of departure from which you can choose the components that interest you.

The point here is to either go all the way, or take the glossy eyelid, the downturned eyes, or mattered lip, adapt it for yourself, and have fun.

Lisa Marie Presley as "the Bombshell"

the Innocent

At the turn-of-the-century, rouge and lipstick were the emblems of "ladies of the night" and roadshow actresses, *both* seen at the time as women of ill-repute. Virtuous females, however, may have affected a "rosy glow," but never of the intensity of their sullied sisters. The aptly named, the Innocent, transcends this shameless moralizing with Tori Amos's timeless, modern-day "Botticelli-esque" beauty. The faraway dreaminess is played up with soft, slightly shimmery makeup, and looks as though she has just stepped out of a beautiful oil painting. There are no definite lines (not even on the lips), just creamy accentuation.

tweezers (if needed)
brow pencil
shimmery liquid foundation and sponge
pink creme blush
white iridescent creme eyeshadow
brown creme eyeshadow
eyeshadow brush
eyelash curler and black mascara
flesh-toned lip pencil
cotton swab
clear lip gloss

1

Lightly groom the brows (if needed).

2

Then fill in the brows, where necessary, with your brow pencil.

3

Apply shimmery liquid foundation all over the face to give it a glow. This will naturally highlight parts of the face. (For this photo, the foundation was applied on the neck, shoulders and collarbones.)

4

Dot pink creme blush onto the apple of the cheek, temples and chin. Then blend well with your fingertips.

5

Next, apply white iridescent creme shadow to the entire eye area with the fingertip.

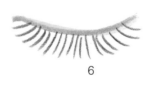

6

Brush brown creme eyeshadow into the crease and softly under the eye, using the shadow brush.

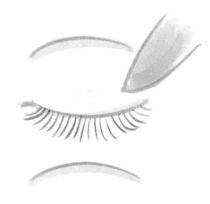

7

Curl lashes and apply the lightest bit of black mascara.

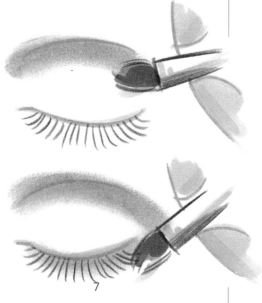

8

Outline the lips with flesh-toned pencil and soften with a cotton swab.

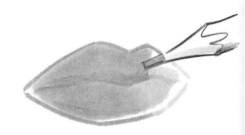

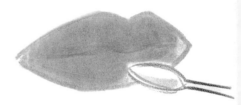

9

With your fingertip, apply clear lip gloss to center of bottom lip and smack.

Tori Amos

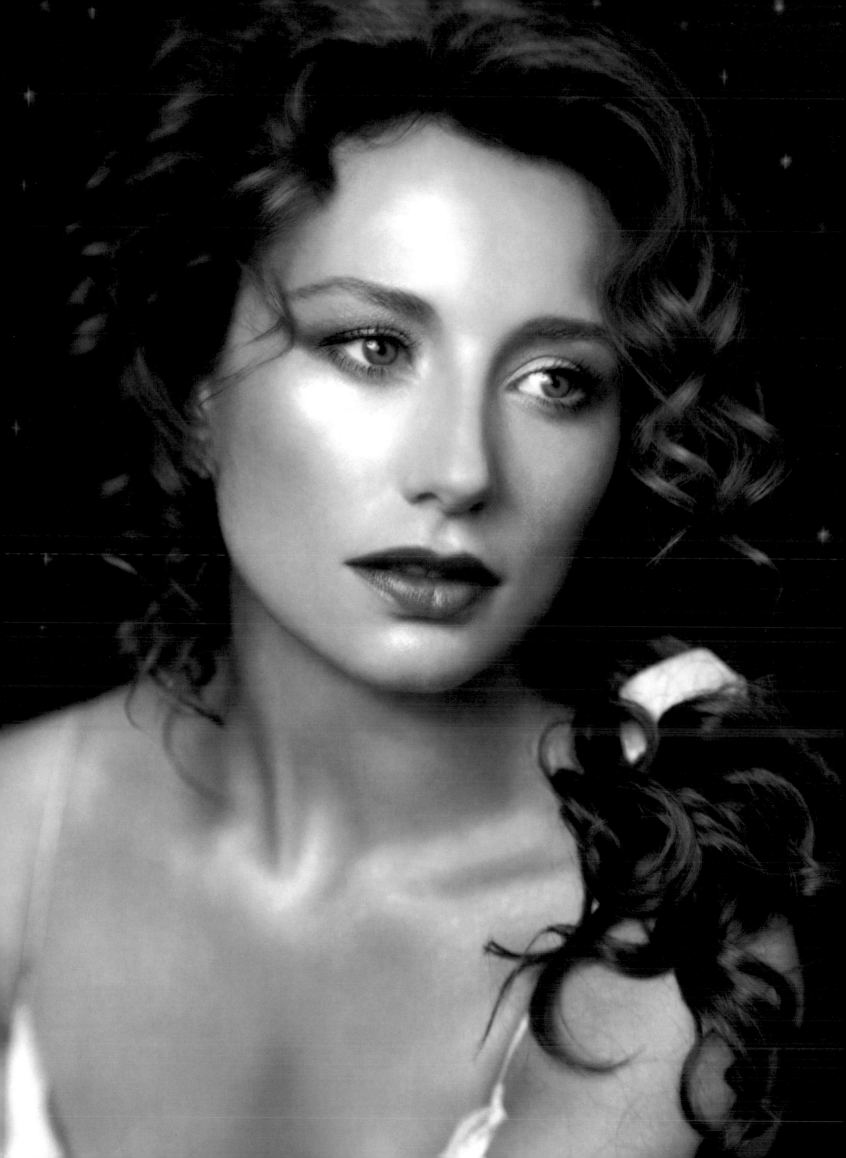

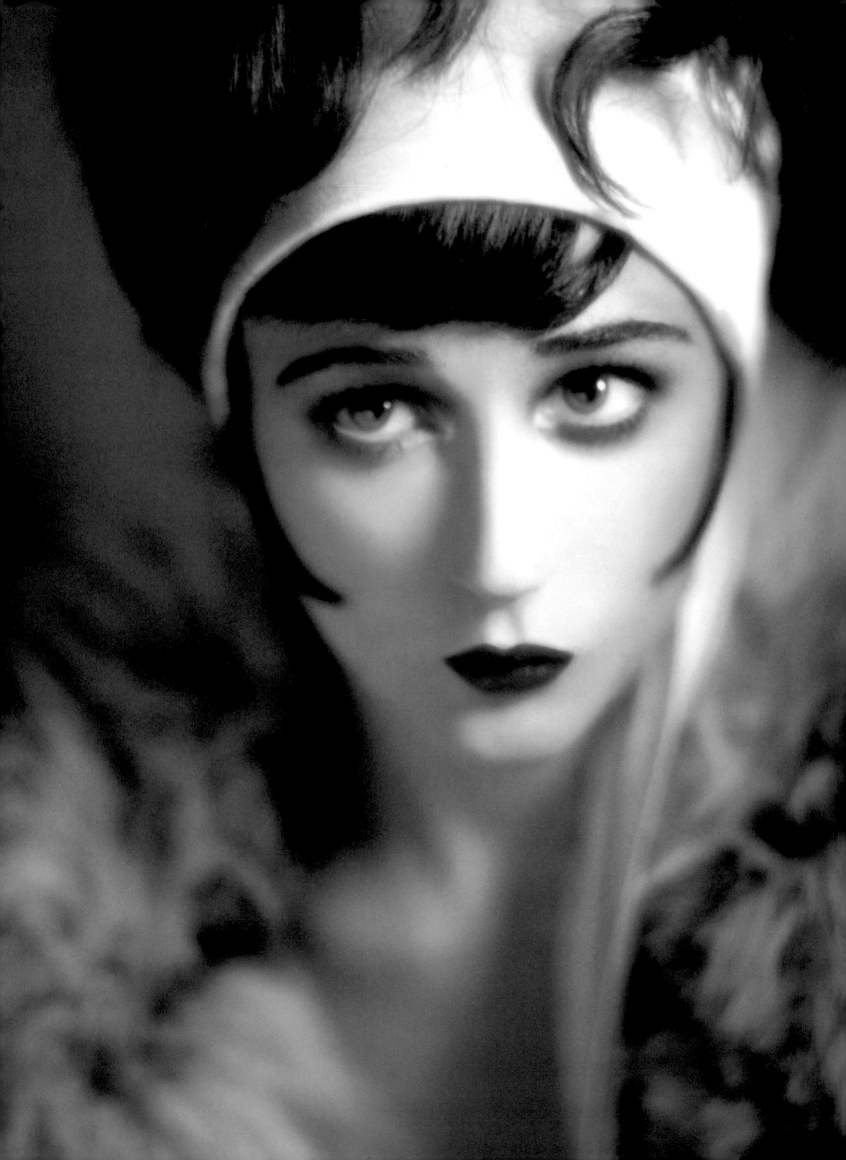

A beautiful young silent screen star named Clara Bow was named the "It" girl of the early 1920s. She was a fun-loving spirit who was seemingly unaware of her intense sensuality. She openly toyed with the hearts of both men and women, never intending any harm (of course). Her face had a certain winsome quality that defended her against any accusation of intentional seduction. Demi Moore captures the Vamp's essence perfectly. By using her doe-like eyes, fragile mouth and pouty disposition, she could manage to soften (and cajole) even the most hardened and indifferent among us.

concealer
translucent face powder
circular sponge
brow brush
dark grayish-brown powder eyeshadow
eyeshadow brush
eyelash curler and black mascara
dark-toned lip pencil

1

(For this photo, there was no foundation used, only a bit of concealer and only where needed.) If you use either product, keep the application light.

2

Next, apply loose powder, using the sponge, all over the face.

3

To achieve this look I intentionally brushed Demi's eyebrows down at the ends and up at the beginning to create a downturned eye.

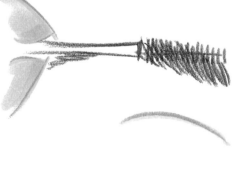

4

Then apply dark grayish-brown eyeshadow with a brush. On Demi it was applied at a downward angle with the concentration of the shadow at the lower *outer* corner and the upper *inner* corner.

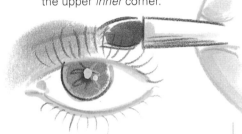

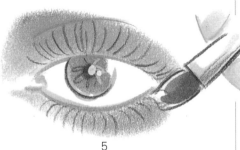

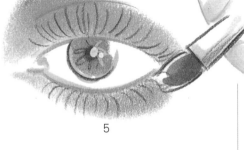

5

Next, mascara is applied, top and bottom, to very curled lashes, completing the winsome effect.

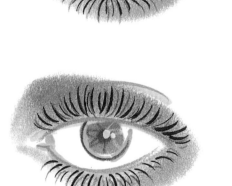

6

This is a lip shape that is drawn inside the natural lip line. Begin by covering the sides of the mouth with concealer and blend well into the skin. (*Before lipstick formulas were perfected in the Thirties, lips were drawn to the insides of the corners of the mouth, to avoid "bleeding" of the color.*)

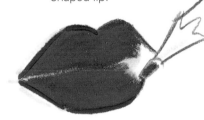

7

Then a dark-toned lip pencil is used to draw (and fill in) the signature "Clara Bow"-shaped lip.

(*These smaller mouths turned up in the middle as if continually blowing a kiss.*)

Demi Moore

the *Flapper*

In 1925 the irrepressible Josephine Baker crossed the Atlantic to France in order to live a life not possible for an African American woman in America at that time. Sometimes appearing on stage in only a banana skirt and a contagious smile, she quickly became the rage in Paris. Smoldering sexuality, along with a gleeful exuberance, made her one of the most celebrated beauties of her time. From her Marcel-waved hair, down to her jeweled and painted toes, she exuded an extraordinary passion for life. Wearing the same simple makeup of smoky black eyes and dark lips, T-Boz (of TLC) truly radiates that same energy and fire.

foundation or concealer (only if needed)
brow brush
near-black creme eyeshadow
kohl black eye pencil
eyeshadow brush
eyelash curler and black mascara
dark brownish-purple lip color
lip brush

1

Apply foundation or concealer only if (and where) it is needed.
(T-Boz has a beautiful honey-colored complexion, so I decided to leave her skin bare.)

2

Gently shape and brush the brows. (T-Boz's eyebrow shape is perfect for this look.)

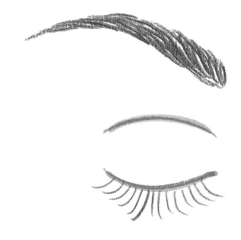

3

Use the kohl pencil to rim the eyes, top and bottom.

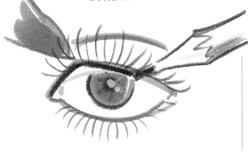

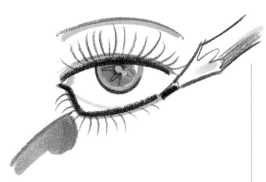

4

Next, apply creme eyeshadow in a near black color, all around the kohl pencil. Smudge, using the brush or your fingertip, to create a very mysterious eye look.

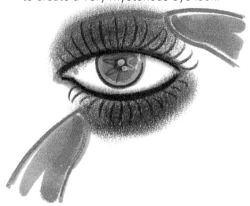

5

Black mascara is then applied to curled lashes, top and bottom.

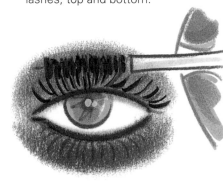

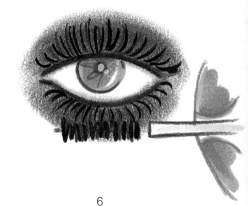

6

Last, apply two coats of dark brownish-purple lip color, using the lip brush. (For this photo, no pencil was used.)

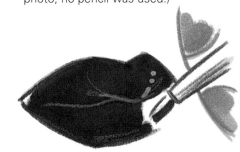

T-Boz

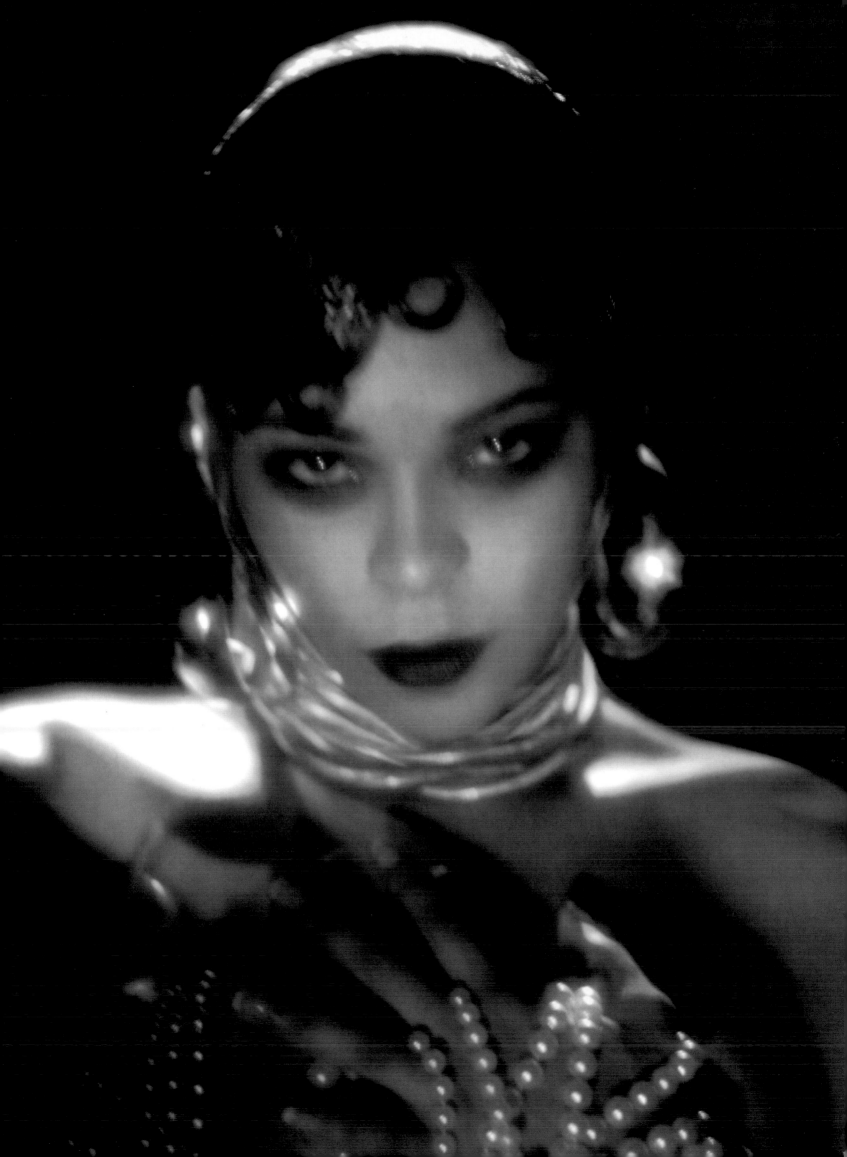

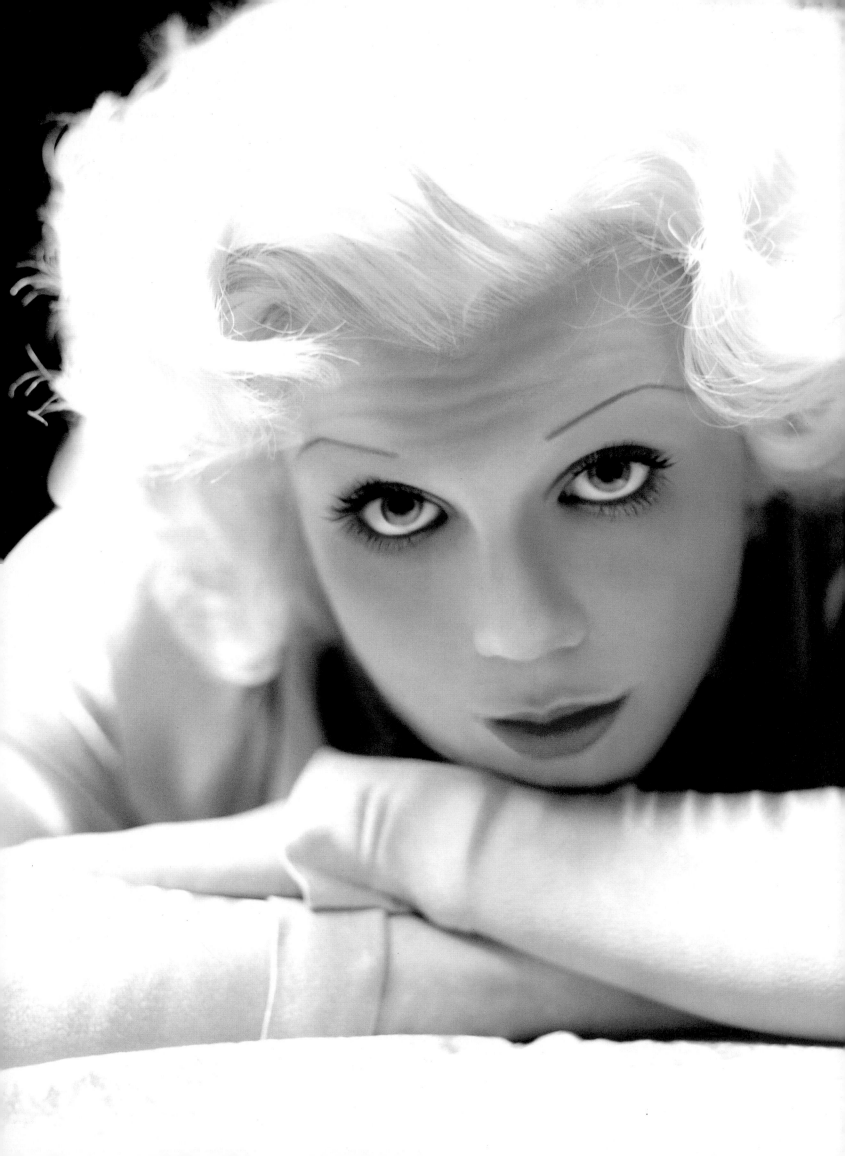

the *Starlet*

Constance Bennett and Jean Harlow are two stars who come to mind when recalling the 1930s Hollywood starlet. They were platinum blondes who had a joyful, yet contemplative look. The starlet was engaging, charming and projected a certain wholesomeness. Courtney Love's classical proportions lend themselves well to this adaptation of the gossamer-haired, rosy-cheeked, blue-eyed star.

gold shimmer foundation
hair bleach (optional)
light brown brow pencil
dark brown eye pencil
eyelash curler and black mascara
bright pink powder blush
neutral-toned lip pencil
glossy red lip color and lip brush

1

Courtney's porcelain skin was the perfect palette for these bright and playful colors. To add to the natural luminescence of the skin, apply a sheer veil of golden shimmer foundation.

2

Over bleached eyebrows (optional) use a light brown brow pencil to create the signature "Starlet" eyebrows.

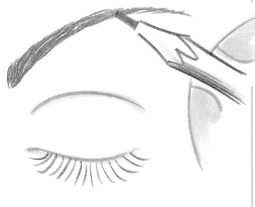

3

Then on the eyelid, draw a thin, curved line of dark brown liner accentuating the look's wide-eyed appeal.

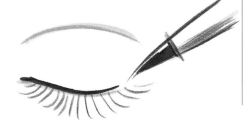

4

Curling the lashes is very important for this look. Mascara is applied to both the top and bottom lashes.

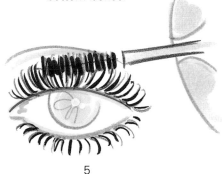

5

Then a bright pink cheek color is used to create a blush effect.

6

Here the lips were drawn inside the lipline and filled in with the lip liner. Follow with glossy red lip color, blotted, re-applied and blotted again.

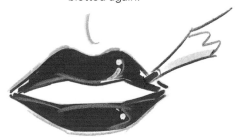

Courtney Love

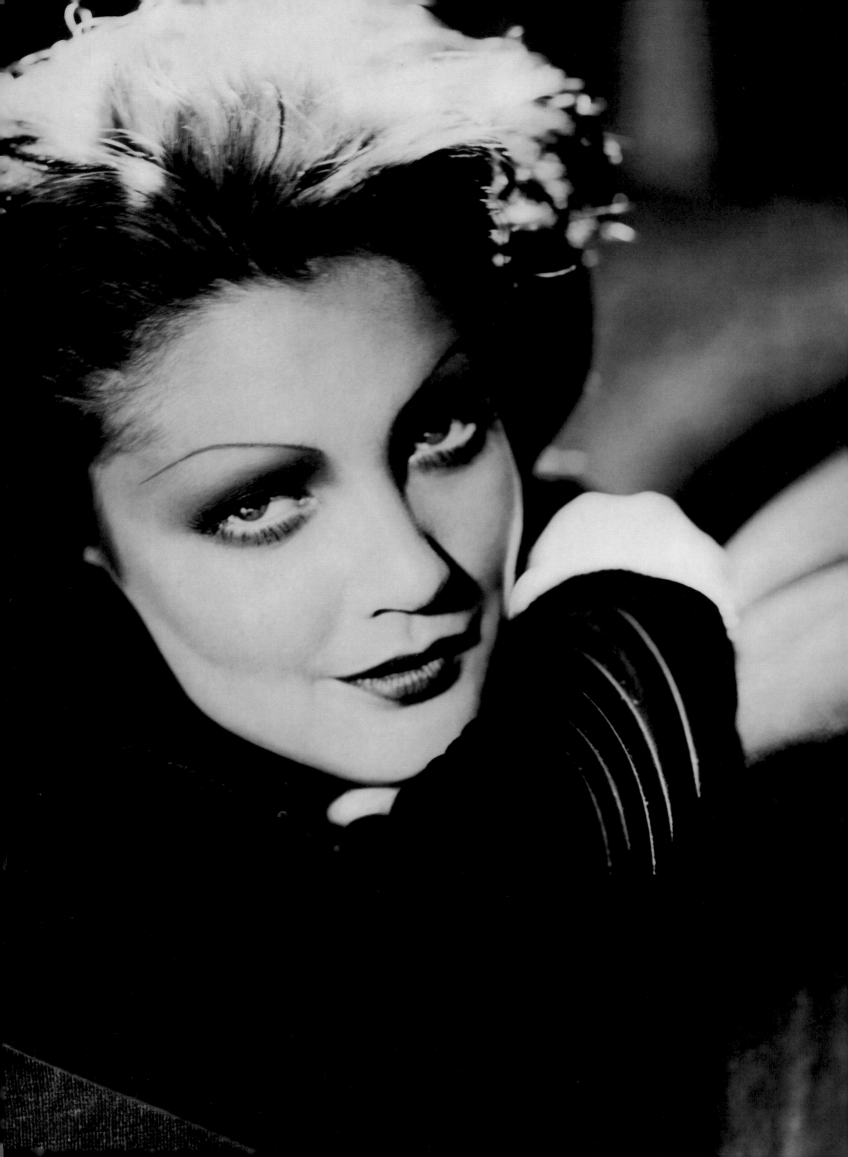

Myrna Loy, Claudette Colbert, Norma Shearer, among many others, were the role models who took us out of the Depression era. They had charm, wit and beauty. Drew Barrymore turned out to be fantastic in this role. Not only does she convey the right amount of sophistication for this portrait, but you will see her amazing versatility if you compare this with the photograph opposite the acknowledgments page. It is the exact same makeup. The only change was an alteration of the brow shape and a switch to color film. Instantly, she becomes a dangerous beauty from the dark, moody side of Hollywood cinema—film noir.

concealer
translucent face powder and sponge
white eye pencil
dark-brown powder eyeshadow
eyeshadow brush
black powder eyeshadow
sponge-tip applicator
individual lashes (all sizes)
adhesive
eyelash curler and black mascara
dark burgundy lip pencil
dark brown-red lip color
lip brush
brown brow pencil

1

For this particular look the brow shape is very important. On Drew we covered them over. (*For special instruction, see page 28.*)

2

Concealer is applied lightly under the eyes.

3

Smooth loose face powder over the face with a powder sponge.

4

Using white eye pencil, draw on the inside rim of the eyes and into the lashes. (You may have to repeat this step later to strengthen the look.)

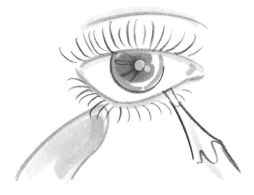

5

A dark brown powder eyeshadow is applied, starting at the outside corner of the eye, following the crease of the eye all the way to the upper *inner* corner of the eye (near to the beginning of the brow).

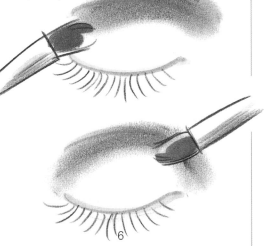

6

Using the residue left on your brush, stroke a soft shadow beneath the lashes in the under-eye area.

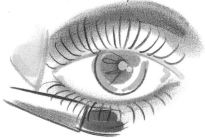

7

Apply black eyeshadow with sponge-tip applicator to the entire length of the upper lashline. Smudge into the crease to create a smoky effect.

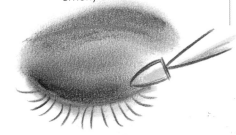

8

Now, affix just a few individual eyelashes (a bit longer than your own) to the outer third of the top eyelid (creating a "butterfly" effect). (*For more detail on applying lashes see page 40.*) Be sure to cover over adhesive with black powder eyeshadow, *after* it has dried.

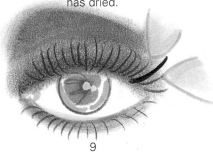

9

Once lashes are dried, curl with the eyelash curler and apply black mascara to top and bottom lashes.

10

Taking a dark burgundy lip pencil, draw in the lip shape.

11

Using the lip brush, fill in the entire mouth with a dark red-brown matte lip color. Blot, re-apply and blot again.

Now, draw on the brow.

12

This face is very dramatic and the eyebrows convey different emotions depending on how they are drawn.

Using a brown brow pencil, draw the shape of the brow, generally starting above the *natural* brow line (use Drew's as a guide). Soften the line with a sponge-tip applicator, being careful not to widen it. (*Remember, with rare exception, the Thirties eyebrows were pencil thin.*)

Drew Barrymore

the Temptress

Throughout the Twenties and Thirties there was a vogue for Oriental beauty. It showed up in architecture, decor, clothing, and photography. In Hollywood, however, Anna Mae Wong was one of the few who came to embody this ideal of beguiling, mysterious Eastern beauty in the flesh. Without a trace of Asian heritage, Andie MacDowell brings her own exotic qualities to this look. Her high cheekbones and pale skin contrast well with the black wig and dark glossy lips. This look can be worn (with modifications for personal taste) by a person of any ethnicity, age, *or* gender.

concealer (if needed)
translucent face powder and sponge
face tape and astringent (optional)
brow brush
dark brown brow pencil
black eye pencil
sponge-tip applicator
white frosted powder eyeshadow
black mascara
apricot and golden-yellow powder blush
medium flesh-toned lip pencil
glossy dark-red lip color
lip brush

1

A small amount of concealer should be used only where needed and blended in.

2

Face powder is distributed (with a powder sponge) all over the face.

3

(Optional)
This is the only photo, besides "the Player," where face tapes were used to slightly change the shape of the eye. (*See page 145 for details.*) Then hairstylist Clyde Haygood fashioned this beautiful jet-black wig to cover over the tapes.

4

Brows are brushed together and filled in, using a dark brown brow pencil to create a strong dramatic line.

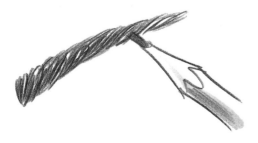

5

Line the eyes with black eye pencil, on both the upper and lower rims, smudging into the lashline.

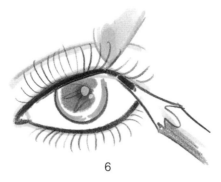

6

Use the sponge-tip applicator to help diffuse and "wing" the pencil line outward and upward.

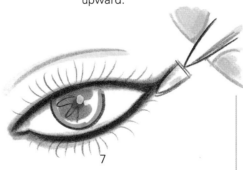

7

White frosted powder shadow is swept over the entire eyelid, using the rounded side of the sponge-tip applicator. (This also helps to soften the "edge" of the black eye pencil.)

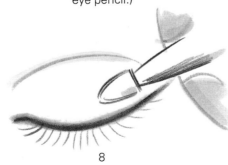

8

For this photo, lashes were not curled, but a light coat of black mascara added definition without *distorting* the shape.

9

Apricot *and* golden-yellow powder blush are used on the temples and cheeks.

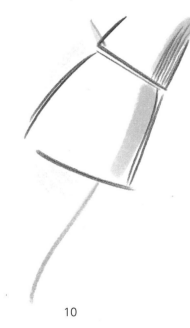

10

Lips are lined with a medium flesh-toned pencil, followed by a glossy dark-red lip color, blotted and re-applied.

Andie MacDowell

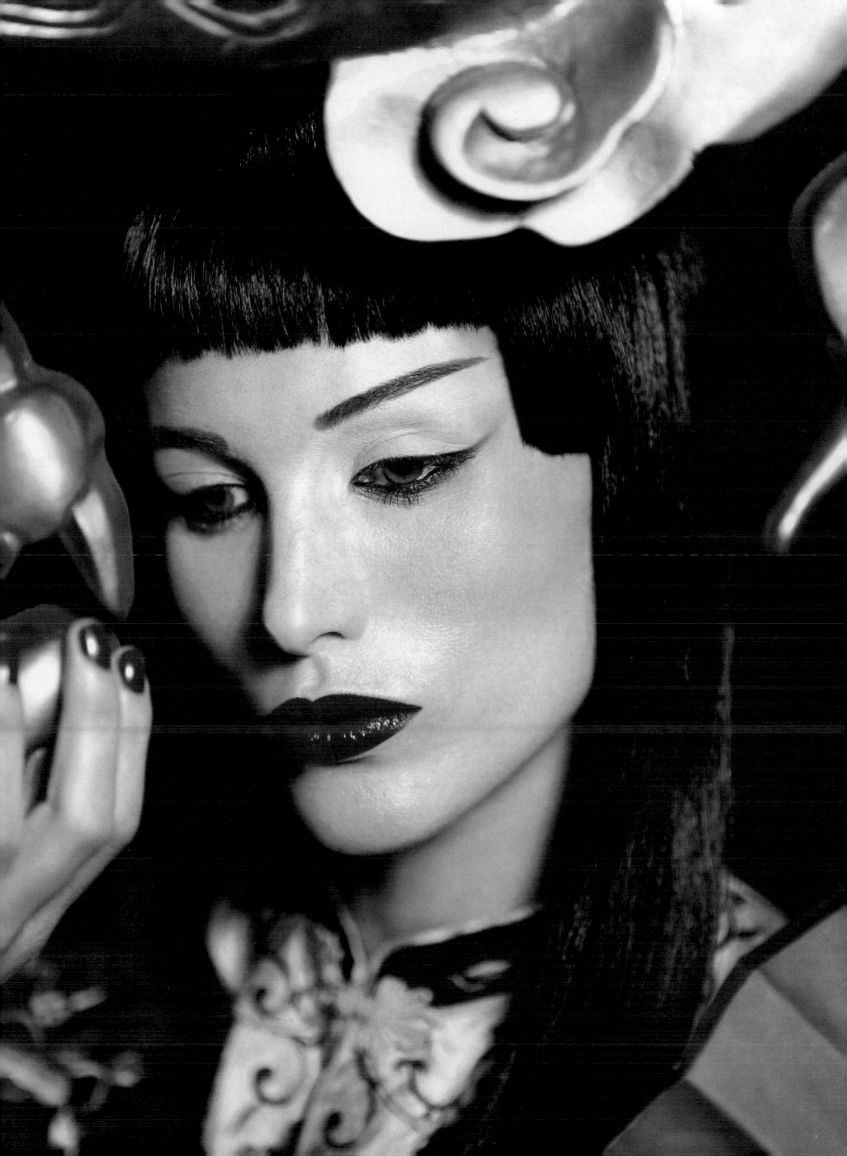

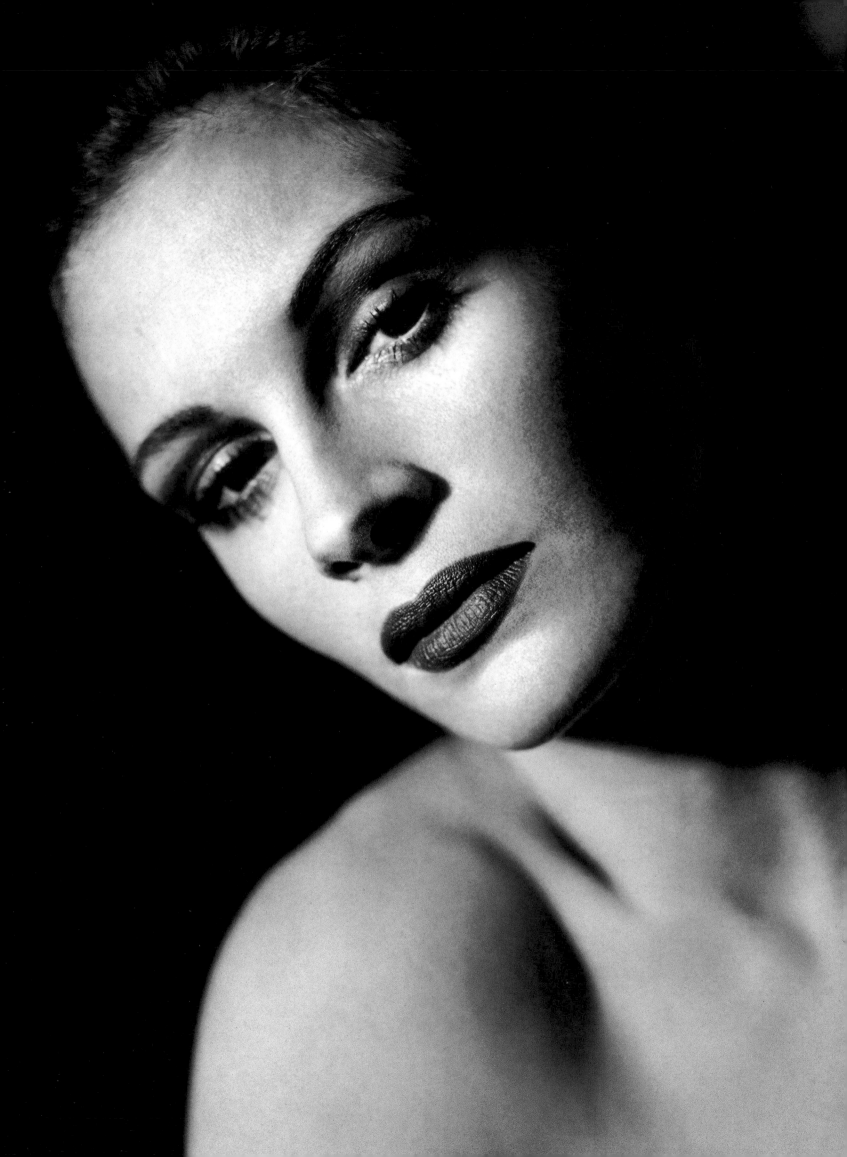

the *Siren*

Wartime 1940s America created a need for escape and fantasy. And Hollywood was ready, as always, to exploit the average citizen's need to dream. Hedy Lamarr, Gene Tierney, and especially because of her flaming red hair, Rita Hayworth, were the paramours, glamour queens and sirens of their time. Taking the name from Greek mythology, these celluloid goddesses lured and transfixed legions of moviegoers with an arched brow and come-hither stare. Julia Roberts, with her seductive gaze and sensual eroticism, is a modern-day version of this eternal femme fatale.

concealer (if needed)
shimmery gold liquid foundation
foundation sponge
translucent face powder
gray-brown creme eyeshadow
eyeshadow brush
dark brown brow pencil
eyelash curler and black mascara
light apricot powder blush
blush brush
dark flesh-toned pencil
dark berry lip color

1

Concealer used only if, and where, needed.

2

Smooth shimmery gold liquid foundation all over the face to create a soft, sheer, luminous finish. (For Julia, liquid was also blended onto neck, shoulders, and collarbone.)

3

Lightly powder all over using the sponge.

4

Sweep gray-brown creme eyeshadow all over the eyelid, up and over the crease and under the eye. Edges are blended to create a soft contrast between the *light* browbone and *dark* crease areas.

5

Brows are penciled in using a dark brown brow pencil. The idea is to create a strong, structured eyebrow with a seductive curve.

7

Lashes should be curled and mascaraed, more for length than thickness.

6

The cheeks are softly emphasized with a light apricot powder blush.

8

Lips are lined in a dark flesh-toned lip pencil. After using the same pencil to fill in the remainder of the lip, use dark berry lip color to cover the entire mouth. Blot, re-apply and blot again.

Julia Roberts

the *Exotique*

Merle Oberon was one. So, too, was Luise Rainer (though sadly she is not as well known today, even though she did win two best actress Oscars for *The Great Ziegfeld* and *The Good Earth*). And without a doubt, Cher is the most famous contemporary example of this rarefied group. To qualify as one you must have that indescribable hard-to-place look that is usually the mix of many ethnicities and results in the most stunning and beautiful combinations. The best makeup application always brings out their remarkable bone structure and makes them look like living sculptures.

sheer foundation
apricot creme blush
brownish-burgundy creme eyeshadow
eyeshadow brush
translucent face powder
circular sponge
medium brown eyebrow pencil
eyelash curler and black mascara
medium flesh-toned lip pencil
petroleum jelly

1

Sheer foundation is smoothed from the center of the face blending outward.

2

Apricot creme blush is blended onto the cheeks.

3

Apply brownish-burgundy creme eyeshadow to the eyelids with an eyeshadow brush, sweeping color softly under the eyes.

4

Loose face powder is lightly applied all over the face, to help set the makeup.

5

Brows are brushed and lightly filled in with a medium brown brow pencil.

6

Lashes are curled and enhanced with black mascara.

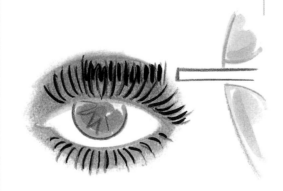

7

Lips are lined in a medium flesh-toned lip pencil.

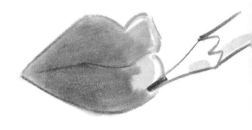

8

Petroleum jelly is applied to the eyelids and lips using an eyeshadow brush.
(Note: you can substitute a high shimmer eyeshadow for the jelly on the eyelids. It will give you less shine, but it is more long-lasting.)

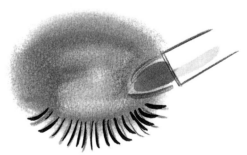

Cher

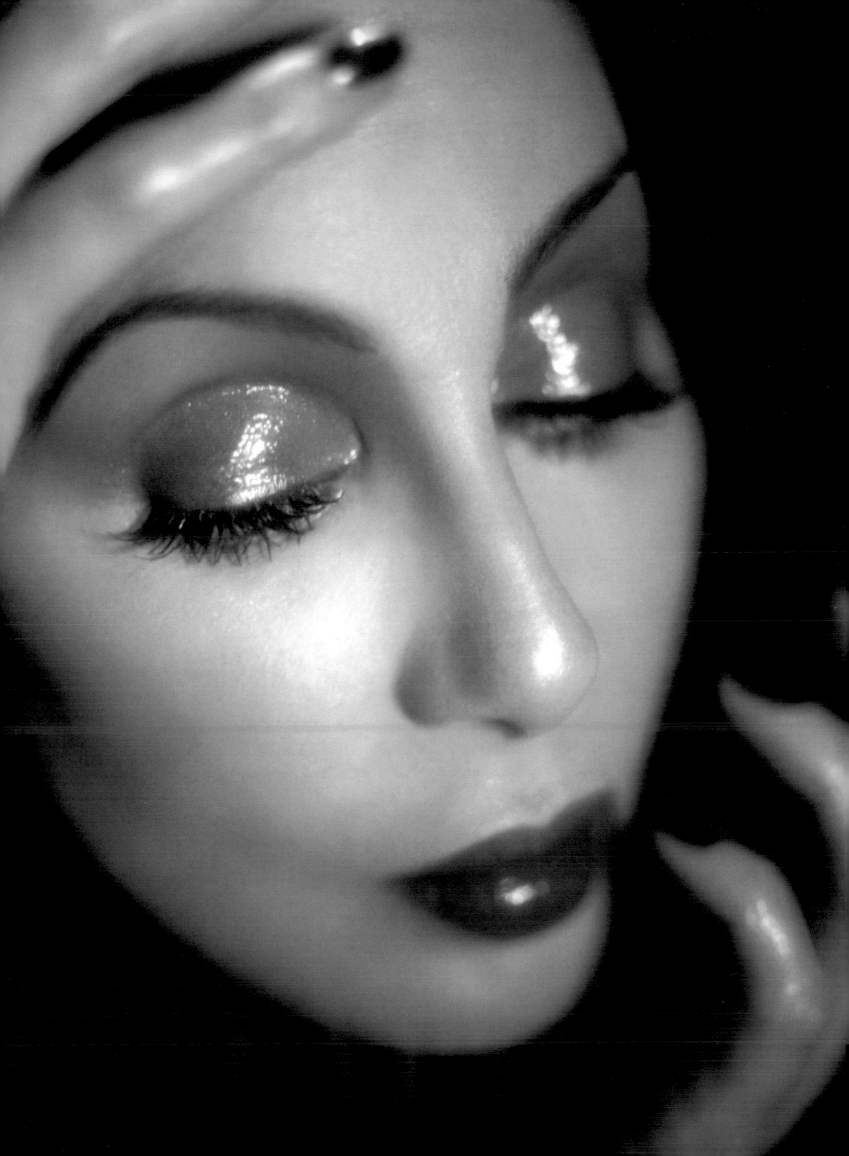

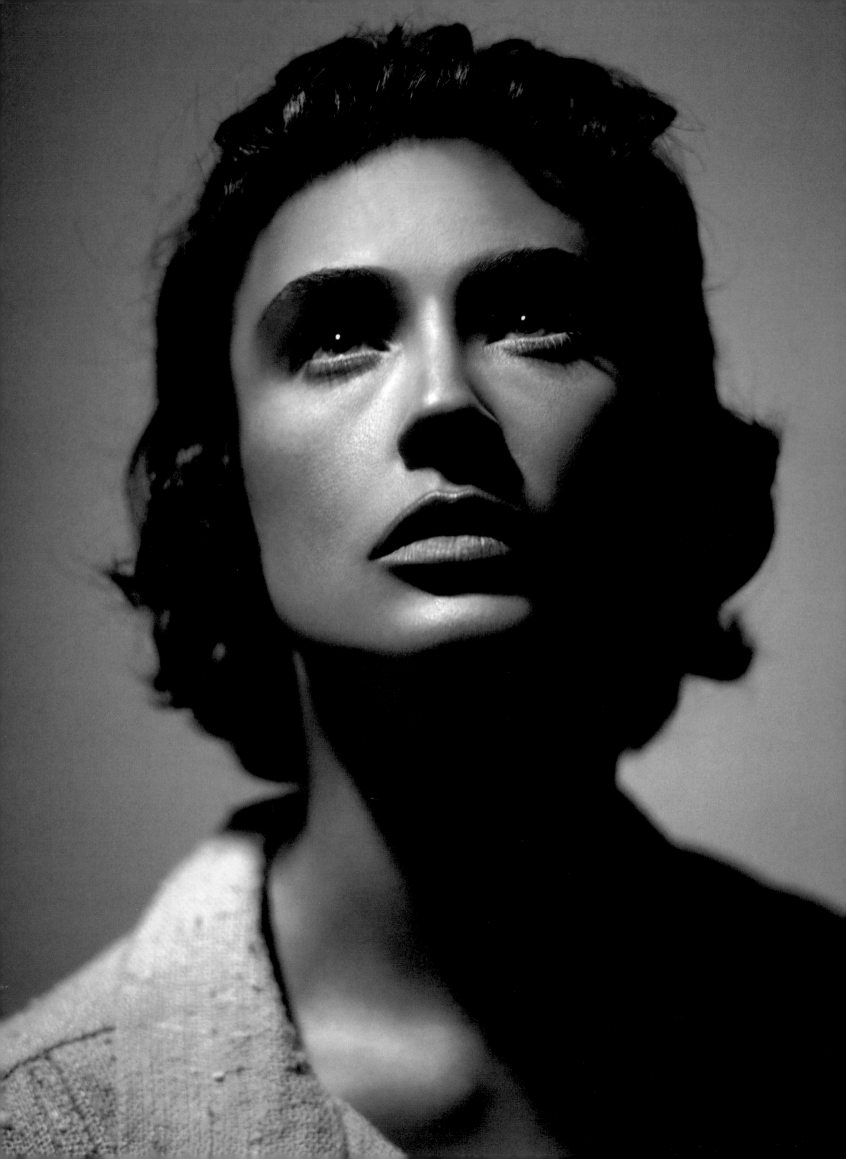

These brave women possess determination and strength in their convictions. From the mythic to real-life, from Joan of Arc to Amelia Earhart, they shoulder their burdens with remarkable grace and stature. Their look was ethereal yet practical to the point of androgyny. Accepted notions of what is beautiful and how to look were not important. To them, it was beside the point. In this take-off of a take-off, Demi Moore, herself a stretcher of boundaries, pays homage to the indomitable Ingrid Bergman, who in turn was playing the role of the famous martyr Saint Joan in the classic 1948 film.

pink liquid blush
neutral brown creme eyeshadow
eyeshadow brush
beige eye pencil
eyelash curler
clear mascara
brow brush
flesh-toned lip pencil

1

For this look (and this photo) no foundation, concealer or powder was needed.

2

Dab and blend liquid blush on cheeks, temples and *tip* of the chin.

3

Neutral brown creme shadow is blended into the crease of the eye and down onto the lid and lashline.

4

Beige eye pencil is drawn just on the *bottom* inner eye rim.

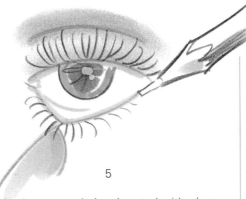

5

Lashes are curled and coated with *clear* mascara.

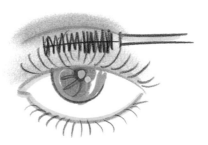

(Clear mascara adds shine and weight to the lashes without making them looking made up and helps to hold the curl.)

6

Brush brows upward and, if you like, set with clear mascara.

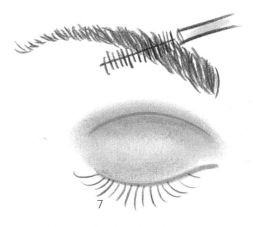

7

Lips are lined and...

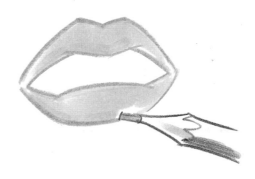

...filled in with a flesh-toned lip pencil.

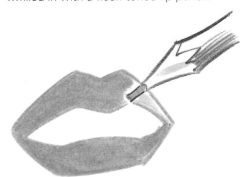

Demi Moore

the Bombshell

Lightly arched eyebrows, glossy red lips, satiny powder-soft eyeshadow, lush eyelashes with ample mascara, and foundation with a healthy tone to imply vitality were the signature cosmetic features of the Bombshell. This zaftig group included Jayne Mansfield, Betty Grable and, of course, Marilyn Monroe, easily the most unique and complex of them all. Lisa Marie Presley's own sexy "bedroom eyes" and flaring upper lip are played up to recall the breathy and voluptuous star. The added touch of a blond wig (straight from Tinseltown) completed the transformation. The resulting resemblance is amazing.

liquid foundation
concealer and sponge
translucent face powder
circular sponge
golden-brown brow pencil
clear mascara
medium brown powder eyeshadow
eyeshadow brush
white frosted powder eyeshadow
black liquid eyeliner
false strip eyelashes
eyelash curler and black mascara
rosy-pink powder blush
blush brush
red flesh-toned lip pencil
true red lip color
clear red lip gloss
lip brush

1

Use concealer to lighten the under-eye area.

2

Smooth liquid foundation on the center of the face and blend outward.

3

Distribute loose powder all over the face with a sponge. Extra powder is dusted onto the bridge of the nose, under the eyes and onto the chin.

4

Brows are lightly penciled with a golden-brown eyebrow pencil, followed by a sweep of clear mascara. (If you have dark brown-to-black brows use a similar pencil color.)

5

Medium-brown powder eyeshadow is applied to the crease of the eyelid and blended well.

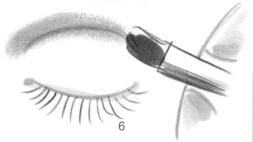

6

Then white frosted powder eyeshadow is blended onto the lid and browbone, sweeping outward and downward.

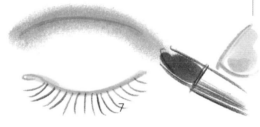

7

Line the lashline (as close to lashes as possible) with black liquid liner, sloping downward.

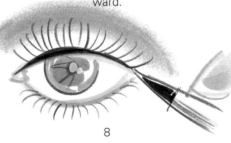

8

Once the eyeliner has dried, false strip lashes are glued right on natural lashes. For this look, strip lashes are pushed down at the ends *while* drying (for a sleepy-eyed effect).

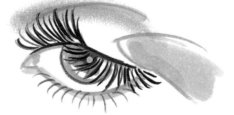

9

Apply black mascara to top and bottom lashes.

10

Using a thin eyeshadow brush, draw a line under the eye, starting where the lashes begin. Slide the brush away from the inner eye, sloping downward past outer lashes.

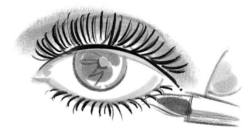

11

Rosy-pink powder blush is swept onto cheeks with brush.

12

Lips are lined in a red flesh-toned lip pencil, then filled in. Follow with true red lip color, blot, re-apply, and blot again. Follow with clear red gloss in the center of bottom lip, using your fingertip or for more accuracy, a lip brush.

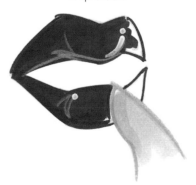

13

As a final touch, use a black pencil or liquid liner to make a beauty mark on the cheek.

Lisa Marie Presley

the Icon

We worship and adore them. To us they seem untouchable, beyond reality, but still ceaselessly and alluringly human. We want to emulate and grow up to be like them. Few exist in our own lifetimes. The names become part of our descriptive language: Elizabeth Taylor, Marlene Dietrich, Greta Garbo…With a mixture of strength and vulnerability, talent, charm, and breathless beauty, Dorothy Dandridge transcended all barriers, albeit briefly, and represented the dawn of a new era for African Americans. Janet Jackson is not only a great admirer, but bears a striking physical likeness to this timeless icon.

This is only a slight variation on the makeup for Lisa Marie Presley's "Bombshell." Here the eyes are not as intensely mascaraed and the lips are colored in a more subdued shade of red. Otherwise all the tools and products are the same. Choices for you depend on your skin tone and personal preference. Here are other slight variations:

Lips

Lip liner is a **dark flesh tone**, followed by a **matte red lip color**, blotted, re-applied and blotted again. Cover with **clear lip gloss**.

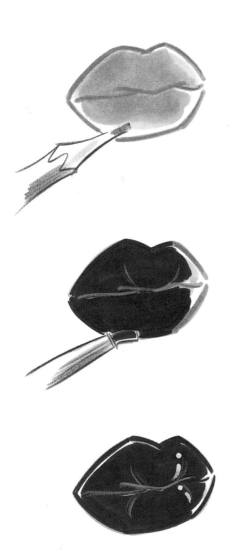

Lids

Frosted white powder eyeshadow is replaced with **frosted gold**.

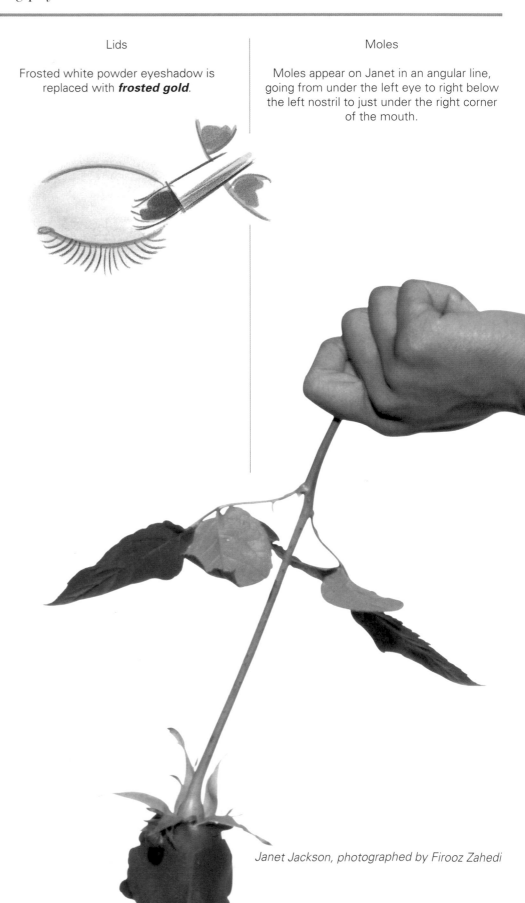

Moles

Moles appear on Janet in an angular line, going from under the left eye to right below the left nostril to just under the right corner of the mouth.

Janet Jackson, photographed by Firooz Zahedi

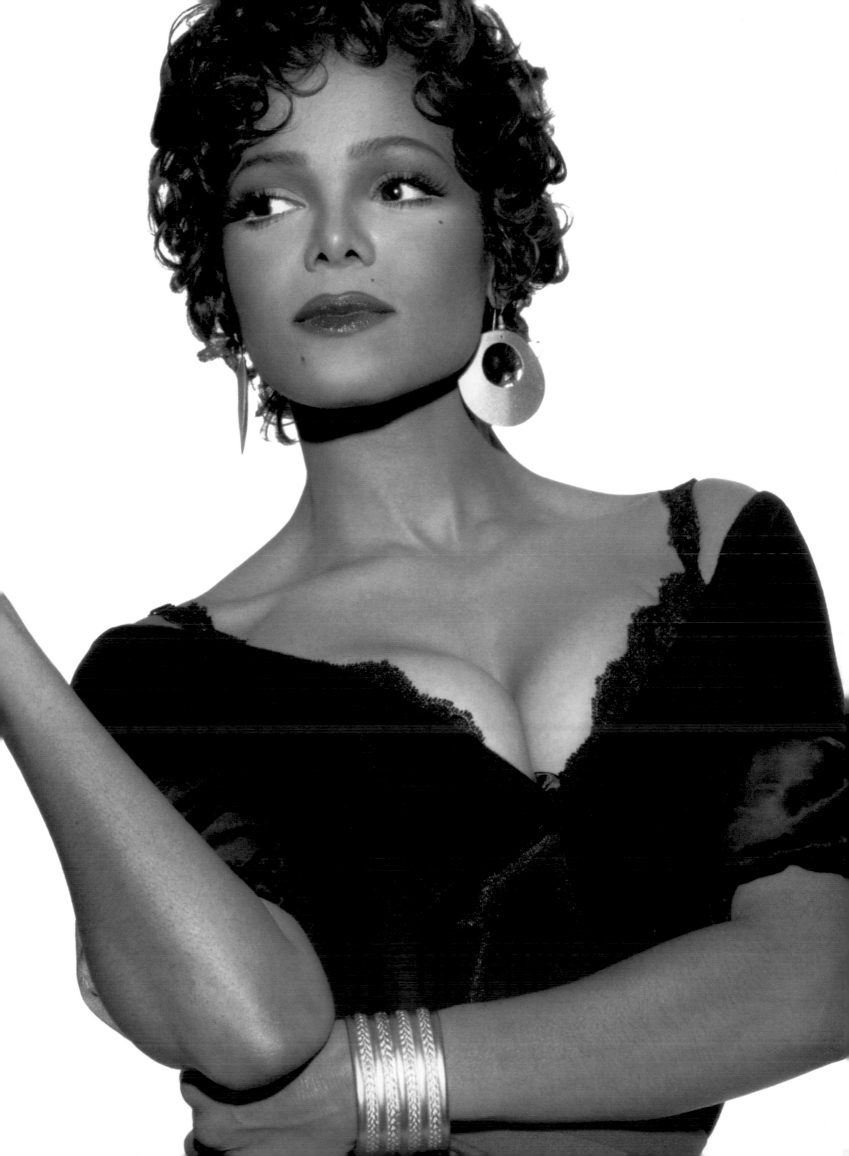

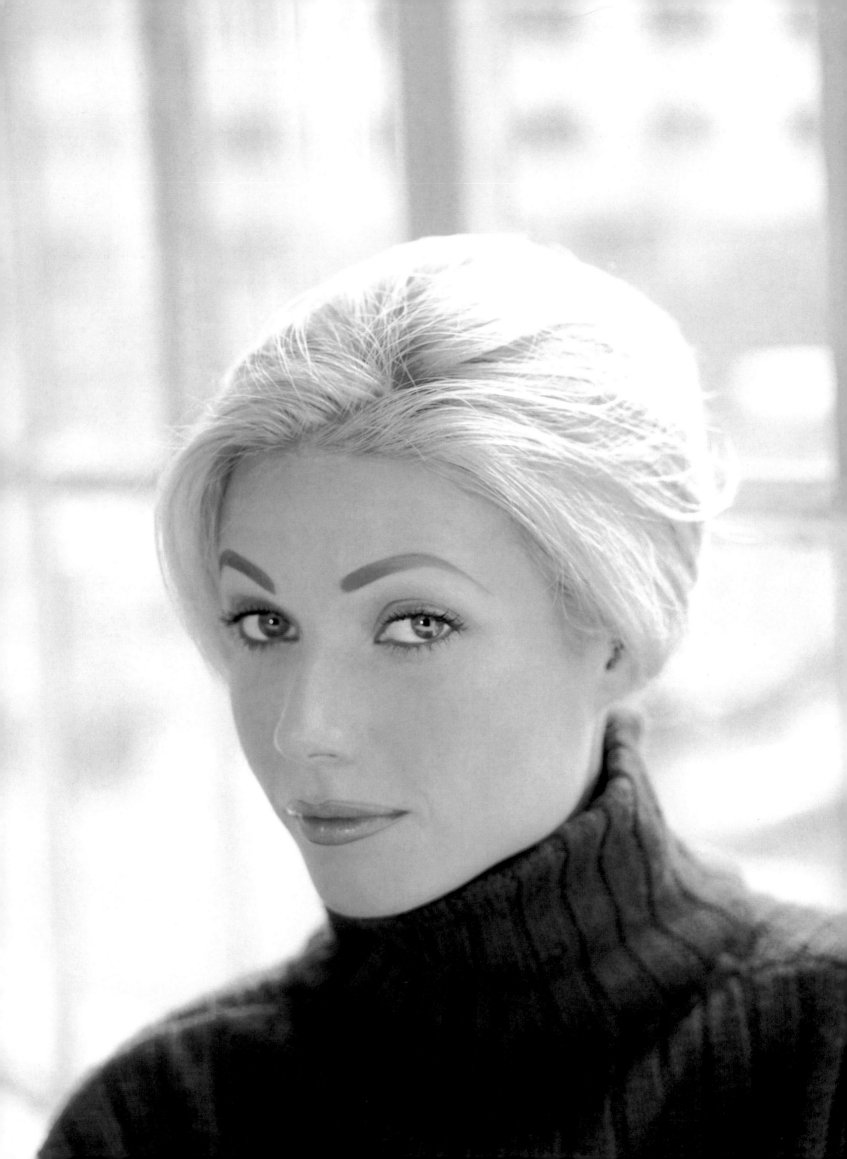

Audrey Hepburn is usually the first person who comes to mind when we hear the word "gamine." But she wasn't the only female star who sported the look. Think of Pier Angeli or Leslie Caron. Blondes, too, had fun with the look, from Jean Seberg to Kim Novak (recall her bedroom scene in *Vertigo*). The important thing was to look boyish, while remaining decidedly feminine. Think of a girl wearing her boyfriend's sweater on a chilly fall afternoon. Gwyneth Paltrow is a perfect Nineties version, here sporting the gamine's hallmarks of thick drawn-on brows and soft, pale lips.

concealer
translucent face powder
medium brown brow pencil
clear mascara
eyelash curler
dark brown mascara
soft rose blush and blush brush
flesh-toned lip pencil
semi-transparent pink lip gloss

1

Concealer should be used just where needed. Here it was lightly applied and blended under the eye with my fingertip.

2

Then the skin is lightly powdered for a soft matte finish.

3

Next, brows are accentuated with a medium brown eye brow pencil. (The shape depends, of course, on your own natural brow shape.) But try to draw the brow *above* the natural brow line, *not below*. Use the shape done on Gwyneth as a guide.

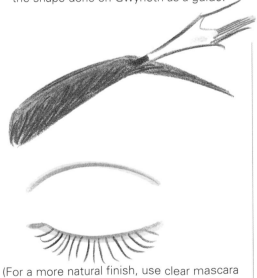

(For a more natural finish, use clear mascara to sweep eyebrow hairs over brow area.)

4

The lashes are *lightly* curled followed by dark brown mascara.

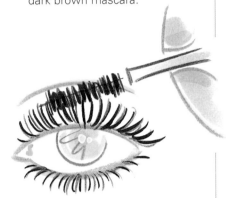

5

Follow with a soft rose blush applied to the apples of the cheek for a healthy, rosy glow.

6

For *soft* definition the lips are lined in a flesh-toned lip pencil, then filled in.

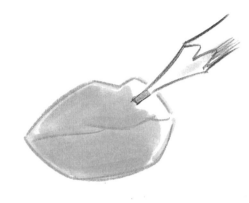

7

Last, a semi-transparent pink lip gloss is applied over the lip pencil.

Gwyneth Paltrow

the Chanteuse

They were able to bring any audience to tears, all in the time it took to sing a four-minute song. Their exceptional voices, paired with a past filled with challenges well met, defined these intensely intimate and expressive souls. Billie Holiday, Edith Piaf, Lena Horne and Eartha Kitt are just a few examples of the Chanteuse. Gifted with this same poignant and seductive power, Vanessa Williams, no stranger to adversity herself, is a rarity among today's performers. Coupled with her stunning beauty, she effortlessy transports us to a dark, velvet-draped room filled with shadowy figures entranced by her mesmerizing presence.

golden-honey stick foundation
golden liquid highlighter
light golden-tawny liquid foundation
translucent face powder
powder sponge
chestnut brown brow pencil
pale beige shimmer creme eyeshadow
eyeshadow brush
warm chestnut brown creme eyeshadow
black liquid eyeliner
eyelash curler and black mascara
beige eye pencil
medium flesh-toned lip pencil
cotton swab
opalescent pink lip gloss

1
Stick foundation (golden-honey-colored for Vanessa) is applied to the center of the face, under eye, eyelids, nose, forehead, and around the mouth and blended outward.

2
Golden liquid highlighter smoothed over a light golden-tawny shade is placed under the eyes, down the center of the nose and around the mouth.

3
Loose powder is applied lightly all over the face with a powder sponge.

4
Next, extra loose powder is placed under the eyes and down the center of the nose and chin, to catch falling eyeshadow and ultimately create a highlighted effect.

5
Brows are filled in using a brow pencil. Here it was chestnut-brown, bringing the natural arch as far out as possible.

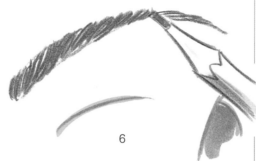

6
Pale beige shimmer creme eyeshadow is applied to the lids and graduated upward to the browbone using an eyeshadow brush. Blend well.

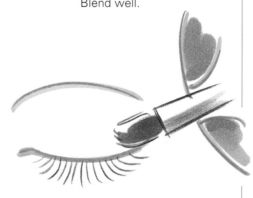

7
Warm chestnut-brown creme eyeshadow is applied in a semi-circular manner to the *outer* upper and lower eye area.

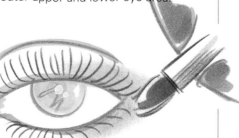

8
Black liquid liner is applied at the lashline, beginning at the inner eye and extending slightly beyond outer eye corner.

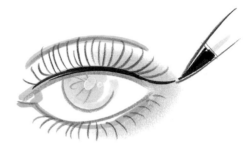

9
Curl the lashes and then use black mascara on top and bottom lashes.

10
Next, apply beige eye pencil on lower inner rims.

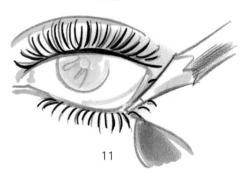

11
Line lips with medium flesh-toned lip liner. Using a cotton swab, blend liner, fading inward.

12
Opalescent pink lip gloss applied with a brush finishes the look.

Vanessa Williams, photographed by Sante D'Orazio

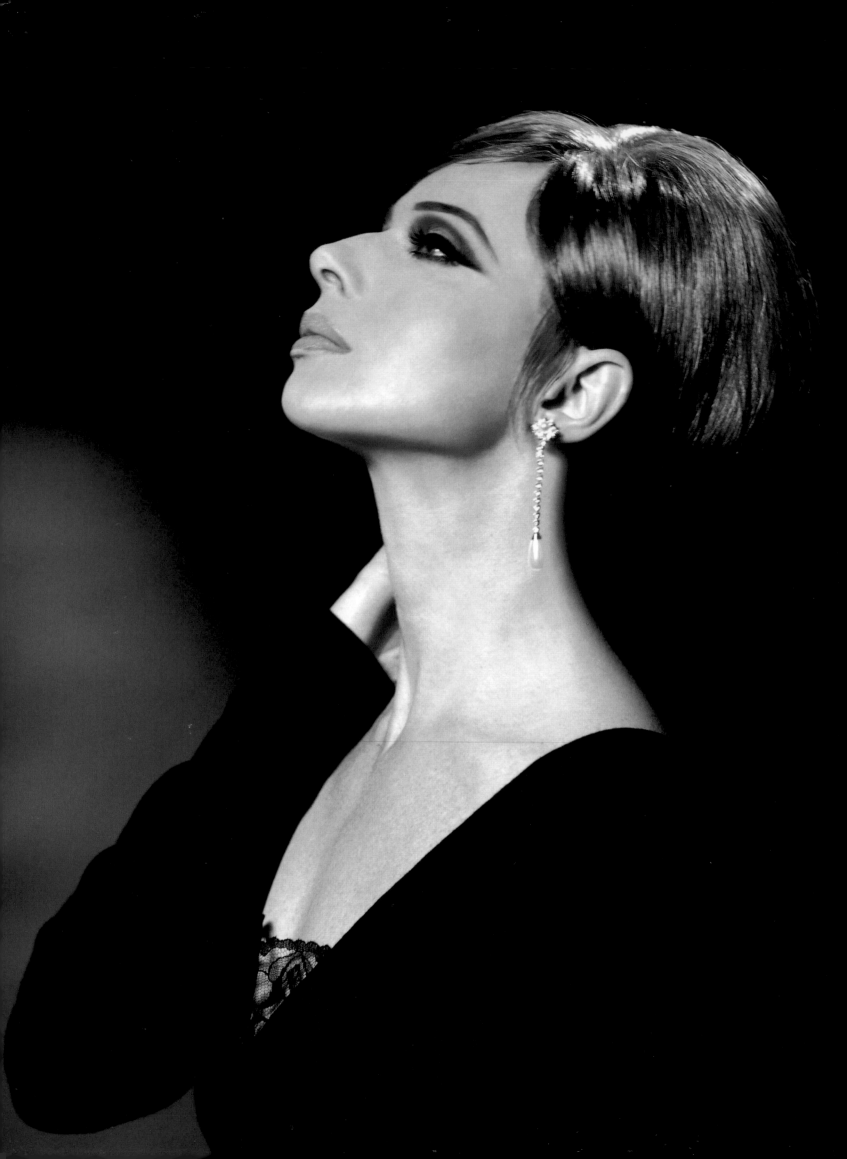

The Diva role in opera was always occupied by the most celebrated individual in the company. These powerful, dynamic women (from Maria Callas to Jessye Norman) commanded attention just by their mere presence. Outside of that arena, Barbra Streisand and Cher have shown the same strength and brilliance. Their enormous talents are not limited to one area of work; rather they move from singer to actress to director with amazing style and wit. Multi-talented Isabella Rossellini, with her magnificent profile, shows how with just the turn of the head you can capture the attention of anyone in the room.

concealer
translucent face powder
powder sponge
light brown brow pencil
brown powder eyeshadow
eyeshadow brush
black liquid eyeliner
(delicate) full strip lashes
eyelash curler and black mascara
soft pink powder blush
flesh-toned lip pencil
cotton swab
semi-transparent lip gloss

1

Concealer is used only to lightly "clean-up" the skin.

2

Loose powder is applied all over the face with a powder sponge and smoothed in.

3

Brows are lightly defined with a light brown pencil into a slightly dramatic arch.

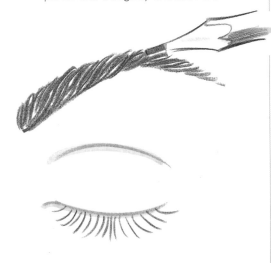

4

Brown powder eyeshadow applied with a pointy eyeshadow brush was used to define the crease and under the eye. Blend edges, but maintain intensity in the crease area.

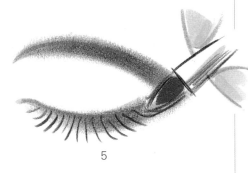

5

Black liquid liner is the "signature" of the Diva look. Apply liner as close as possible, extending well past outer lash. Liner should follow a straight line outward, not up or down.

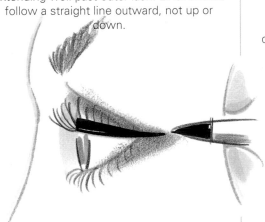

6

Delicate false lashes are applied next to the lashline and lightly curled.

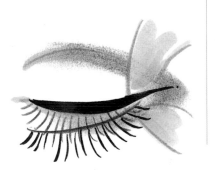

7

Follow by mascara on top and bottom.

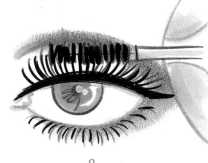

8

Soft pink powder blush is sparingly applied to the cheeks.

9

A flesh-toned lip pencil is used to softly define the lip line, softly blended in with a cotton swab.

10

The finishing touch is a coat of semi-transparent lip gloss.

Isabella Rossellini

the *Ingenue*

The Ingenue's naivete and wonderment were a large part of her appeal, but along with all her virtues there was the undercurrent of her alter-ego, the sex kitten. Of course there were others, like Pamela Tiffin and Tuesday Weld, but Ann-Margret was the most famous ingenue of the Sixties. With her pale, sensual lips and soft doe eyes, she charmed many a hardened soul. It would be hard to find this type of girl in our harshly realistic times. Nicole Kidman's delicate features and chameleon-like ability to adapt to any role, bring this neo-Lolita character to life.

foundation
translucent face powder
powder sponge
golden-brown brow pencil
dark brown liquid eyeliner
cool brown powder eyeshadow
pale beige shimmer powder eyeshadow
eyelash curler and black mascara
soft pink powder blush
blush brush
light flesh-toned lip pencil
cotton swab
pinky-beige creme lip color
lip brush

1

A light texture and color foundation is smoothed onto the center of the face and blended outward.

2

Next, apply loose powder all over the face, with the sponge.

3

Using a golden brown eyebrow pencil, fill in the brow area.

4

Apply dark brown liquid liner just to upper lashline.

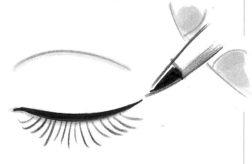

5

Cool brown powder eyeshadow is swept into the crease and under the eye and blended well.

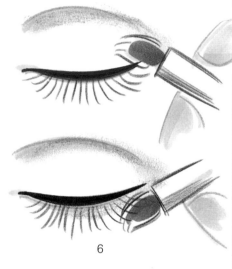

6

Apply pale beige shimmery powder eyeshadow to the entire eyelid area.

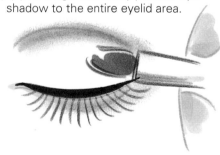

7

Curl the lashes and apply black mascara, top and bottom.

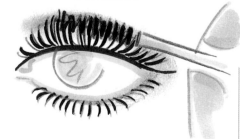

8

Soft pink powder blush is dusted onto the cheeks, temples, chin and sides of neck for a healthy glow.

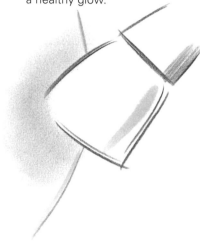

9

Light flesh-toned lip liner is applied around the mouth and softly blended with a cotton swab.

10

Last, pinky-beige creme lipstick is applied all over the mouth, blotted, re-applied and blotted again.

Nicole Kidman, photographed by Herb Ritts

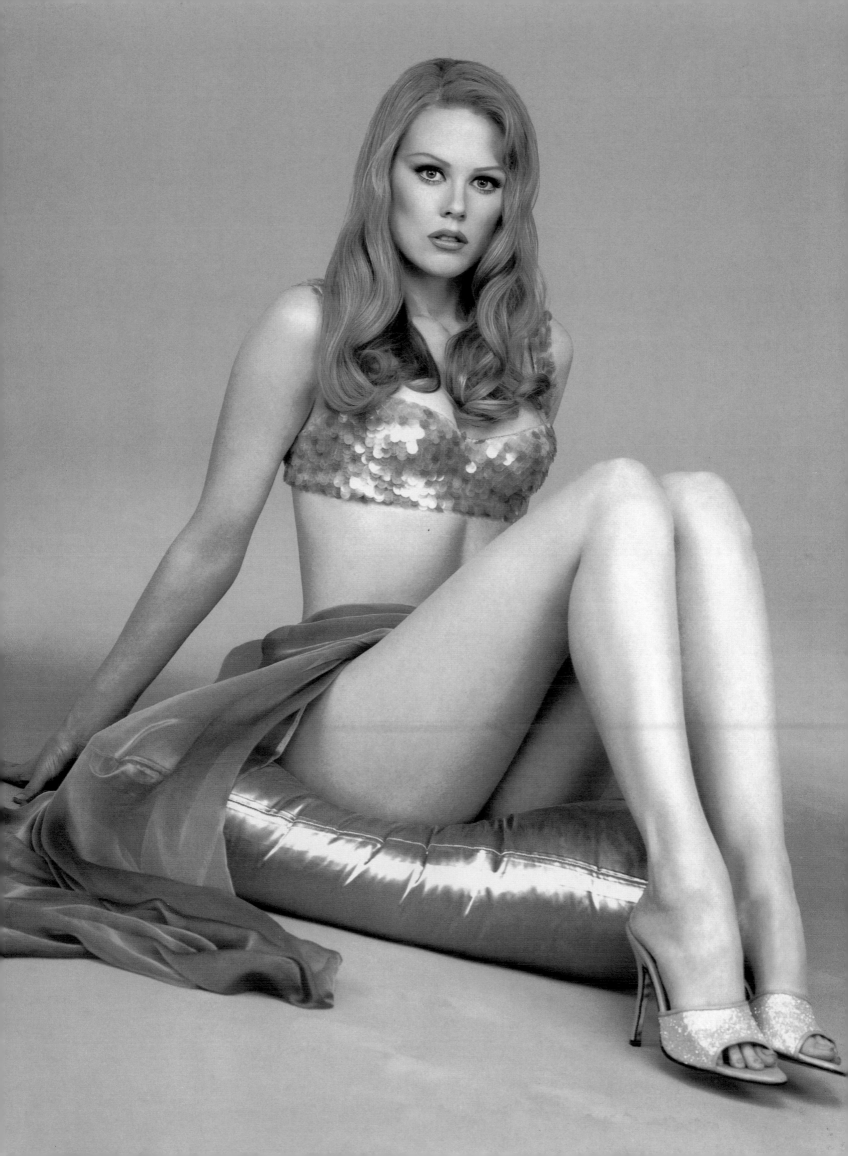

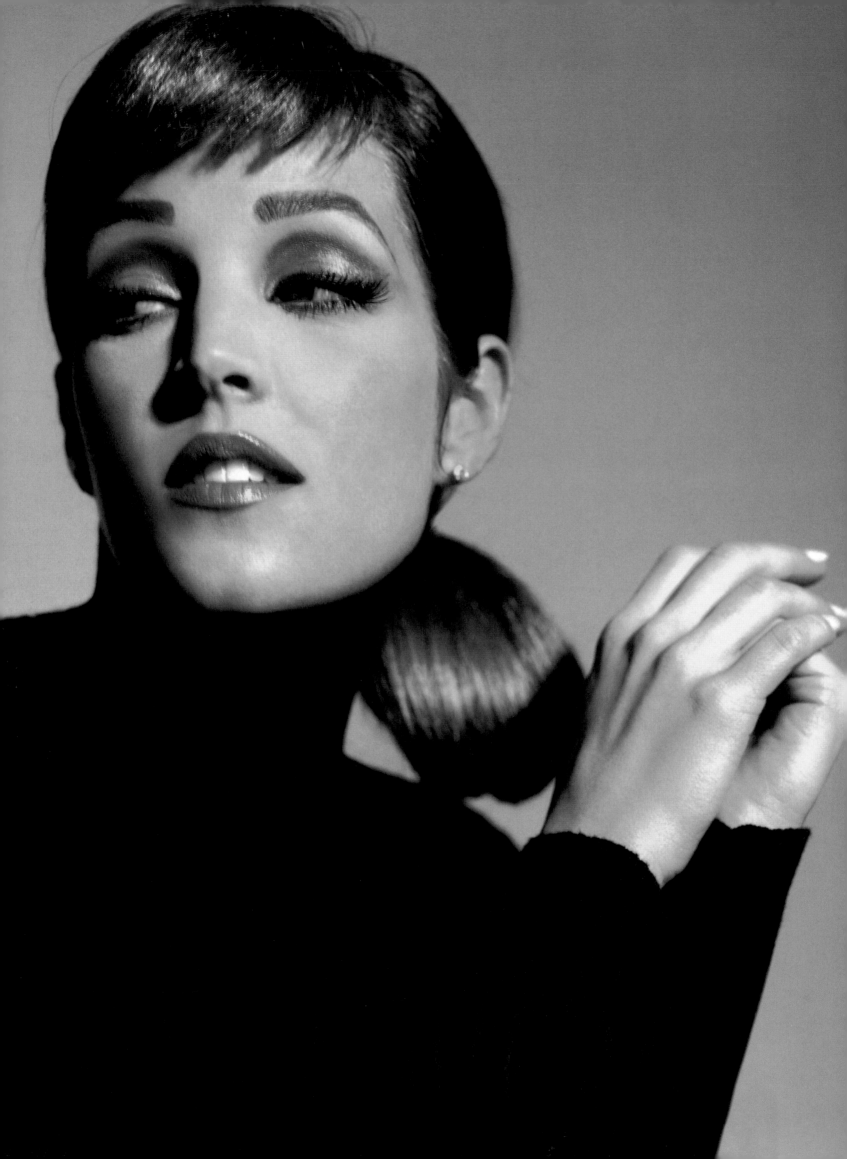

With her carefully applied eyeliner, precise eyebrows, and light, glossy lips, this Sixties "cool cat" could be seen dancing the Frug or the Pony at the "grooviest" club in town, at a backyard barbecue or serving fondue for a ranch-style house full of guests. Very Mary Tyler Moore à la Laura Petrie. Showing amazing versatility, Lisa Marie Presley made an easy transition from her earlier incarnation (as the Bombshell) to this crowd-pleasing party girl. With her hair pulled back in a tight, springy ponytail and wearing a flirtatious smile, her congenial gaze seems to say, "Twister, anyone?"

concealer (if needed)
translucent face powder
powder brush
medium brown brow pencil
black liquid eyeliner
light neutral brown creme eyeshadow
pale pink blush
blush brush
flesh-toned lip pencil
cool-toned pink lip gloss

1
Use light concealer only where needed and blend well.

2
Loose powder all over the face.

3
Next, using a medium brown brow pencil, fill in the brow, fairly "squared-off" at the front and tapering to a point at the end.

4
Apply black liquid liner in a wide swath at the lashline, making sure to get the liner as close to the lashes as possible.

5
Next, light neutral brown creme eyeshadow is applied all over the lid for emphasis and sheen.

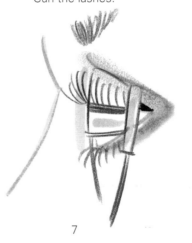

6
Curl the lashes.

7
Add a thick coat of black mascara to both top and bottom lashes.

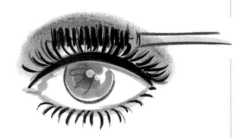

8
Apply pale pink powder blush onto the cheeks.

9
Use light flesh-toned lip pencil to define and fill in the entire mouth. Then pale cool-toned pink lip gloss is applied over the pencil.

Lisa Marie Presley

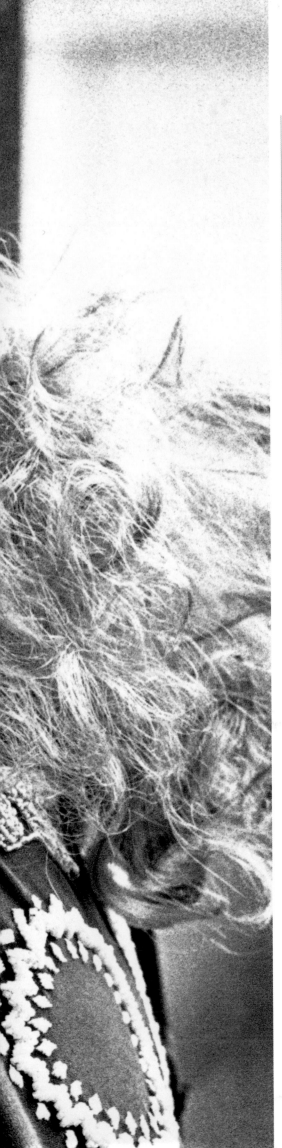

Beginning in London, the Biba look (named for a woman's clothing store) ultimately found its way into every major fashion magazine of the Sixties. A mixture of silent screen star and romantic Gypsy, she was most often seen in photography by Sarah Moon and Deborah Turbeville. Kate Moss, whose perfectly symmetrical face adapts well to any look, embodies the Biba with an ethereal, yet ambiguous, gaze.

tweezers
hair bleach (optional)
sheer foundation
translucent face powder
powder sponge
black eye pencil
eyeshadow brush
black creme eyeshadow
eyelash curler and black mascara
light pink blush
blush brush
dark-toned lip pencil
dark plum lip color
lip brush

1

Brows are tweezed and bleached to a light golden blond.

2

Next, sheer foundation is applied all over the face.

3

Apply loose powder all over the face with a sponge.

4

Then the eyes are lined with a black eye pencil, on upper and lower rims, and smudged with an eyeshadow brush to create a smoky look.

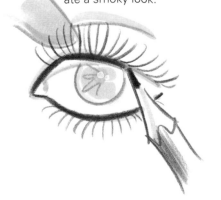

5

Next, black creme eyeshadow is applied in a circular motion around the eye. The emphasis is slightly downturned. Blend well.

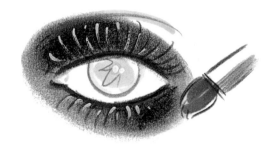

6

Extra light loose powder is used to set the edges of the creme shadow so it won't "travel." (This is also a great way to soften and seal the color.)

7

Apply black mascara to top and bottom lashes.

8

Light pink powder blush is swept onto the cheeks.

9

Last, dark-toned lip pencil is used to line the lips. The shape is a fuller version of the "Cupid's bow." Then darkest plum (almost black) lip color is applied over the pencil, blotted and re-applied.

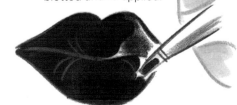

Kate Moss, photographed by Thierry LeGoues

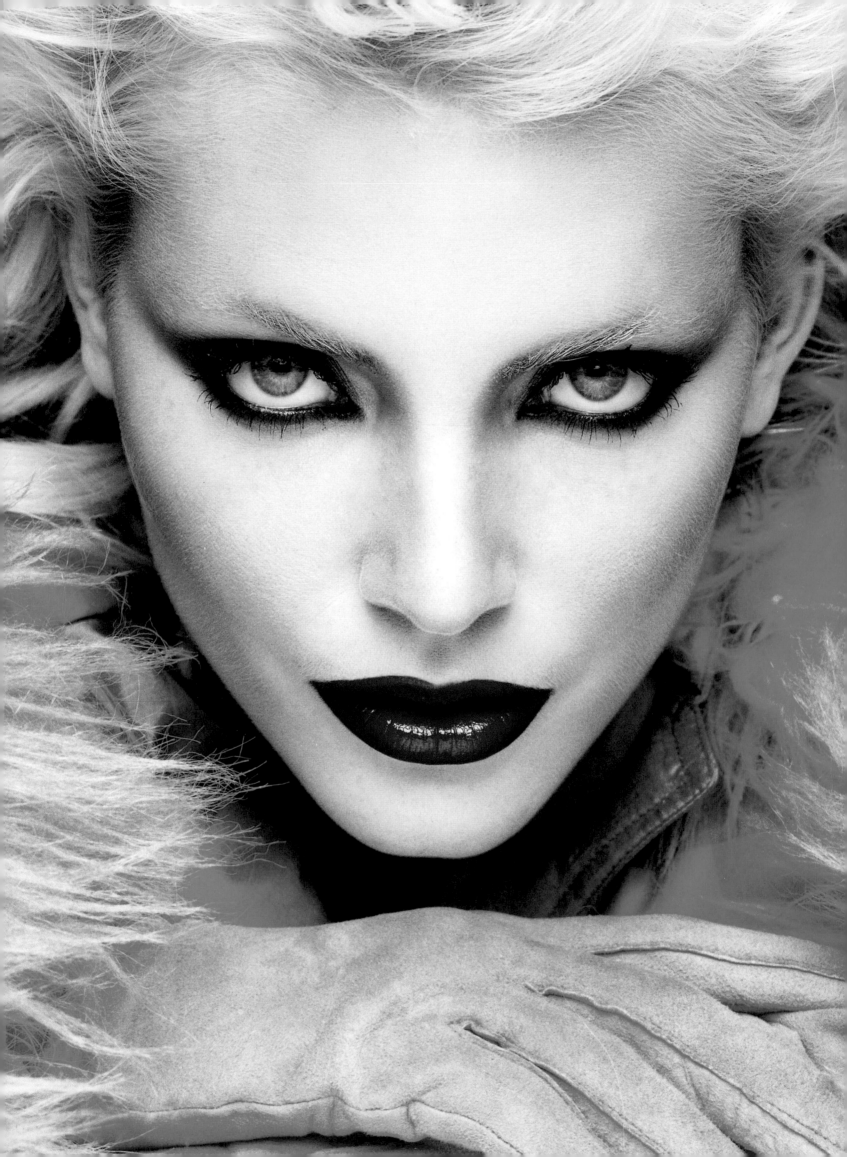

the *Model*

To the outsider, the Seventies fashion world was the fast-paced, somewhat decadent milieu of the elite, from Andy Warhol to Halston. In the film *The Eyes of Laura Mars* the fashion ideal of that maligned decade is put on full display. In homage to photographer Helmut Newton, intensely made up models in nothing but lingerie are depicted pulling each other's hair in the middle of a New York City intersection, complete with water fountains *and* burning cars. The glamour meter went right off the Richter scale. Here, gorgeous supermodel Nadja Auermann re-creates the look of the Seventies-style muse extraordinarily well.

light foundation
translucent face powder
powder sponge
light golden brow pencil
hair bleach (if needed)
black pencil eyeliner
black powder eyeshadow
golden beige shimmer eyeshadow
sponge-tip applicator
eyelash curler and black mascara
golden-yellow powder blush
hot-pink blush
blush brush
dark flesh-toned lip pencil
dark burgundy glossy lip color
lip brush

1

First apply light foundation, starting in the center of the face and blending outward.

2

Next, loose powder is applied all over the face with a sponge.

3

On bleached brows use light golden brow pencil to softly define shape.

4

Apply a thickish line of black eye pencil along the top and bottom lashline and inside the the upper and lower lashline. Blend well.

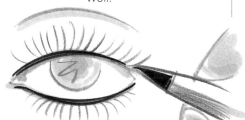

(For this photo I used black eye pencil, inside the eye rims, for even more intensity.)

5

Using a sponge-tip applicator, run black powder eyeshadow around the entire eye (top and bottom), "wing" outward and blend well.

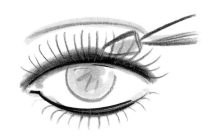

6

Also using the sponge-tip applicator, apply golden beige shimmer eyeshadow to the inner corner of the eyes and browbone.

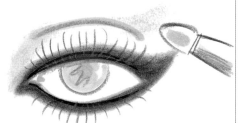

7

Apply black mascara to curled lashes.

8

Next, golden-yellow powder blush mixed with hot pink is dusted onto the cheeks with a powder brush.

9

Apply dark flesh-toned lipliner. Then fill in the entire mouth.

10

Finally, dark burgundy glossy lip color is applied with lip brush. Blot, re-apply and blot again.

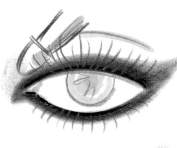

Nadja Auermann, photographed by Patrick DeMarchelier

the *Showgirl*

Forget the sleazy Nineties movie of the same name. Instead, think of Susan Anton, Joey Heatherton, Lola Falana and even Tracey Ullman's on-target character *Linda Granger*. These women were the essence of the Seventies and early Eighties. All legs and lipstick, they dazzled and entertained with over-the-top productions, costumes, and tunes. The Showgirl's camp value was part of her attraction. My friend Tom Woolley, a brilliant New York City writer, was kind enough to take on the persona (his "before" picture and another look are on the following pages). I must say, next to his predecessors, Tom looks quite demure!

face tapes (optional)
stick foundation
foundation sponge
translucent face powder
circular sponge
apricot blush
light brown powder eyeshadow
mid-brown powder eyeshadow
iridescent peach powder eyeshadow
eyeshadow brush
golden-blond brow pencil
eyelash curler and black mascara
dark brown brow pencil
medium flesh-toned lip pencil
pinkish-beige lip color
lip brush

Prepreparation: shave

1

Tape the face (if necessary) to "lift" certain areas, such as the lids and brow (*see page 145 for details*).

2

Cover over the brows, making them as flat as possible (*see page 28 for instruction*).

3

Next, stick foundation is generously applied all over the face (lids, lips, etc.), neck and chest (if it will be showing). Apply first with fingers, then blend in with a sponge. (*Stick foundation is used when maximum coverage is desired.*)

4

Set the entire face with a light translucent face powder, using a sponge

5

Lightly dust apricot blush onto the cheeks, temples, collarbones and chest.

6

Light brown powder eyeshadow is applied lightly all over the eye area (up to the brow bone *and* softly under the eye), using a medium eyeshadow brush.

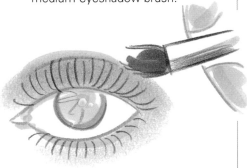

7

Apply mid-brown eyeshadow, over light brown shadow, in the crease of the eye (soften in all directions).

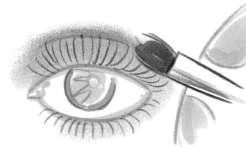

8

Apply an iridescent peach eyeshadow over entire eye area to highlight.

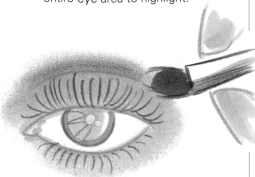

9

Using a golden-blond eyebrow pencil, draw in the brows. (Begin the line at the inside of the eye, starting slightly higher than where the real brow grows, arc the line across and taper off.)
(*This takes practice. You might want to ask a friend to help.*)

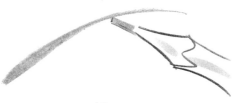

10

Curl the lashes, then apply mascara (top and bottom). (Special note: Tom has extremely long lashes naturally, so false ones weren't used.)

11

Over the blond pencil, with a dark brown brow pencil, draw in "hairs" with short, sharp strokes.

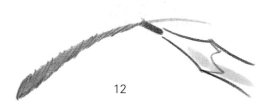

12

Outline the mouth with a medium flesh-toned lip pencil and fill in.

13

Over that, apply a pinkish-beige lip color. Blot and re-apply.

> **Question: Where did he get that cleavage?**
>
> **Answer: From shading, contouring, a padded bra and some serious "taping." (Using the kind you use to tape a box you're sending overseas!)**

Tom Woolley

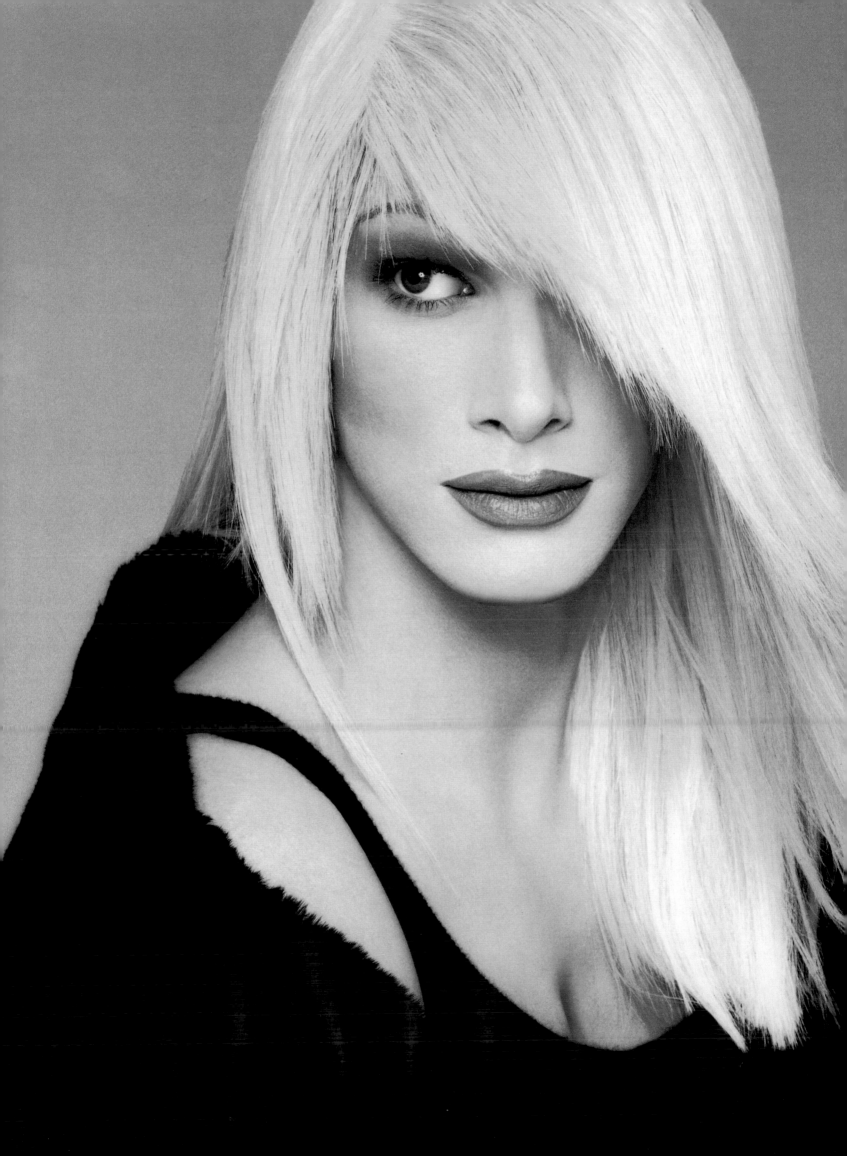

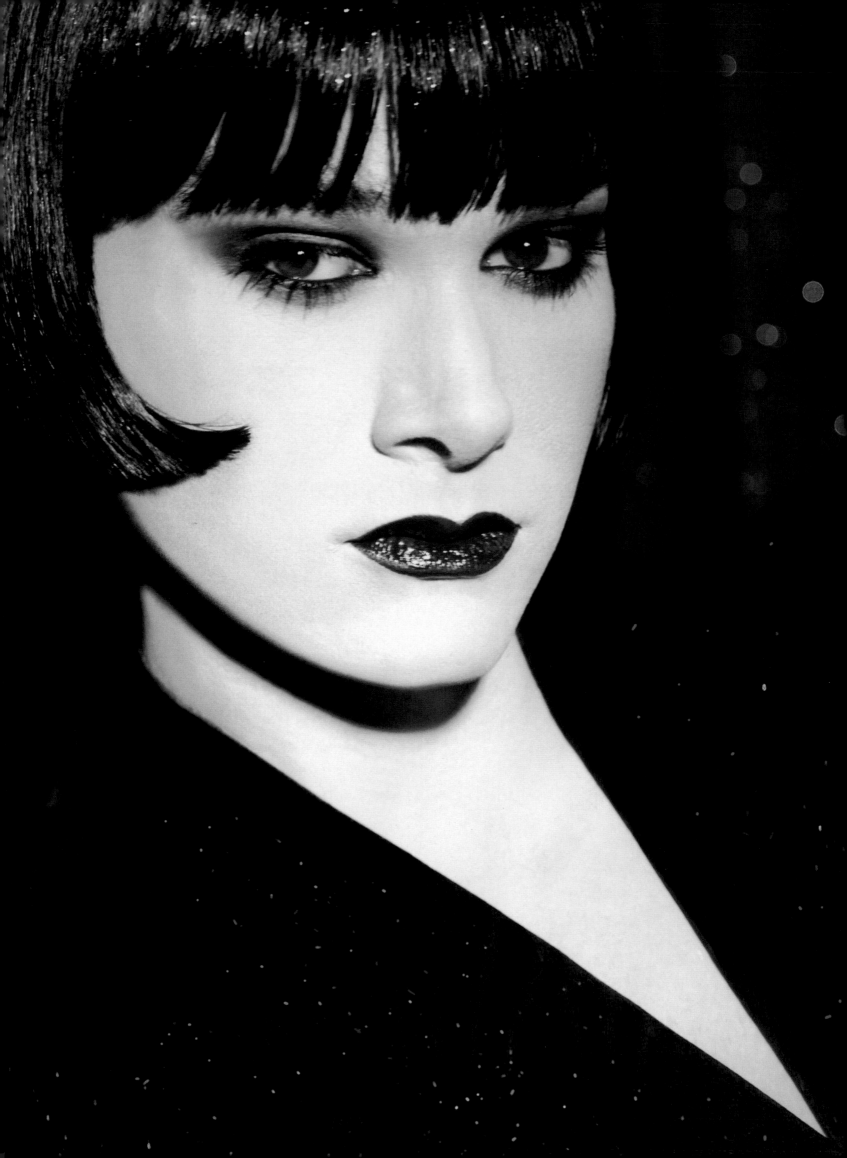

As the roulette wheel spins round and round, a guy who looks uncannily like James Bond wins at black-jack. Here, in the smoke-filled rooms of a Riviera casino, you can always find the Player nearby. No stranger to artifice, this is a woman who lives by her wiles. Cunning and clever, she plays the slinky, slithering villain and often double-crossing love interest of the unwitting male. She is never to be trusted or left out of your sight. Tom Woolley offers yet another transformation, albeit somewhat darker and more mysterious than his last incarnation.

face tape (if needed)
pale liquid foundation
translucent face powder
black eye pencil
greenish-gray creme eyeshadow
metallic black powder eyeshadow
small eyeshadow brush
sponge-tip applicator
eyelash curler and black mascara
pink powder blush
dark brown lip pencil
true red lip color
lip brush
nails and wig (if needed)

1

SHAVE!

2

Tape the face in places where necessary (see below).

3

Pale liquid foundation is smoothed all over face, neck and chest (lips and ears, too).

4

Then set the face with loose powder.

5

Next, rim the inside of the eyes with black eye pencil and smudge with shadow brush..

6

Apply greenish-gray creme shadow all over the eye area up to the browbone and "wing out" slightly at the outer corner.

7

Apply black metallic shadow over that, also winging outward.

8

Curl the lashes and apply a generous amount of black mascara.

9

Just a hint of pink blush.

10

Then line the lips with a dark brown lip pencil in a bow shape (very important). Fill in.

11

Next, cover over lip pencil with powder, then…

12

…apply true-red lip color with a brush just up to the lip line.

13

Last, apply nails and put on a wig, if you like.

Taping

Step one - Clean the skin with an astringent where the tapes are to be applied. (Skin oils and makeup will cause the tapes to loosen and eventually come off.)

Step two - Adhere tapes to face, where desired, hook in and pull cords to back of head.

Step three - Use bobby pins to secure cords to hair in back of head.

Step four - Brush hair over cords or cover with wig.

Some places to affix:

High on the forehead to lift the arch of brows. The temples (pulling up or sideways) to lift or change the shape of the eyelids (*see page 117*).
Back of jawline (by the ears) to smooth cheekbones and lift the chin.

Tom Wooley

the Anarchist

Once again England was the home of a trend-setting look. From the streets of London, the Punk movement represented anti-beauty, rebellion, the Urban Guerilla. Vivienne Westwood and Malcolm MacLaren, two of the founders of this cultural æsthetic, created looks that were simultaneously tribal and anarchic. Body piercing, Day-Glo hair color. safety-pinned black clothes, not to mention Mohawks, heavy, oddly shaped eyeliner and black nails and lipstick were the hallmarks of the Anarchist. Shalom Harlow's exotic beauty adds a disarming quality to this fierce look.

concealer (if needed)
brow brush
brow pencil
(pointy) eyeshadow brush
dark metallic blue liquid eyeshdow
metallic green liquid eyeshadow
clear red lip gloss

1

Concealer can be spot-applied but only if needed. No foundation.

2

Brows are brushed and lightly penciled.

3

Using a pointy eyeshadow brush, starting at the inner corner of the eye, draw a dark metallic blue line with the liquid shadow.

4

The metallic blue is mixed with liquid metallic green and the combination of the two is used to continue the line into the crease.

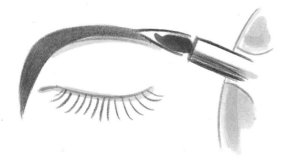

5

Metallic green alone is used to finish off the "wing," trailing off toward the temple. No mascara was used.

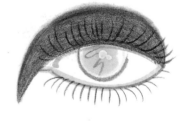

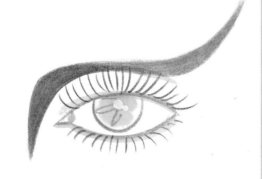

6

Sheer clear red lip gloss is applied and blotted to create a no-lipstick feel, but still finishing the mouth.

Remember, the shape you draw should be of your own creation. The Anarchist followed no rules. But here are a few examples of simple shapes you can create using generally the same guidelines.

Keep in mind, though, the shape will appear very different, depending on which way it is viewed (front/side), so draw it accordingly.

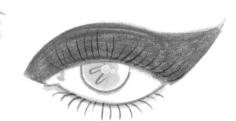

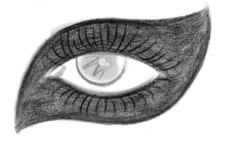

Shalom Harlow

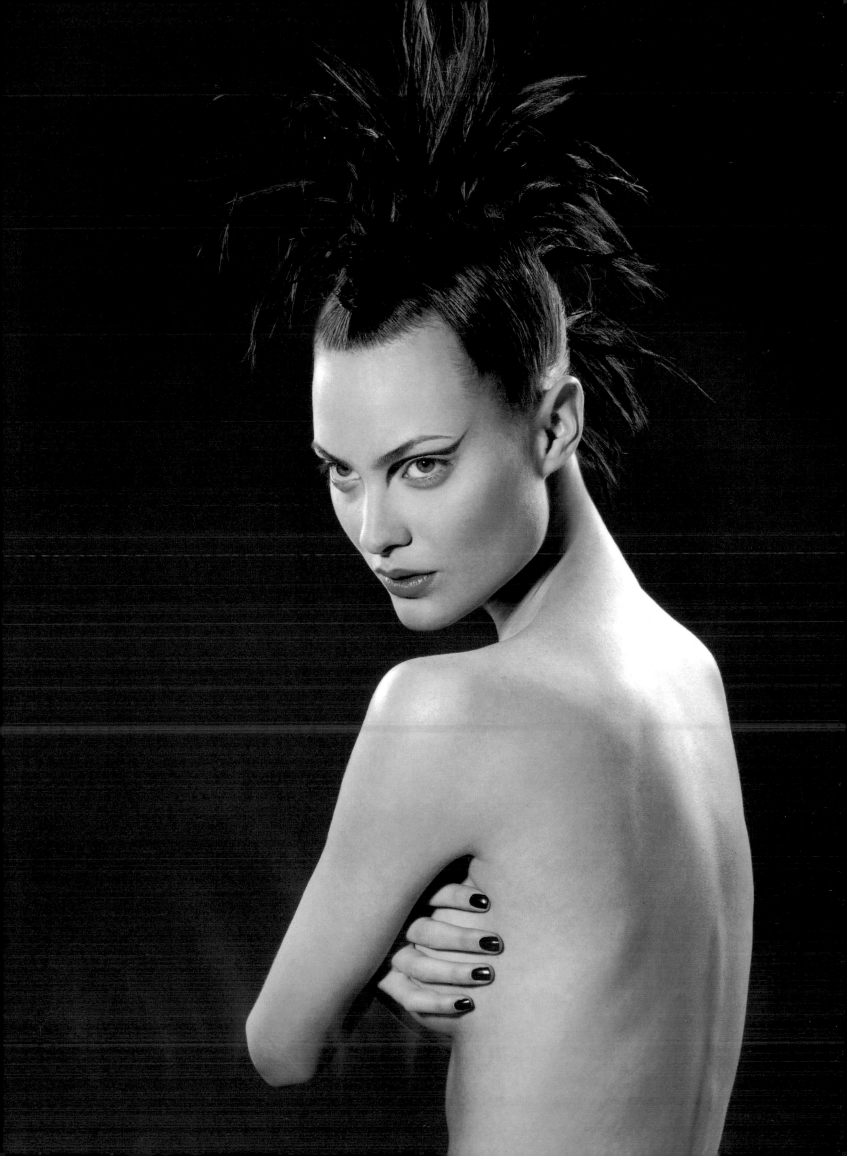

Thankfully, we have become more aware of our effect on the environment. Even the beauty industries have recognized this. We share this planet and what we do and what we *use* has an impact. Our Purist face embraces this new global æsthetic. It is the look of health and vitality. Using moisturizing products makes the contours of the face reflect light naturally, and leaves the skin soft, supple and youthful. And with just a touch of ripe color here and there, mainly around the eyes and cheeks, a beautifully balanced face is achieved on stunning model Kiara Kabakuru.

concealer
sheer liquid founadtion
orangy creme blush
dark brown brow pencil
purple creme eyeshadow
orange creme eyeshadow
eyelash curler and black mascara
dark-toned lip pencil
bronzy-black lip gloss

1

Apply concealer just where needed.

2

Next, sheer liquid foundation is smoothed all over the face.

3

Follow with orangy creme blush smoothed onto the cheeks, chin and hairline.

4

Fill in with dark brown brow pencil to lightly define the brow shape.

5

Apply purple creme eyeshadow very lightly on the outer corners of the eyes and blend.

6

Next, orange creme eyeshadow is *lightly* applied on the browbone.

7

Curl lashes and add a light coat of black mascara.

8

Use dark-toned lip pencil to line the mouth. (These shades should be chosen based on your own natural lip colors.)

9

Last, apply lip gloss over pencil. (Bronzy-black was used on Kiara.)

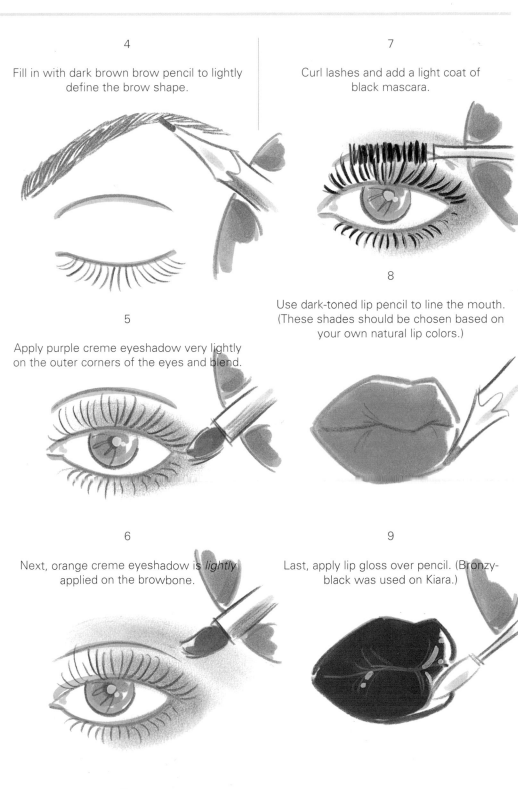

Kiara Kabakuru

the Enigma

The Enigma face is a mix of two very distinct and memorable visual inspirations. The first, and most easily recalled, is the recent grungy, "waif" look of the last few years. The second, and more evocative (I feel), comes from some of the great Italian movie actresses of the late Fifties and early Sixties. For two good examples try viewing Sophia Loren in *Two Women* and Anna Magnani in *The Rose Tattoo*. Their look is very emotionally charged, only rubbed mascara and tear-stained faces. Here Gwyneth Paltrow projects just the right amount of pathos and vulnerability necessary to bring it all together beautifully.

light golden shimmer liquid foundation
orangy-red creme blush
brow brush
black eye pencil
eyelash curler and black mascara
flesh-toned lip pencil
clear red lip gloss

1

Apply light golden shimmer liquid all over the face (and for this photo the neck and arms).

2

Next, orangy-red creme blush is lightly applied to the cheeks, temples, and collar-bone.

3

Brush brows and groom if necessary.

4

Apply black pencil liner on the upper and lower inner rims. Squeeze shut to distribute evenly.

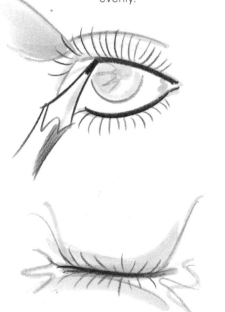

5

Next, apply black mascara to curled lashes, top and bottom.

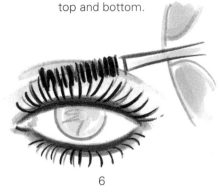

6

Take a black mascara wand and randomly press onto the eyelids, crease and under-eye area, to create a splattered look. (You can use liquid eyeliner or eyeshadow if you prefer.)

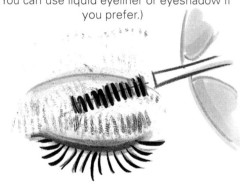

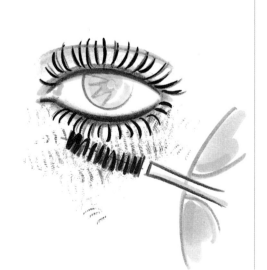

7

Use a flesh-toned lip pencil to softly define and fill in the lips.

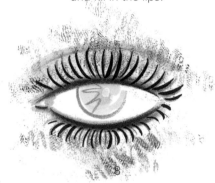

Follow with a clear red lip gloss to cover pencil.

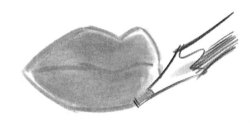

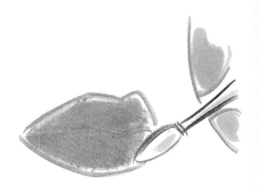

Gwyneth Paltrow

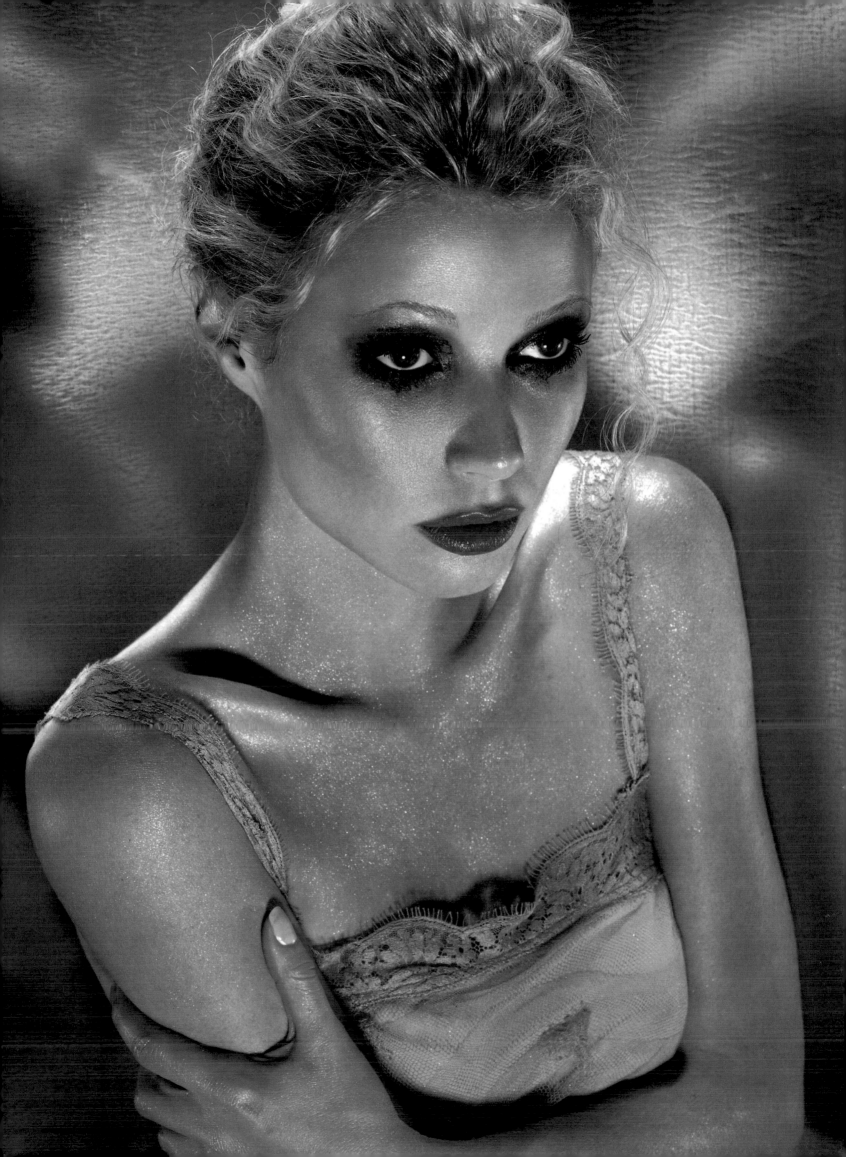

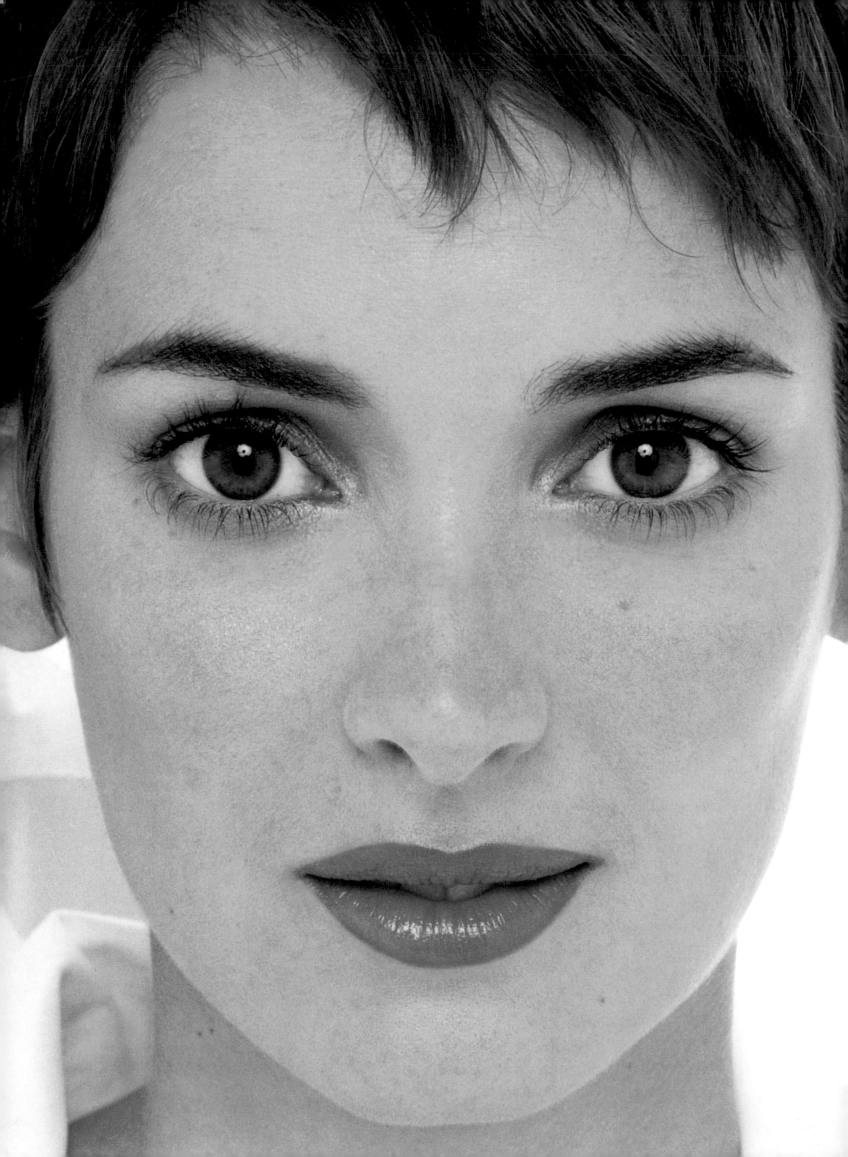

the Minimalist

The Minimalist face is not altogether dissimilar from the Innocent face at the beginning of this section. I believe this goes to prove that makeup, like all creative endeavors, is part of a constantly evolving tradition that builds on, and often reinvents, the past. Though there are makeup trends each year, the lines between them are, thankfully, becoming more blurred. Our increasing diversity inspires designers, magazines and cosmetic companies to offer us more choices. And choice is what this book is all about. Remember, there is no such thing as "too much makeup" or "too little makeup," only what's right for you.

concealer (if needed)
pink liquid blush
brown creme eyeshadow
white liquid shimmer eyeshadow
eyelash curler and black mascara
natural flesh-toned lip pencil
clear lip gloss

1

Lightly apply concealer only where and if needed.

2

Next, pink liquid blush is dabbed onto the cheeks, temples and chin.

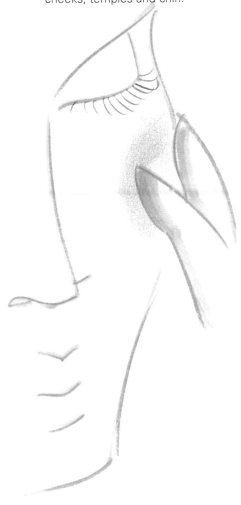

3

Apply brown creme eyeshadow in crease and lightly under the eye. Blend well.

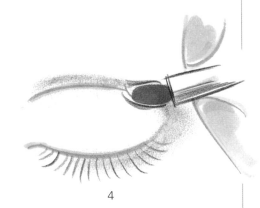

4

Use white liquid shimmer eyeshadow lightly on inner corner of the eye to highlight.

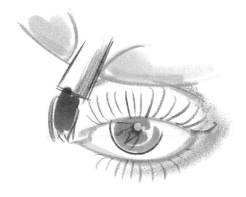

5
Next, curl the lashes.

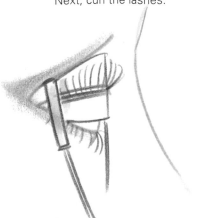

6

Apply a thin coat of black mascara on top and bottom lashes.

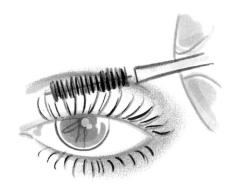

7

Apply natural flesh-toned lip pencil to softly define the shape of the mouth and fill in.

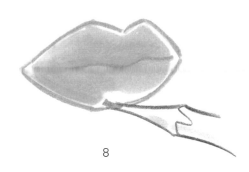

8

Last, apply clear lip gloss to lips and blot.

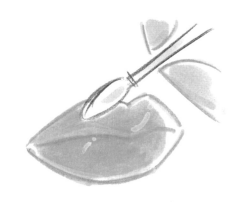

Winona Ryder, photographed by Patrick DeMarchelier

acknowledgments

First of all I'd like to thank the incomparable Gena Rowlands for her brilliance, kindness and generosity. What an honor and overwhelming joy it is to have such a wonderful friend.

Unending gratitude to my extraordinary editor, Jennifer Josephy, whose support, hard work, endless cheerfulness and faith made this a wonderful and memorable experience. And to everyone at Little, Brown, especially Bryan Quible, Abby Wilentz, Page Dickinson, Holly Rapport, Holly Wilkinson, Beth Davey, Jean Griffin, Amy Rhodes, Sarah Crichton, Josh Marwell, Beth Halloran, Mary Tondorf-Dick, Jane Comins and Caroline Hagen for their limitless enthusiasm and professionalism. Very special thanks to Suzanne Gluck and Marsinay Smith at ICM for their faith, encouragement and perseverance in this project. To Dr. Dan Baker and Dr. Pat Wexler, with admiration for their extraordinary talent and for sharing so generously with their knowledge and insight.

To the magnificent photographers Miles Aldridge, Patrick DeMarchelier, Sante D'Orazio, Thierry LeGoues, Peter Lindbergh, Kei Ogata, Herb Ritts, Eric Sakas, Patric Shaw, Michael Thompson, Eddie Wolfl and Firooz Zahedi, it is a thrill to work with you and an honor to have your amazing photographs in this publication. And to Billy Jim for bringing his own incredible camera artistry to these pages.

To the following fantastic women and men: Tori Amos, Nadja Auermann, Drew Barrymore, Alpana Bawa, Vanessa Brook, Dawn Brown, Naomi Campbell, Adia Coulibaly, Valerie Celis, Richard Elms, Sandy Franklin, Trish Goff, Shalom Harlow, Kirsty Hume, Janet Jackson, Jewel, Kiara Kabakuru, Nicole Kidman, Lauren-Claire, Courtney Love, Andie MacDowell, Joy Middlebrook, Demi Moore, Masako Mori, Kate Moss, Carolyn Murphy, Chandra North, Gwyneth Paltrow, Jaime Rishar, Julia Roberts, Isabella Rossellini, Winona Ryder, Gregory St. Cerin, Catherine Sherman, Christina Shimizu-Morrison, Shinya, Margarita and Gigi Solis, Jay Swanson, T-Boz, Stella Tennant, Tina Turner, Denise Vasi, Amy Wesson, Tom Woolley, Vanessa Williams and Amber Valetta for giving so graciously of their time, allowing me to use their images and providing me with the perfect subjects. I feel blessed to have such amazing and loving friends. Also, my greatest admiration to the beauty icons who inspired our portraits.

For giving so freely of their time and talents and making themselves available at a moment's notice, I'd like to thank Tony Lucha, Enzo Angileri, Howard Barr, Christopher-John, Clyde Haygood, Orlando Pita, and Serena Radaelli for genius hair styling and coloring; Karen Binns, Freddie Leiba, Julieanne Mijares, Wendy Schecter, Wayne Scot Lukas and Jesse Rodriguez, for beyond brilliant clothing styling; Michael Solis for his genius prop work; Olga Titova for fantastic nails; and especially Andreas Hesse, John Giunta, Bobby Fisher, Ivan Brodey and Jennifer Smith for their tireless support behind the camera. To the staffs at Industria SuperStudio in New York, Smashbox Studio in Los Angeles and, in particular, Kara Glynn, for providing the perfect environments for our photos.

I'd like to thank Pascal Dangin for his amazing skill and professionalism and for putting his heart and soul into this project. Extra special thanks to Jed Root, my friend from the very beginning, for his loyal support and generosity. After all we've been through together it is a blessing to have you in my life. Major gratitude goes to Deborah Izzard for holding it all together and somehow managing to never flip out. Thank you for your dedication, organization, devotion and true grit. You are an angel. To Jami, Klaus and Nicoletta von Heidegger of Kiehl's, for your graciousness and generosity, I adore you all. Very special thanks to Marcy Engelman for her dedicated support on my behalf year-round. You are a true friend and incredible talent. And to Howard Musk and Andrew Harris for being a caring and generous last-minute savior.

To my mom and dad, Isidore and Thelma; to my brother and sisters, Keith, Carla, and Kimberly; and to my nieces and nephews, Samantha, Tatjana, Ian, Katarina and Fallon; our love for one another means more to me than all the success in the world. To my extended family, Todd Littleton, Thomas Woolley, Thomas Efaw, Ari Harris, Robert Montgomery, Anthony Styant, Warren Leight and Caroline Rhea, thank you for being there through it all, with a shoulder to cry on, a heart full of love and enough sick jokes to keep me laughing till I die. To my love and inspiration, Eric Sakas, for his advice, compassion, support, devotion, caring and love. You mean everything to me and have taught me more than anyone I've ever known. You are in my heart forever.

opposite, from top left, row one: my beautiful niece Fallon; with gorgeous Drew Barrymore; Shalom Harlow backstage at Todd Oldham; my godchild, Samantha and nephew Ian; Kiara Kabakuru and Ari Harris. row two: at David Letterman's with Jewel; Alek backstage at Vivienne Westwood; with my love, Shalom; Andie MacDowell with my dog, Alex; with dear friends Tom Wooley and Caroline Rhea. row three: krazy Kristen McMenamy; at home with Eric; Whitney Houston on the set of a music video; nieces Tatjana and Katarina; Tatjana backstage at Vivienne Westwood. row four: T-Boz made up as a guy; glowing Bette Midler; my birth mother, Nelda Sweat; my birth father, Jerry Burch; in London with David Lisnet, Anthony Styant and Stella Tennant; sexy Cindy Crawford. row five: Nicole Kidman at the Academy Awards; Nadja Auermann; a tender moment with Julia Roberts; Liza Minnelli; trying to hide my big lips in a school picture; Janet Jackson at Patrick DeMarchelier's studio. row six: holding my little angel, Fallon; Kirsten Owen; with Naomi Campbell backstage at Isaac Mizrahi; Jaime Rishar clad in feathers; Kirsty Hume. row seven: Michelle Hicks at a Dolce & Gabana shoot; Valerie Celis and Irina at Irving Penn's studio; Carolyn Murphy; Kylie Bax backstage at Ralph Lauren; Shirley backstage at Sonia Rykiel

"Collage," photographed by Billy Jim

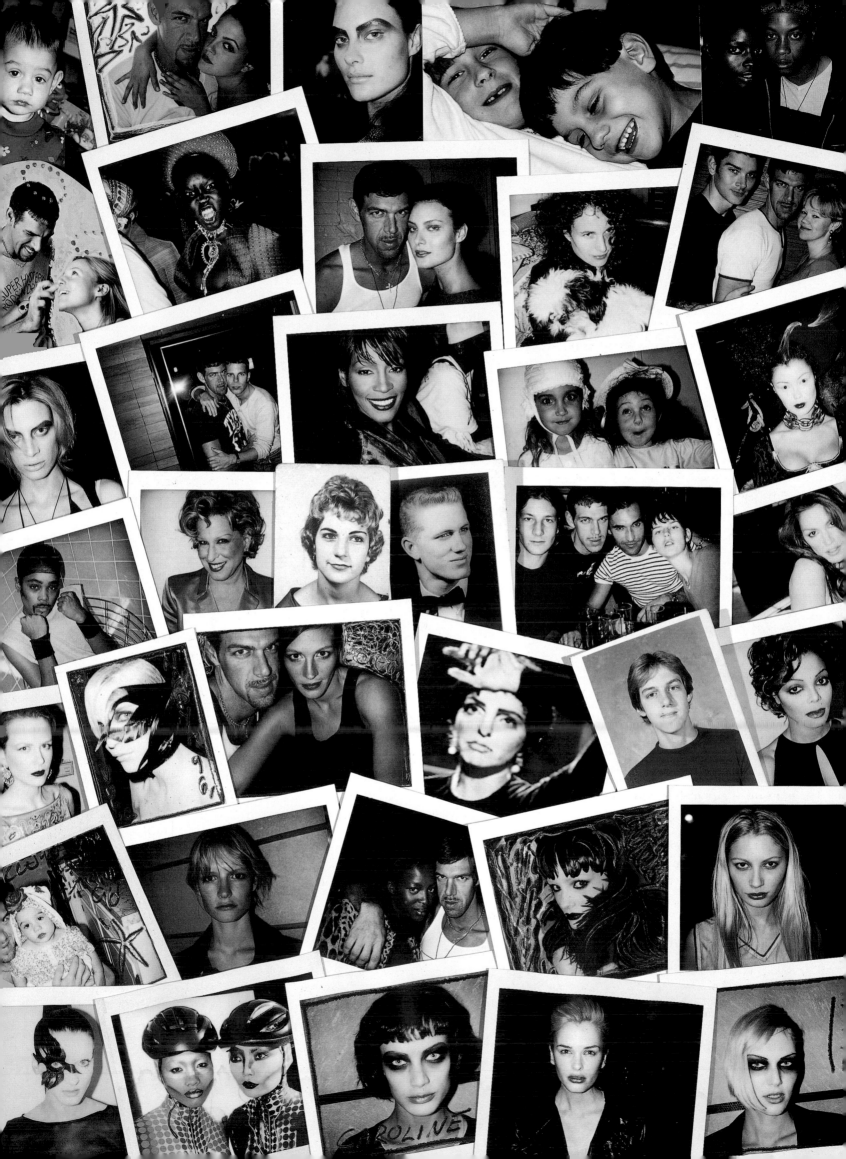

Finally, I also want to dedicate this book to my partner and dear friend, Donald Reuter, whose brilliant creative vision, boundless talent and tireless perseverance took our concept and made it a reality. Thank you for your love and patience, you mean the world to me.

Thanks, also, to the following individuals and organizations for their help, continuous support, contributions and inspiration: Victor Alfaro, Art & Commerce, Amy Astley, May Au, Doe Avedon, Richard Avedon, Gina Avery, Vicky Bartlett, Jeanne Beker, Alisa Bellettini, Sandra Bernhard, Halle Berry, Chris Bishop, B-Lab, Blanpied-Rubini, Angelica Blechschmidt, Chastity Bono, Janet Botaish, Kim Bowen, the staff at Box, John Bradshaw, Tim Braun, Holly Brubach, Joan Juliet Buck, the Burch family, Cammie Burns, Renata Buser, Kathy Caesar, Dr. Carmine Caggiano, Colleen Callaghan, Charlotte Carlson, Hampton Carney, Anthony Carro, George Casson, Brian Cellar, C-Lab, Carol Clark, Mitch Clark, Chantal Cloutier and the staff of Cloutier, Patty Cohen, Nancy Collins, Michael Flutie and Company Models, John Lum and the staff at ComZone, Daneen Conroy, Patti Conti, Robyn Crawford, Tom Cruise, CYMK, DNA, Kim-Van Dang, Roger Davies, Preston Davis, Marion de Beaupre, Ellen DeGeneres, Paige Dorian, Angel Dormer, Andrea Doven, Susan Duffy, Peter Dundas, Elite, Rene Elizondo, Linda Evangelista, Favian Hair, Frederic Fekkai, Linda Ferrando, Denis Ferrara, Fabrizio Ferri, Sara Foley Anderson, Ford, Robert Forrest, Mark Flyer, Dennis Freedman, Vanessa Freidman, Peter Galvin, Mme. Simone Galton, Garren, Jean-Paul Gaultier, GLAAD, The Gay and Lesbian Anti-Violence Project, Odile Gilbert, Candace Gingrich, Michael Goff, Elaine Goldsmith, Lori Goldstein, Tonne Goodman, Bebe Gordon, Hugh Grant, Eddie Green, Nina Griscom, Nicolai Grosell, John Guerre, LeeAnne Haigney, Gale Hansen, Kevin Haley, Jessica Harmon, Holly Harper, Kate Harrington, Stan Herman, Michael Hinkle, Jesse Hoey, Elizabeth Hurley, Huvane, Baum and Hall, IM New York, IMG models, Iman, Anne-Marie Iverson, Jennifer Jenkins, Karen Johnston, Jun Kanai, Karin Models, Mari Katsura, Steven Klein, Cathleen Klemm, Mme. Valerie Klipp, Nick Knight, Laurie Kratochvil, LTI, Evelyn Lange, Suzanne Lanza, Matt Lauer, Patrice Launay, Ralph Lauren, Sarah Lazin, George LeBar, Warren Leight, Lens & Repro, Jodi Leesley, Louis Licari, Davien Littlefield, Dr. Greg Lituchy, Valentino Longo, Tony Longorio, Roxanne Lowit, Didier Malige, Fern Mallis, Kevin Mancuso, Raul Martinez, Martha McCully, Mark McKenna, Sam McKnight, Newell McNair, Steven Meisel, Rebecca Meiskin, Polly Mellen, Jaime Mendoza, Bette Midler, The Harvey Milk School, Liza Minnelli, Isaac Mizrahi, Jean-Baptiste Mondino, Suzanna Moniger, Mary Tyler Moore, Kirsten Morehouse-Kenney, Maria Moreno, Kate Mueth, Michael Musto, Glenn Neely, Camilla Nickerson, Queen Noor of Jordan, Serge Normant, Billy Norwich, Todd Oldham, Oribe, Edgar Otte, Rick Pannell, P-FLAG, Susana E. Parks and everyone at the Four Seasons, Patrick Prendergast, Irving Penn, Ro Pennuliar, Shane Perdue, Sarah Pettit, Phyllis Posnick, Julianne Quay, Beau Quillian, Dee Ragano, Jeanine Recckio, Hunter Reinking, Mark Robertson, Matthew Rolston, Mark Romanek, Jed Root, Inc., Roseanne, Liz Rosenberg, Paolo Roversi, Carin Rothfeld, Paul Rowland, Charlene Roxborough, the entire staff at PMK, Jennifer Ruiz, RuPaul, Joanne Russell, Sonia Rykiel, Elizabeth Saltzman, Robert Sammons, Nicoletta Santoro, Lydia Sarno, Diane Sawyer, Wendy Schmid, Michelle Schweitzer, Stephane Sednaoui, Polly Sellars, Nancy Seltzer, James Servin, Jane Siberry, Kim Skalecki, Liz Smith, Patty Smyth, Arthur Spivak, Liz Stafney, Andrew Steinberg, Dane Stevers, Norma Stevens, Sharon Stone, Barbra Streisand, Gwenn Stromen, Susan Swan, the Sweat family, Mary Tannen, Elizabeth Taylor, Mario Testino, Ben Thomas, Daniel Thomas, Liz Tilberis, Blaine Trump, Christy Turlington, Cindy Uhl, Tracey Ullman, Max Vadukal, Lindsy van Gelder, Tom Vasatka, Patricia Velasquez, Annie Veltri, Lionel Vermeil, Visage, Lynne Volkman, Rob Walker, Linda Wells, Chantal Westerman, Vivienne Westwood, Oprah Winfrey, Anna Wintour, Brana Wolf, Women, Dana Wood, Billie Woodruff, Hubert Woronniecki, Alice Young, and Shawn Young.

● ●

I was so excited to be involved with Kevyn in this book. I used to read about him with fascination and the first time I felt his hands on my face I remember feeling total trust. Kevyn is the first makeup "artist" I have ever known; by artist I mean purely involved with transformation that is genderless and boundless. He knows the art of transformation, whether it's anarchy or high glamour or mixing blackberries into Vaseline.

When Kevyn made me up for the Golden Globes, I remember looking into the mirror and starting to cry. I had never before seen myself the way he saw me and his hands made me. It was overwhelming and far deeper than I can articulate.

Makeup is deception. Makeup is intellectual. Makeup is probably one of my favorite things in its ability to communicate all the archetypes of a woman. Makeup is a grand luxury, not an imperative. Kevyn breaks every makeup "rule" because he is an artist and like any master, he knows the crazed masonic secrets whispered throughout movie studios and by Avon ladies in small towns for decades. To this secret woman's knowledge he brings his own genius.

The origin of the word "glamour" is the verb "to cast a spell," and for Kevyn I can only think of my favorite quote from Emily Dickinson:

*Then Sunrise kissed my Chrysalis —
And I stood up — and lived —*

Courtney Love, Los Angeles, 1997

Courtney Love as "the Starlet"

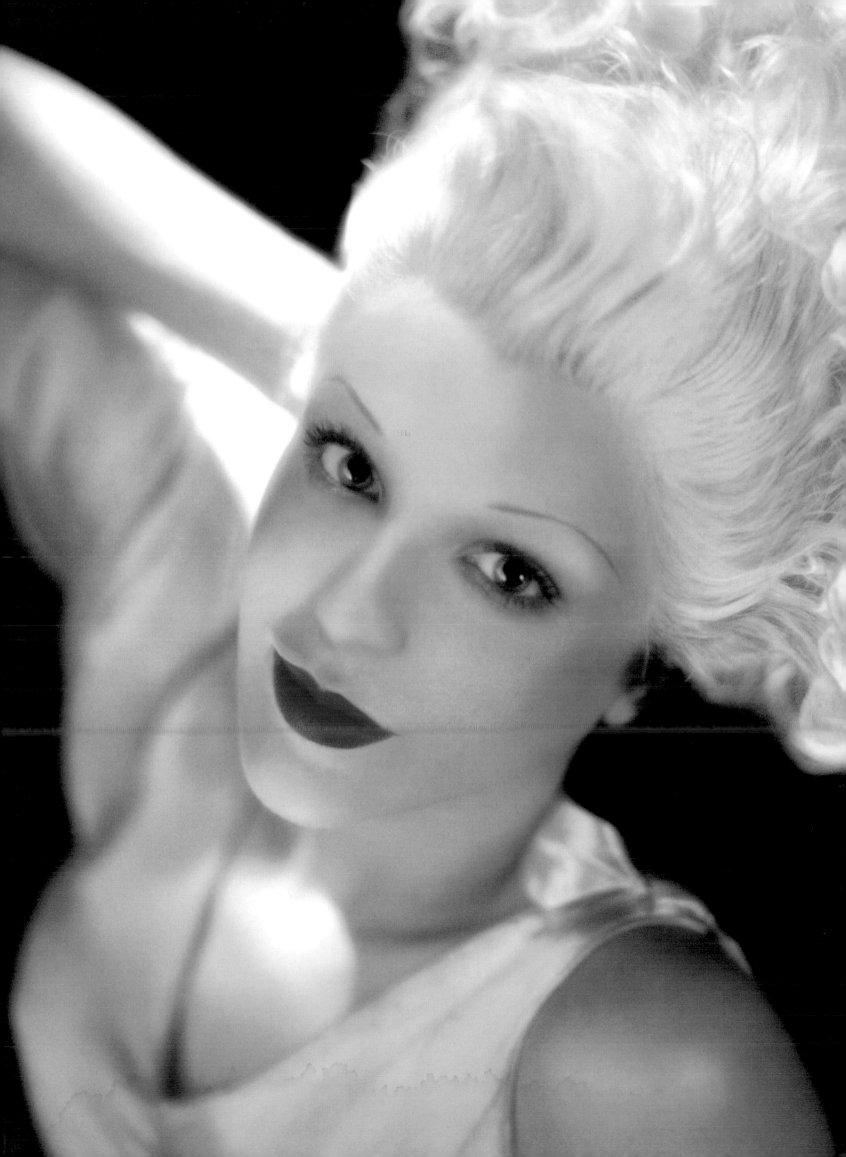

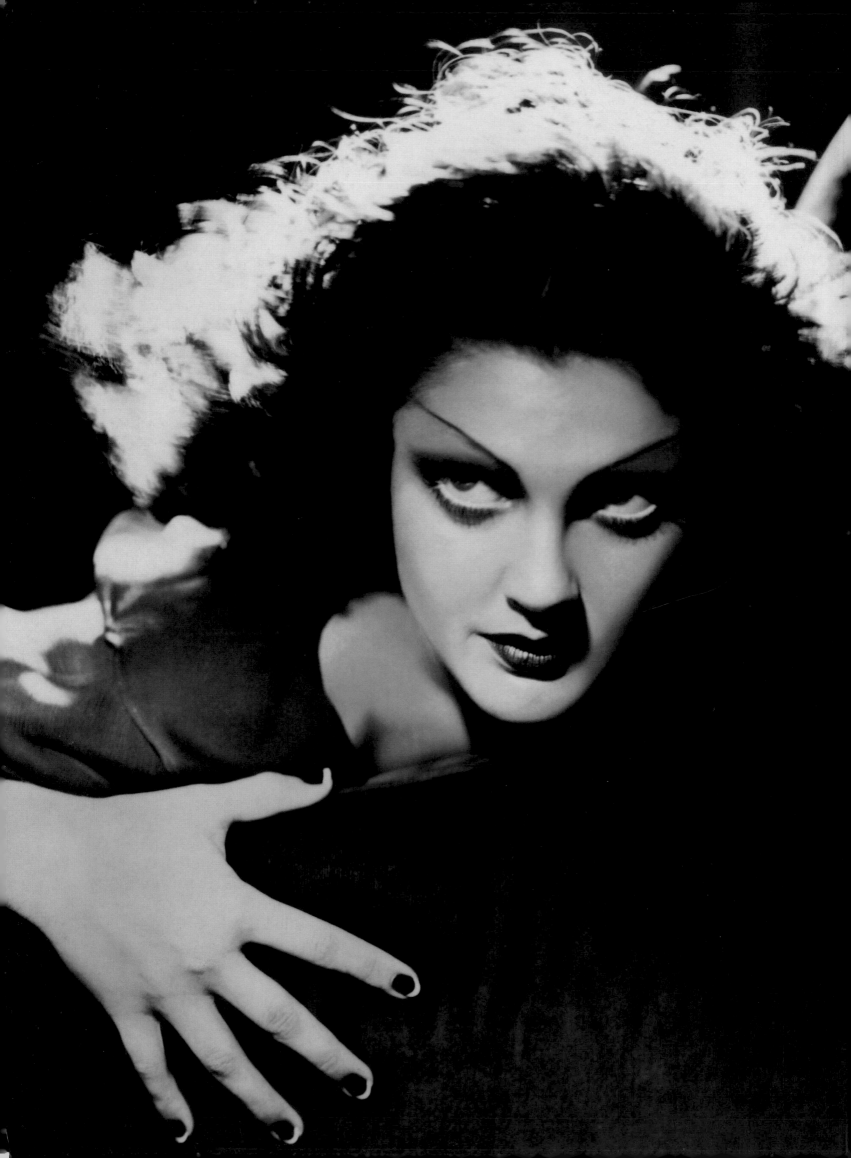

credits

Stylists and Editors

Karen Binns (*pages 2-3, 48 and 67*); David Bradshaw (*page 42*); Paul Cavaco (*pages 31, 138-39 and 140*); Kelli Delaney (*pages 29, 76, 98 and 101*); Lori Goldstein (*pages 44 and 46*); Tonne Goodman (*page 152*); Kate Harrington (*page 135*); Jules Frankham (*page 64*); Freddie Leiba (*pages 10-11, 62, 104-05, 117 and 147*); Wayne Scot Lukas (*pages 9, 12, 15, 72, 90, 95, 97, 107, 114, 126, 143, 144 and 158-59*); Julieanne Mijares (*pages 108, 111, 121 and 122*); Jesse Rodriguez (*pages 47, 82, 124, 128, 136 and 151*); L'Wren Scott (*page 131*); Wendy Schecter (*pages 112-13 and 157*); Ricky Vider Rivers (*pages 36, 38 and 41*); and Joe Zee (*page 53*)

Hairstylists

Enzo Angileri (*pages 53, 108 and 122*); Howard Barr (*pages 19, 20, 21, 26 and 45*); James Brown (*page 152*); Danilo (*pages 138-39*); Yannick D's (*pages 32 and 140*); Clyde Haygood (*pages 1, 82 and 117*); Sally Herschberger (*page 135*); Yumiko Ishibiki (*pages 56 and 57*); Oscar James (*page 131*); Tony Lucha (*pages 2-3, 4-5, 9, 12, 15, 22, 24-25, 47, 67, 72-73, 81, 87, 90, 95, 97, 104-05, 107, 114, 118, 124, 128, 136, 143, 148, 151, and 158-59*); Serge Normant (*pages 31, 36, 38 and 41*); Orlando Pita (*pages 42, 44, 48, 51, 54, 132 and 147*); Serena Radaelli (*pages 11, 112-13 and 155*); John Sahag (*pages 6, 29, 76, 98 and 101*); Ward (*page 16*); and Janet Zeitoun (*pages 40, 126-29*)

Haircolorists

Christopher-John and Ellen Levar

Manicurist

Olga Titova

Prop and Set Sylist

Michael Solis

HM Lighting Technician

Rob Halle (at RHG Lighting)

Designers

Chloe, Jean Colonna, Dolce & Gabbana, John Galliano, Jean-Paul Gaultier, Romeo Gigli, Gucci, Marc Jacobs, Norma Kamali, Donna Karan, Calvin Klein, Ralph Lauren, Hervé Leger, Isaac Mizrahi, Anna Molinari, Thierry Mugler, Rifat Ozbek, Todd Oldham, Prada, Sonia Rykiel, Jil Sander, Anna Sui, Richard Tyler, Valentino and Vivienne Westwood.

Magazines

Allure (*pages 29, 36, 38, 41, 76, 98 and 101*); **Elle-Japon** (*pages 58-59*); **German Vogue** (*page 16*); **Harper's Bazaar** (*pages 31, 138-39, 140 and 152*); **Spur-Japan** (*pages 2-3, 49 and 67*); **Tatler** (*page 126-27*); and **W** (*page 53*)

opposite, Drew Barrymore, "Film Noir"
back page, "Letters from Home," photographed by Billy Jim

Kevin Oct. 13

She has brown eyes and brown
hair. She is a baby. She wairs
little pants and a shirt. Today
is her birthday. She is one year
old. And she is small. She has tan
lips and big brown eyes. She has
a big smile all the time too.
She walk funny. She has a
cute face. She can walk too.
She is as cute as any thing.
She has short hair too.
And she laughs all the time.
She has brown eyebrows.

EDGAR MARTIN ELEMENTARY SCHOOL
401 BROADMOOR BLVD.
LAFAYETTE, LOUISIANA

MERRITT S. BEADLE
PRINCIPAL

November 5, 1969

Dear Mr. and Mrs. Aucoin,

Kevin has satisfactorily completed the work for the first nine
weeks period. He is a good worker but does enjoy "visiting"
with his neighbors.

He asks to go to the rest room quite often. I don't know whether
you have noticed this at home but thought I should call it to
your attention.

He is a nice child. I am enjoying having him in my room.

 Sincerely,

 Tommie A. Curtis
 Mrs. Tommie Curtis